THE PERFECT PORTRAIT GUIDE
How to Photograph People

RotoVision

RotoVision

A RotoVision Book
Published and Distributed by RotoVision SA
Route Suisse 9
CH-1295 Mies
Switzerland

RotoVision SA, Sales, Production & Editorial Office
Sheridan House, 112/116A Western Road
Hove, East Sussex BN3 1DD, UK

Tel: +44 (0) 1273 72 72 68
Fax: +44 (0) 1273 72 72 69
e-mail: sales@RotoVision.com

Copyright © RotoVision SA 2002

All rights reserved. No part of this publication may be reproduced, stored
in a retrieval system or transmitted in any form or by any means,
electronic, mechanical, photocopying, recording or otherwise, without
permission of the copyright holder.

The photographs used in this book are copyrighted or otherwise
protected by legislation and cannot be reproduced without the
permission of the holder of the rights.

10 9 8 7 6 5 4 3 2

ISBN: 2-88046-687-3

Book design by Brenda Dermody
Cover design by Design Revolution
Diagrams by Roger O'Reilly and Kath Williamson

Production and separations in Singapore by ProVision Pte. Ltd.
Printed in China by Midas Printing

THE PERFECT PORTRAIT GUIDE

How to Photograph
People

MICHAEL BUSSELLE AND DAVID WILSON

Contents

Informal Portraits

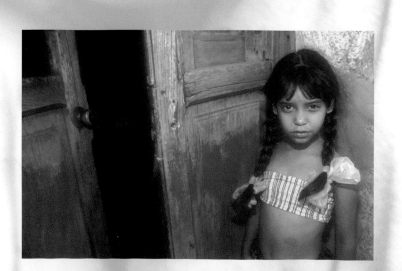

I

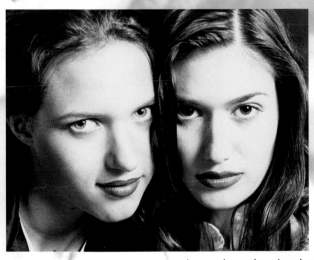

Informal portraits are all about capturing a mood. Successfully done, they portray the subject in a way that reveals something about their personality. However, informal does not mean unplanned. Thoughtful composition, a good sense of timing and the ability to put subjects at ease are all factors which will help produce images that are on a completely different plane from the run-of-the-mill snapshot.

Framing the Image

The first concern in portraiture, as in every other type of photography, is composition. The human face is the focus of the image, but there are many different ways of placing it within the frame. Striking compositions can help emphasise the subject's features, but there is no need to include the whole of the subject in the picture — or even the entire face.

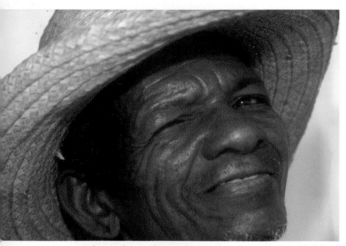

Kobi Israel wanted to emphasise this Cuban man's wrinkled face and the texture of his hat, and so shot from a low viewpoint and framed the image tightly. He used a 28–105mm lens to zoom in close, and took advantage of the tilt of the man's hat to create a diagonal composition. He selected a wide aperture which, used at the telephoto end of the zoom, threw the background completely out of focus.

Technical Details

35mm SLR camera with a 28–105mm lens and Kodak Elitechrome 100 transparency film.

Rule of Thumb

The rule of thirds, or the golden section, is a classic compositional device. Imagine lines splitting the frame into three equal portions horizontally and three equal portions vertically. Placing elements of the composition on these imaginary lines will help to balance the image. Framing so that the subject, or part of the subject, falls on a point where the lines intersect will help to focus attention on it. Portraits are often enhanced by placing the subject's head, or in close-ups their eyes, on or near an intersection of thirds.

Seeing

While travelling in the Himalayas, Diane Barker attended a religious ceremony at a monastery in Ladakh, Northern India. As the ceremony came to a close, the young monks crowded round and she was attracted by this boy's cheeky expression. The wooden door frame provided a natural frame for his face and its scuffed grey paint nicely complemented the deep red of his robes.

Thinking

The mood was light-hearted, and the young monks were just as interested in the photographer as she was in them. This meant she had plenty of time to capture the shot she wanted. She was helped by having a friend with her who was naturally flamboyant and had the knack of putting people at their ease. As the boy stared at the visitors, Barker simply raised the camera and snapped him.

Acting

Barker composed the image instinctively so that the wooden beams neatly framed the boy's face. At the same time they partly obscured the more serious expressions of his companions. The beams provided a natural frame within the image frame and divided the picture up into several distinct areas of interest. The only illumination was from natural daylight.

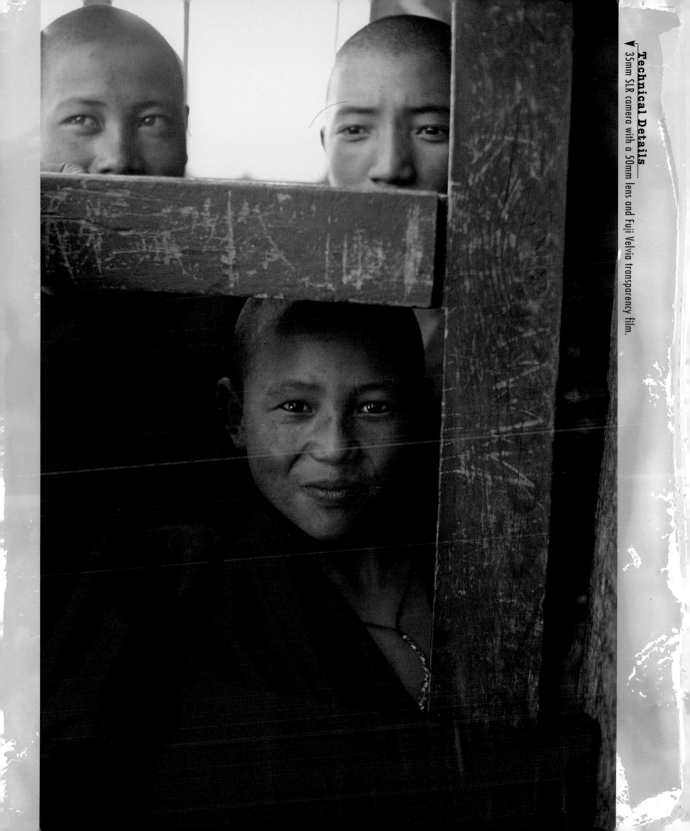

Technical Details
35mm SLR camera with a 50mm lens and Fuji Velvia transparency film.

Framing the Image

35mm SLR with a 28–105mm zoom lens and Ilford FP4 b&w film. ▼

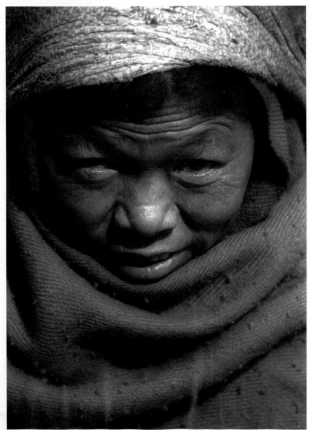

For this picture, Kobi Israel used the telephoto end of a 28–105mm zoom lens to crop in closely on the face of this elderly lady. He emphasised the textures of her weather-beaten face and the fabric she was wrapped in and chose black-and-white film rather than colour. He completed the image by making a black-and-white print and sepia-toning it.

Seeing

Kobi Israel photographed this young girl on a trip to Cuba. He was drawn by the serious look on her face and her dark, expressive eyes. The entrance to her family house, with its plain cement wall and the battered, weathered wood of the door, made the perfect background. The textures and colours added warmth to the picture but were neutral enough not to distract attention from the girl.

Thinking

The photographer was faced with a number of options in framing the picture. He could have shot from relatively far back to include the whole of the girl's body and a large part of the house and door, or he could have turned the camera on its side to take a full-body, vertical portrait. Instead, he chose a horizontal crop and moved in close for a tight composition. Using a 28–105mm zoom lens meant he could try out different framing options quickly.

Acting

Israel used the rule of thirds to compose the shot, placing the girl a third of the way in from the right-hand side of the frame and balancing the composition with the dark, vertical line of the half-open door on the left. Her face was near the top of the frame, placing her eyes, the main focus of interest, on an intersection of thirds for added emphasis.

This was a more obvious crop, but Kobi Israel chose to frame horizontally and balance the image so that attention was focused on the girl's eyes.

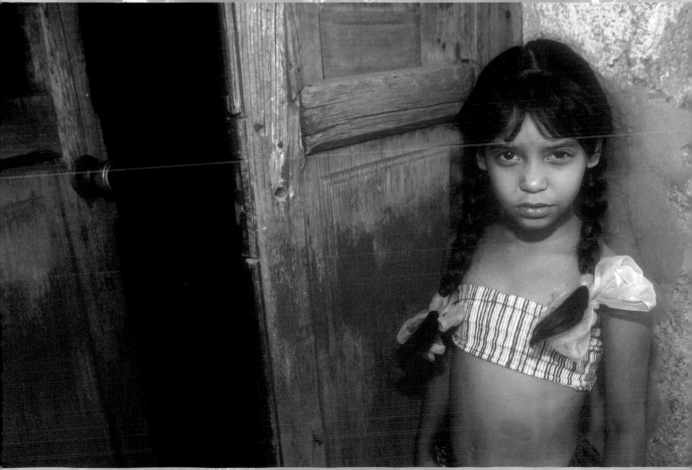

▲ Technical Details
35mm SLR with a 28–105mm lens and Kodak Elitechrome 100 transparency film.

Seeing

Kris Rackham developed this bold technique of shooting tightly cropped faces as a means of adding drama to his portrait photography. He wanted to create attention-grabbing close-ups and, by focusing on eyes staring steadily back into the camera, make the viewer wonder what was going on in the mind of the subject.

Thinking

This girl came along to the studio simply as a friend of another model, but after the session was over, agreed to have her own picture taken too. The photographer framed very tightly, and off-centre, so that although only half of her face was visible, it filled the frame. A 70–210mm lens let him zoom in and out to compose the image.

Acting

Rackham wanted the lighting to be gentle so that it would flatter the model's unblemished skin and her soft blonde hair. He used a relatively simple set-up, with a single softbox to her right supplemented by a reflector that bounced light back into the shadow areas.

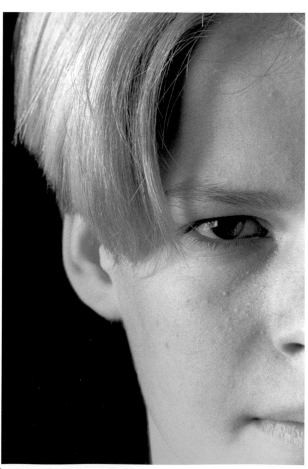

Technical Details
35mm SLR camera with a 70–210mm lens and Kodak Tri-X b&w film.

The approach to these two pictures was similar although Rackham varied the lighting set-up to give a slightly harder effect. The girl with the hair over her eye was quite assertive but the photographer wanted to bring out the shy individual he felt was lurking underneath. He used two softboxes with a reflector, together with a spotlight to increase the level of contrast. The shot on the left was a warm-up shot taken before the session got properly under way, but it turned out to be one of the most successful. This time the lighting set-up consisted of one softbox, a spotlight and a reflector.

▲ Technical Details
35mm SLR camera with a 70mm lens and Kodak Tri-X b&w film.

▲ Technical Details
35mm SLR camera with a 70mm lens and Kodak Tri-X b&w film.

Seeing

Michael Busselle saw this picture from his hotel bedroom window while staying in Negombo, Sri Lanka. He was attracted by the **bold shape** of the catamaran's sail as well as by the man's pose.

Thinking

He had to act quickly, and decided that it would be best not to attempt to include the whole of the boat as this would have meant some **distracting details** would be featured and that the man would be too small in the frame.

Acting

Busselle decided to use a **long-focus lens** to frame the image quite tightly, and this also allowed him to place the man on the **intersection of thirds**.

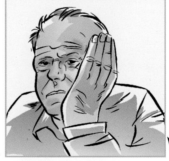

Busselle decided a frontal viewpoint of this cottage, which he'd come across in a village in Normandy, was his best option, as he wanted to emphasise the patterned effect of the timbered facade and the shuttered windows. He framed the shot using his zoom lens to include the man's feet and all of the upper floor windows, and a viewpoint which allowed the man to be in the centre of the image.

Technical Details
Medium Format SLR Camera with an 55–110mm zoom lens, an 81A warm-up filter and Fuji Velvia.

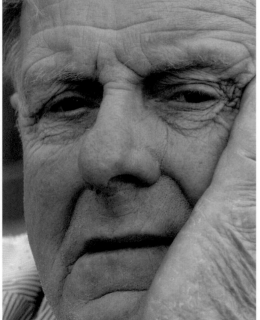

Busselle opted for very tight framing for this portrait, as he wanted to emphasise the man's rich skin texture and to include as little background as possible. He used a long-focus lens and shot from around two metres away to avoid distorted perspective.

Technical Details
35mm SLR Camera with an 70–210mm zoom lens, an 81A warm-up filter and Kodak Ektachrome 64.

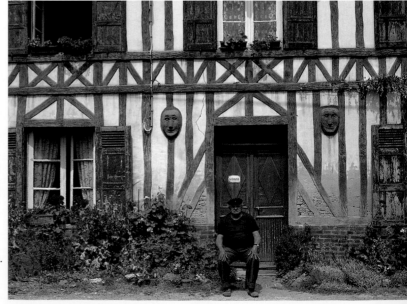

Technical Details
35mm SLR Camera with an 70–210mm zoom lens, an 81A warm-up filter and Kodak Ektachrome 64.

Framing the Image

Rule of Thumb

One of the most common causes of photographs lacking impact is that too much information has been included in the image. Before making your exposure it is wise to first consider whether you could frame the image more tightly, by moving closer to your subject or by using a longer focus lens.

Technical Details
▼ 35mm SLR Camera with an 35–70mm zoom lens, an 81A warm-up filter and Kodak Ektachrome 64.

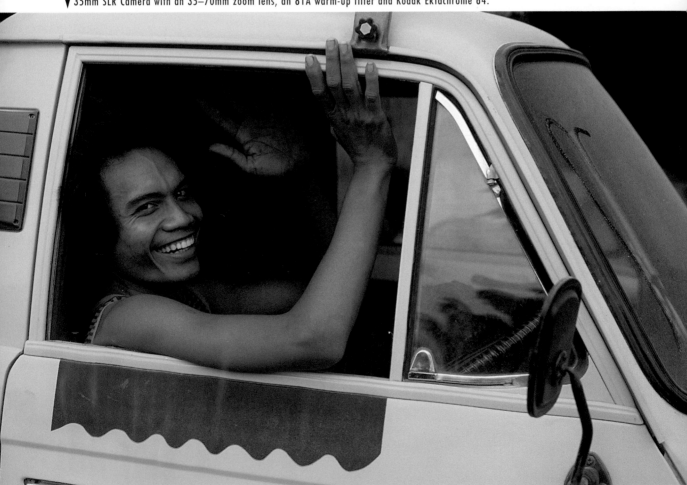

Busselle would have photographed this situation, seen in a Moroccan village, even if the man and child had not been there. He framed his picture so that the background was quite symmetrical, and he placed his subjects in the centre of the composition.

Technical Details
35mm SLR Camera with an 70–210mm zoom lens, an 81A warm-up filter and Kodak Ektachrome 64.

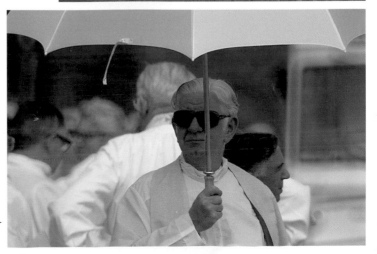

Seeing

Michael Busselle spotted this man in his van in a street in Bali, and was struck by the interesting combination provided by the rich brown of his skin and the bright saturated yellow of his van.

Thinking

He realised that the van's window could make an effective frame within a frame, and his first thought was to shoot from the side and square-on to the window, but this would have denied him an effective view of the man's face.

Acting

Instead he used a viewpoint from where he had a better view of his subject, and he framed the shot so that enough yellow was featured to be effective while the man himself was allowed to remain the dominant element of the image.

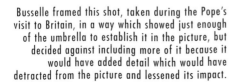

Busselle framed this shot, taken during the Pope's visit to Britain, in a way which showed just enough of the umbrella to establish it in the picture, but decided against including more of it because it would have added detail which would have detracted from the picture and lessened its impact.

Technical Details
35mm SLR Camera with an 75–150mm zoom lens, an 81A warm-up filter and Kodak Ektachrome 64.

Capturing the Moment

Timing is everything. A split-second can make the difference between a successful image that captures a mood and an unsuccessful one that misses it. With experience, the portrait photographer will get a feel for the right moment to fire the shutter. Make sure you're absolutely familiar with the way your equipment works: practise focusing and framing until they become second nature. Limitless patience and fast reactions are invaluable assets, while knowing the subject is always an advantage.

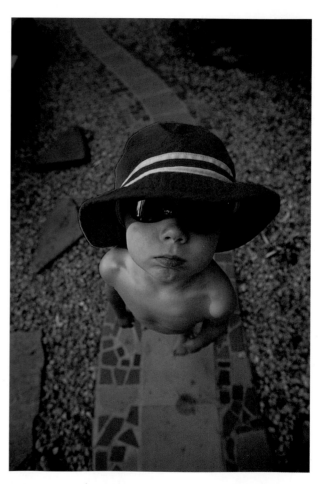

Seeing

Terry Way set out to create a humorous picture exploring the perspective of a small child looking up – which, after all, is what small children invariably have to do when dealing with adults. His young son Colton, wandering around the family garden wearing a pair of swimming goggles and a floppy red hat, provided the perfect model.

Thinking

Way wanted to suggest the thought processes going on inside a child's head, and so aimed to catch his son staring directly into the camera. The fact that the boy's eyes were obscured by the dark goggles added humour to the picture, as did his quizzical, deadpan expression. He positioned the boy on a garden path and framed so that it snaked off into the distance.

Acting

Using an extreme wide angle lens – a 17mm – he exaggerated the size of the boy's face in relation to the rest of his body and to his surroundings. This also created a rather dizzying perspective. The red hat, and the late afternoon sunlight falling on the boy's face and chest, made him stand out from the neutral background. Then the photographer just had to wait until his expression was right before firing the shutter.

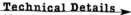

Technical Details

35mm SLR camera with a 17mm wide angle lens and Kodak E100VS colour transparency film.

Technical Details

▼ Medium format camera with a 150mm lens and Fuji Neopan 400 b&w film.

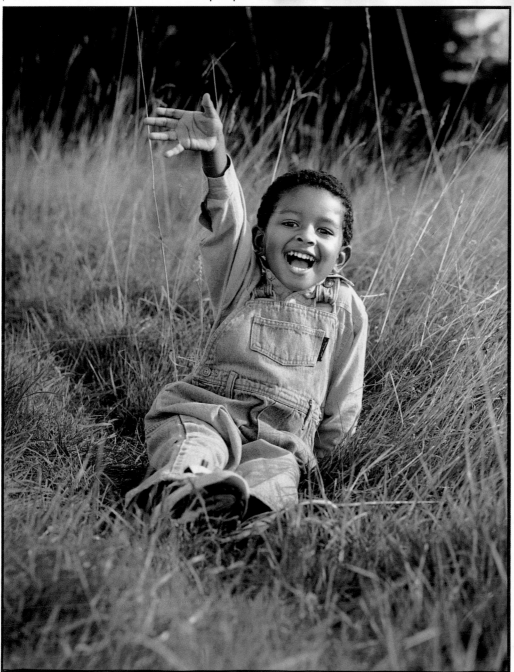

First of all Ronnie Bennett photographed this lively four-year-old with his parents and then took some pictures of him on his own, sitting in the long grass. She asked mum and dad to stand just behind her camera position and to attract their son's attention. While he was busy waving to them he paid little attention to the camera, which gave the photographer the chance to capture his exuberant expression.

This diagram shows how the composition would have been altered had the photo been taken seconds earlier or later.

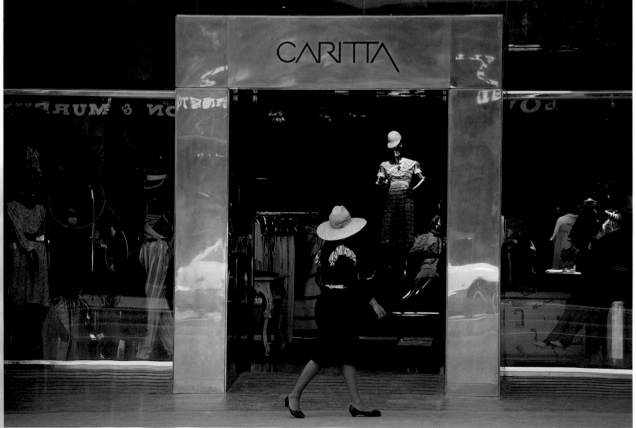

Technical Details
35mm SLR Camera with a 35–70mm zoom lens an 81A warm-up filter and Kodak Kodachrome 64.

Rule of Thumb

Familiarity with your equipment is an important factor in being able to capture a fleeting moment successfully. It's a good idea to practise aiming, framing and focusing your camera, so that it becomes a swift, fluid action and you are able to do it almost without thinking.

Seeing

Michael Busselle spotted this impressive shop front in Rodeo Drive in Los Angeles. He was attracted by the **rectangular gold portal** and the way the interior lighting had **highlighted** the shop dummy inside.

Thinking

He had taken a few shots of it before wondering if the inclusion of a **human figure** might make it more interesting. He decided to wait to see if a suitable candidate might **walk by.**

Acting

This lady with her **splendid hat** was more than he could have hoped for. With his image **ready-framed**, he simply waited until she arrived at the most **effective spot** and then fired, thanking his lucky stars as she turned her head towards the dummy at the **crucial moment.**

Technical Details
▼ 35mm SLR Camera with a 35–70mm zoom lens an 81A warm-up filter and Fuji Provia.

This shot depends entirely for its effect upon the juxtaposition of the statue and the passing woman. A second sooner or later would have completely altered the composition.

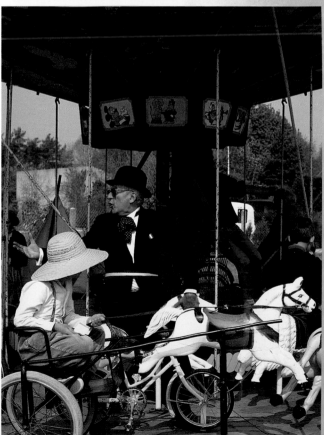

This picture was taken during a small French village fair in which the locals had all dressed in period costume. This fine-looking man was the mayor, and Busselle felt the opportunity presented by his dignified appearance and the incongruity of his riding on the merry-go-round was too good to miss. He was able to wait while the man went round a few times and then shot when this backward glance coincided with him being placed in a good position from Busselle's chosen viewpoint.

Technical Details ➤
35mm Rangefinder Camera with a 90mm lens, an 81A warm-up filter and Kodak Ektachrome 100 SW.

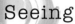

Technical Details
▼ 35mm SLR Camera with a 35–70mm zoom lens, an 81A warm-up filter and Kodak Kodachrome 64.

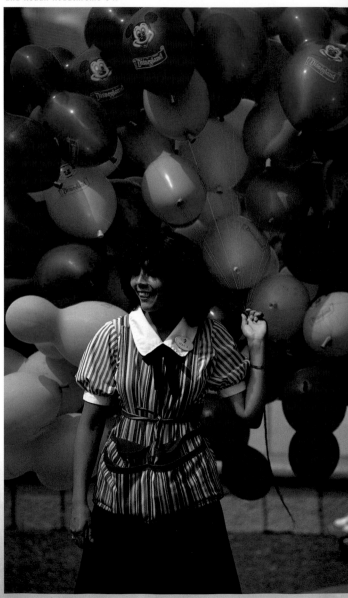

Seeing

Michael Busselle had been watching this young lady selling balloons for some time while shooting in the Los Angeles Disneyland and he felt that she offered the potential for a good picture.

Thinking

It seemed to him that the most effective shot would be one where the background consisted of just balloons, and so he quietly manoeuvred himself into the best viewpoint to achieve this picture, with his lens already set to frame the shot quite tightly.

Acting

Unfortunately, however, her head was turned to the right all the time as she dealt with a small queue of customers, and this meant her face was in deep shadow. When she momentarily turned her face into the light the picture suddenly became alive, and Busselle was able to shoot a couple of quick frames, this one featuring the best expression.

Rule of Thumb

It's a mistaken belief that motor-drives, which many cameras now feature, will allow you to hedge your bets successfully and to depend upon rapid firing to guarantee the most important moment will be recorded. In reality this rarely happens, and in most cases you will stand a far better chance of capturing the most significant moment of an action by good anticipation and a quick reaction.

Technical Details
▼ 35mm SLR Camera with a 80–200mm zoom lens and Kodak Ektachrome 200.

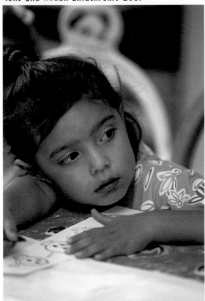

Busselle had his camera ready to aim at this little girl for a while as she was engrossed in a game at a children's party. But it was not until she looked up for a moment that a worthwhile picture became possible, and then only for a second or so as she became self-conscious upon realising Busselle was photographing her.

This picture has worked quite well simply because of the juxtaposition of the various elements. The players were obviously moving all the time, and there was just one fraction of a second when the figure on the far left struck this pose, and was also clearly separated from the others. This was the moment Busselle was waiting for, and it meant he could achieve a sense of order and balance in the composition.

Technical Details
▼ 35mm SLR Camera with a 35–70mm zoom lens and Fuji Provia.

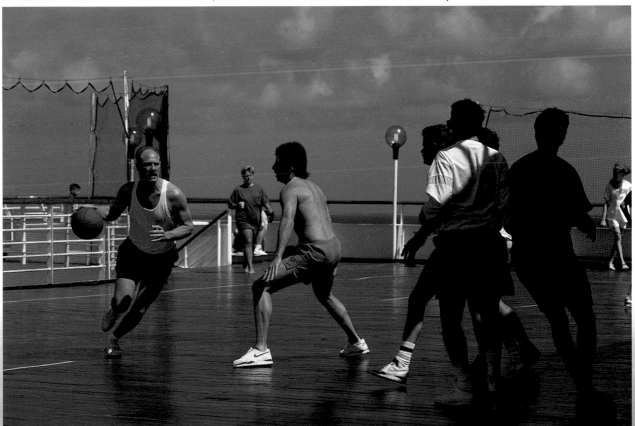

Directing Relaxed Poses

When people are tense, they rarely make good portrait subjects. Mood, environment and the behaviour of the photographer can all affect the way they interact with the camera. The photographer should do all he can to put his subjects at ease. The more relaxed they are, the more natural they are likely to appear in the finished image. The important thing is to make them feel part of a collaborative process.

Seeing

Michael Busselle saw these two charming old ladies as he walked past their house in a village in Alsace, and could not resist the appeal of their relaxed attitude as they rested after sweeping the attractive old courtyard. The hazy morning sunlight he encountered had created a pleasantly atmospheric quality.

Thinking

Since he had already asked their permission for a photograph, his first thought was to approach them closely, shooting them as a straightforward double portrait. On reflection, however, he felt the most pleasing way of photographing them was to include more of the setting in which they were seated. Although sunlit, the light was soft and the shadow it cast was attractive, ensuring that the contrast between the shaded ladies and the highlight on the distant wall wasn't too great.

Acting

Busselle decided to use a wide-angle lens so that he could move in close without the ladies appearing too large in the frame, while at the same time, including a reasonably large expanse of the building behind them. He framed the shot so that the women occupied the bottom quarter of the frame and the edge of the shadow led away diagonally to the sunlit wall.

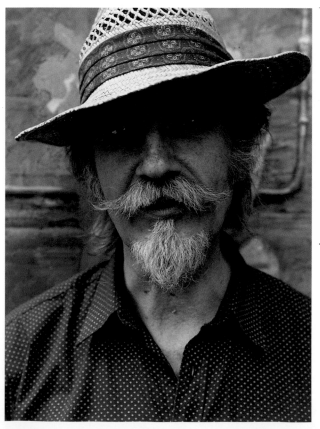

Technical Details
35mm SLR Camera with a 28–70mm zoom lens and Fuji Astia.

This shot of Michael Busselle's friend, the painter Bruce Pennington, was taken on a cloudy day in his shaded garden and, since the soft daylight was hitting him from directly overhead and creating shadows on his face, Busselle used a large white reflector as close as possible under his chin to bounce light back into this area. He used one of the paintings he was working on as a background which has echoed the overall bluish quality of the image.

Rule of Thumb

One way of ensuring a relaxed and natural-looking portrait is to ensure that your subject is comfortable. They need not necessarily be seated but they should be posed in a way which avoids the rigid, standing-to-attention appearance which often results when a photographer says, 'Let me take your picture' without first considering the models comfort.

Technical Details
▼ Medium Format SLR Camera with a 55–110mm zoom lens, an 81A warm-up filter and Fuji Velvia

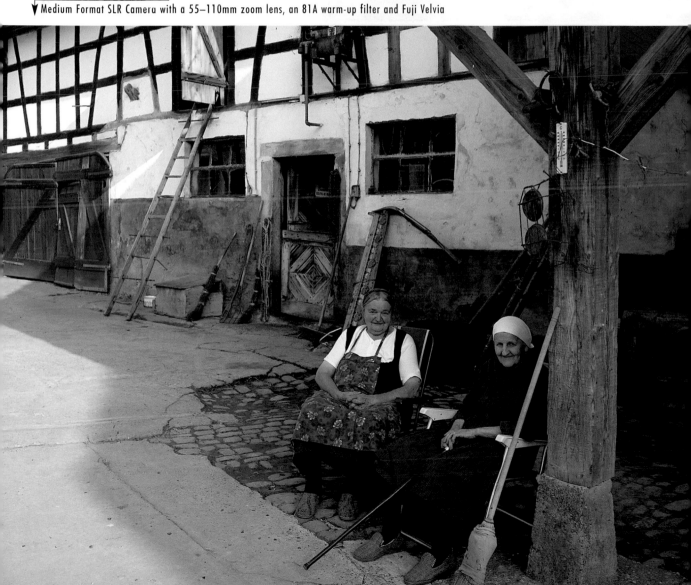

Directing Relaxed Poses

Rule of Thumb

Be very wary of approaching your model too closely when shooting close-up head shots, as this can produce an effect where the subject's features are noticeably distorted with the nose and chin appearing disproportionately large. As a general rule, around one-and-a-half metres should be considered the safest minimum distance. If you wish to obtain an image which has a tighter crop, you can use a long-focus lens.

Seeing

Taken in Sri Lanka, this portrait of a shop keeper appealed to Michael Busselle because of the contrast between the man's rich brown skin and the colour of the screen he was standing behind. Busselle also liked the shapes created by the windows.

Thinking

His first thought was to shoot this as a closer, upright image but this would have reduced the amount of blue and detracted from the overall effect Busselle was after. He also felt that the man's slightly apprehensive expression would be less disconcerting if he shot the picture as a horizontal, allowing the man's face to feature less prominently in the image.

Acting

He composed the shot to include all of the screen and both of the adjacent windows, a view which filled the frame quite nicely and also placed him just off centre.

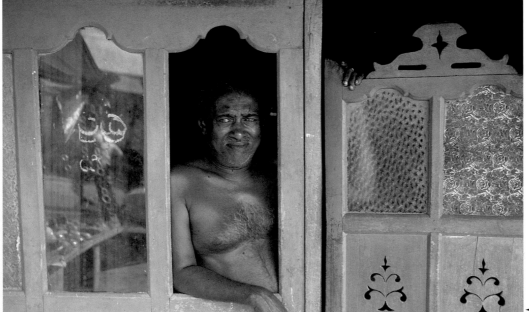

Technical Details
35mm SLR Camera with a 75–150mm zoom lens and Fuji Velvia.

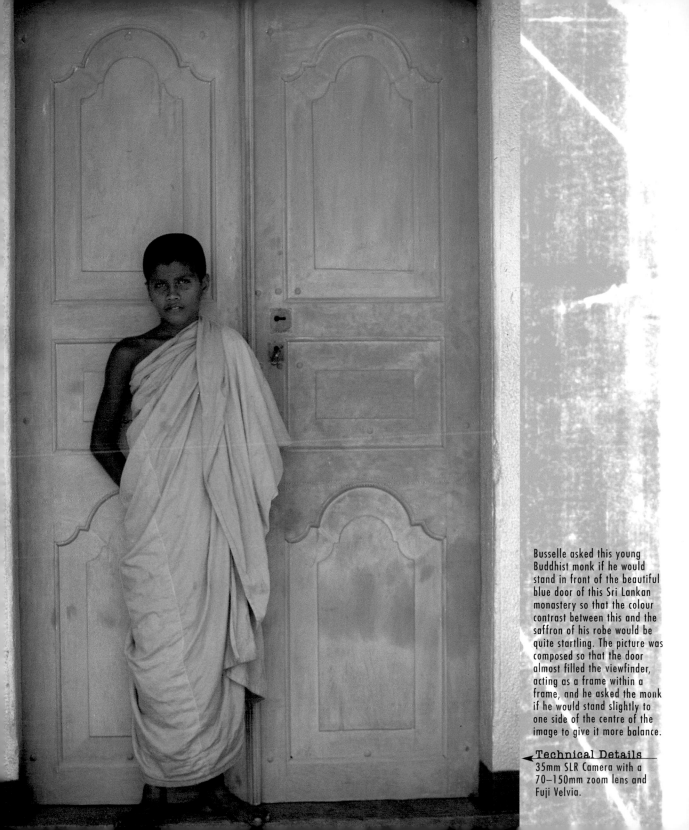

Busselle asked this young Buddhist monk if he would stand in front of the beautiful blue door of this Sri Lankan monastery so that the colour contrast between this and the saffron of his robe would be quite startling. The picture was composed so that the door almost filled the viewfinder, acting as a frame within a frame, and he asked the monk if he would stand slightly to one side of the centre of the image to give it more balance.

Technical Details
35mm SLR Camera with a 70–150mm zoom lens and Fuji Velvia.

Seeing

Michael Busselle had stumbled across this old village in Galicia, Spain, near the Portuguese border, and had spent some time shooting the old houses and almost mediaeval farm carts and implements which were scattered around. These two farmers were watching him with amusement, and Busselle thought they would make great subjects for a double portrait in a setting which was almost too good to miss.

Thinking

He wanted to find a background which was not too obtrusive but which, at the same time, conveyed something of the remarkable old village's character and atmosphere.

Hazy afternoon sunlight from one side had created a pleasing degree of modelling on this French farmer's face, and Michael Busselle framed the shot to include most of the nice old wicker basket the man was holding and some of the oak barrels on his cart.

Technical Details
▼ 35mm Medium Format Camera with a 105–210mm zoom lens and Fuji Velvia.

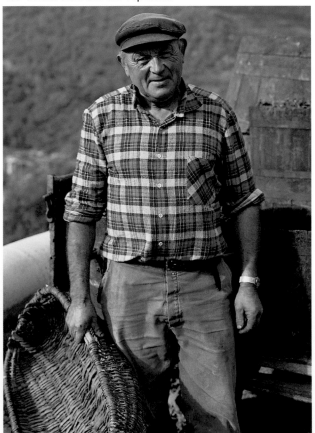

This was a very impromptu picture of a family harvesting their grapes, and Busselle had little opportunity to arrange things carefully. The soft evening sunlight wasn't too harsh, however, and since its direction was just to one side of the camera, it created only small facial shadows. To get the photograph he wanted, he needed only to quickly position them so that each face could be clearly seen against the blue sky.

Technical Details
▼ 35mm Camera with a 35–70mm zoom lens and Fuji Velvia.

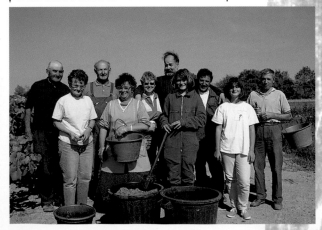

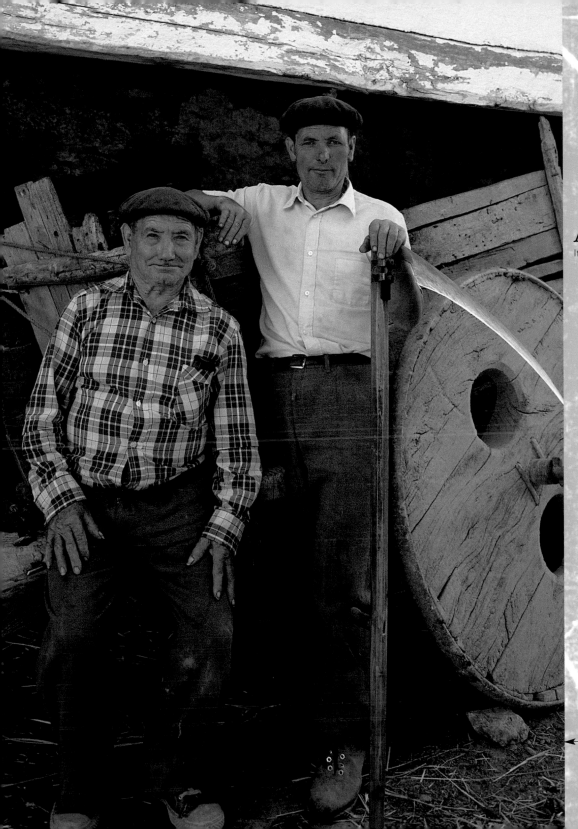

Acting

It was a bright **sunny** day and Busselle wanted to find a shaded area to create a **softer light** for his subjects. This spot seemed ideal and he asked them to move there, and once in position they adopted immediately this nice, **relaxed pose** without Busselle's involvement. He framed the shot to include part of the ancient wooden wheel.

◄ **Technical Details**
35mm SLR Camera with a 28–70mm zoom lens and Fuji Velvia.

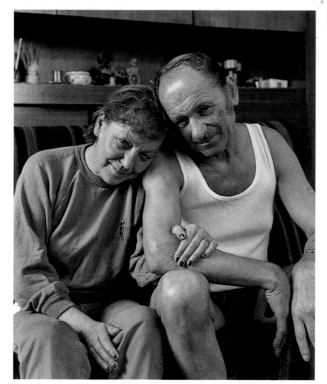

Wolfram Eder set up his camera and tripod in this couple's own living room, where they felt very much at ease. He got them talking about their younger days and the happy memories invoked a tender and intimate mood. Illumination was by available window light.

▲Technical Details
Medium format camera with an 80mm lens and Kodak Tri-X b&w film.

Seeing
Ronnie Bennett took this studio portrait immediately after an outdoors photo session. The two boys were cousins, and earlier on had been charging around outdoors. When the photographer brought them inside and sat them down on the bench, they adopted this affectionate pose without any prompting.

Thinking
Bennett saw that the positions the boys had taken up made a perfect composition, with their relaxed arms and legs forming vertical lines which flowed from top to bottom of the frame. Only minor adjustments were necessary to tidy up the pose. To keep the feel of the picture intimate, she cropped in tightly on the pair, using a 150mm lens on her medium format camera.

Acting
To light the picture, the photographer used a single small flash head with a softbox and positioned it off to the left of the camera, so that the light was thrown obliquely across the two boys. Two white reflectors, placed to the right and angled together to form a V-shape, threw light back from that side of the frame.

Technical Details

▼ Medium format camera with a 150mm lens and Fuji Neopan 400 b&w film.

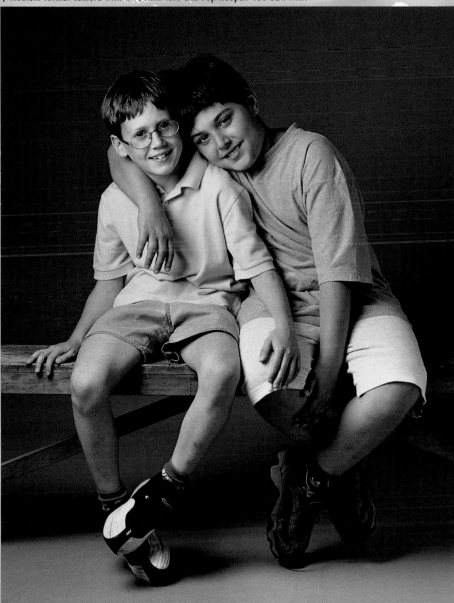

The flowing lines formed by the arms and legs of the boys created a tight composition in Ronnie Bennett's intimate portrail. Many subjects, especially children, are less comfortable in front of the camera and adopt stiff, awkward poses, like those in the illustration.

Directing Relaxed Poses

Technical Details
▼ 5x4in large format camera with a 135mm lens and Kodak Tmax b&w 400 film.

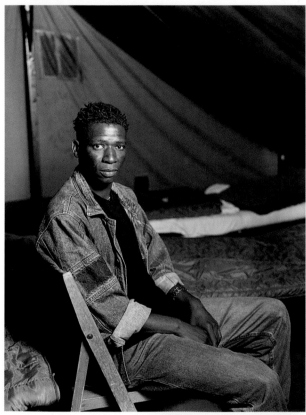

Seeing

Ton Hendriks wanted to portray the plight of illegal refugees in Holland, and visited a camp where refugees were living in tents. He asked this man, who came from Mali, if he would demonstrate his spartan living conditions. It was one of a series of portraits he took of different people on the same day.

Thinking

Hendriks used a moderately wide angle lens. He positioned the chair in the left foreground, but framed so that a large part of the background, including the roof of the tent and the camp beds, was also visible. As it was a documentary-style portrait, he wanted the subject to tell his own story. The way the man sat and the way he looked at the camera were largely natural.

Acting

It was very dark in the tent so Hendriks lit the shot with a portable flash unit on a tripod, placed to the right of the camera and fired into a white umbrella so that the light was bounced back on to the subject's face. It also provided just enough illumination to light the background. When he developed the film, the negative turned out unevenly, with the edges of the frame badly underdeveloped. To compensate, he dodged in those sections heavily at the printing stage.

Ton Hendriks wanted the subject to tell his own story and so allowed him to adopt his own, natural pose. Illumination came from a flash unit mounted on a tripod and fired into a white umbrella so that the light was thrown back on to the subject's face.

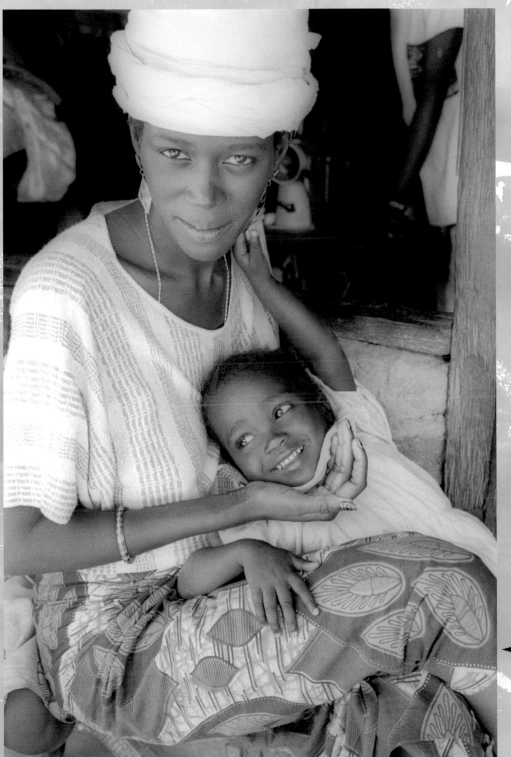

Alain Paris photographed this mother and child in a village in Senegal, a country he has visited many times. He always makes a point of building up a rapport with his models, many of whom he has photographed over a period of years. This means they are at ease with the camera and more likely to adopt poses that are relaxed and spontaneous. For this shot Paris used a moderate wide angle lens, with illumination provided by natural outdoors daylight.

◄ **Technical Details**
35mm SLR camera with a 35mm lens and Kodak Tmax 400 b&w film.

Directing Relaxed Poses

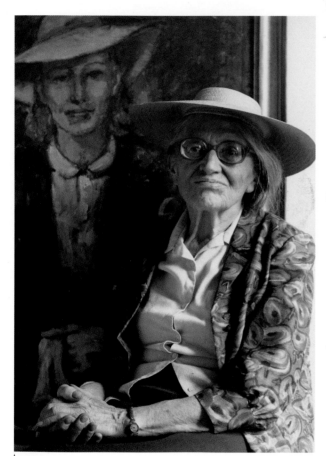

Seeing

This portrait was part of a project Wolfram Eder undertook to photograph the inhabitants of a small German town. In each case he looked for a corner of the person's home or workplace that epitomised the way they lived their lives and said something about their character. Hanging on a wall in the old lady's house was a portrait of herself as a young woman, and he felt this would make the perfect background.

Thinking

She was a vivacious lady who still dressed flamboyantly, and so was happy to pose for the camera. The photographer wanted to contrast the idea of past and present, but he also wanted to stress the continuity of the old lady's life. So he asked her to wear a hat similar to the one she had worn for the portrait many years before, and sat her directly in front of the painting. To create the right mood, he asked her to tell him about her younger days.

Acting

The lighting was natural daylight, falling on to the subject from a window just out of shot. With the camera firmly fixed on a tripod, Eder framed the image tightly to cut out extraneous detail. He used an 80mm lens, which with a 6x6cm medium format camera is a 'standard' lens. He composed so that the subject's arm formed a natural frame to the bottom right-hand corner of the image.

Technical Details
Medium format camera with an 80mm lens and Kodak Tri-X b&w film.

To portray the head of a medical clinic, Wolfram Eder chose the doctor's office as the location for the picture. The subject felt comfortable behind his own desk, where he was used to making decisions and dispensing advice. People having their picture taken often don't know what to do with their hands, so the photographer made sure that the doctor had his hands occupied, with a small cigar held in the left and a pen in the right. The result suggests a busy individual caught at a relaxed moment.

The Candid Camera

Once people see you with a camera, you run the risk of them becoming stilted and self-conscious, but you can avoid this problem, and produce pictures that are completely spontaneous, by taking pictures of people when they are unaware of you. You do need to take some care, however, since such pictures can easily become muddled and confusing if you do not give enough thought to the composition of the image and the choice of viewpoint and background.

Seeing

Michael Busselle was wandering around the weekly market in Colmar, France, when he saw this farmer waiting in his car at the edge of the square. The incongruous juxtapostion of the eggs on the car roof with his head below, framed by the window, appealed to him enormously.

Thinking

He felt the greatest impact would be created by framing the image quite tightly and, as the man looked fairly settled, Busselle had time to change to a long-focus lens and choose a viewpoint which showed his profile and placed the car in front of an unobtrusive area of background.

Acting

He framed the shot so that the eggs were almost at the top of the frame, while just enough of the car door was included to complete the frame effect, while excluding some distracting background details behind the car's windscreen.

Technical Details
▼ 35mm Rangefinder Camera with a 45mm lens, an 81B warm-up filter and Kodak Ektachrome SW.

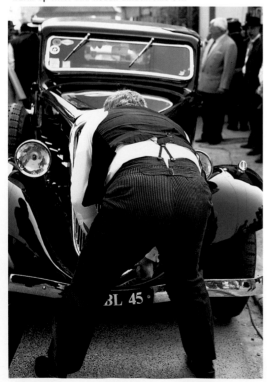

This was one of those fleeting opportunities, at a village festival in the Loire, when Michael Busselle found himself with very little time to change lenses or make decisions. His camera was fitted with a standard lens at the time so, when the man bent over to crank his car, he simply moved very quickly into a position where he and his vehicle filled the frame and shot almost immediately.

Rule of Thumb

In situations like these, when you want people to be to be unaware that they are being photographed, it's best to keep a low profile as far as equipment is concerned. Don't carry a large and ostentatious camera bag or have your camera boldly displayed around your neck. Carry your camera partly hidden and have a spare lens or two and some extra film in your pockets.

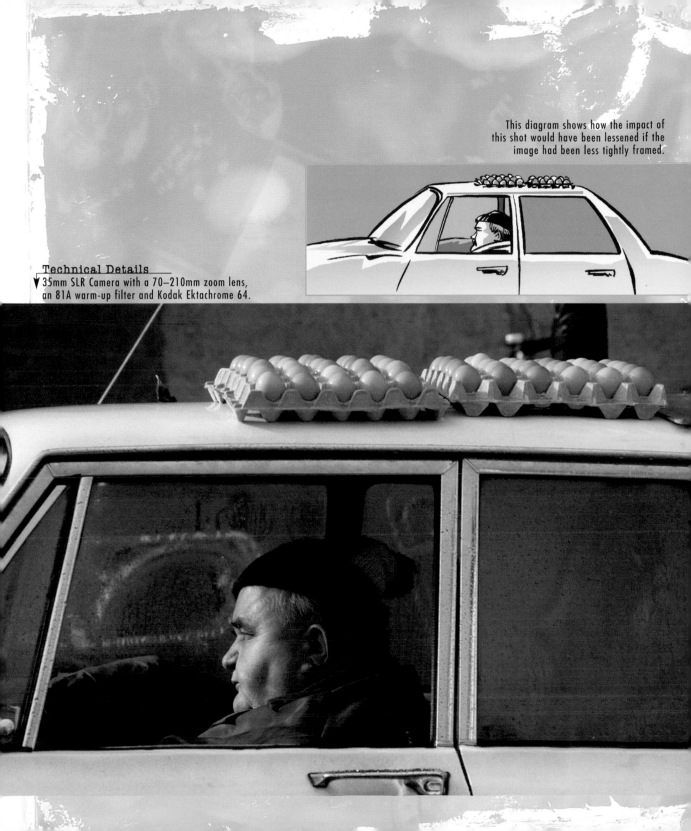

This diagram shows how the impact of this shot would have been lessened if the image had been less tightly framed.

Technical Details
35mm SLR Camera with a 70–210mm zoom lens, an 81A warm-up filter and Kodak Ektachrome 64.

Seeing

Michael Busselle spotted this man in a street market in Bali, and was attracted by his stance and by the limited colour range featured in the scene.

Thinking

He wanted to shoot the man while he was unaware of the camera but he had been watching Busselle approach. Without looking too much in the man's direction, he moved to a good viewpoint just in front of him and then began aiming his camera at someone on the other side of the street.

Acting

The man soon lost interest in Busselle and began a conversation with his neighbour. At this moment Busselle quickly swung the camera around, framing the image so that the man was more or less in the centre where he was framed by the blue-green door and barrel.

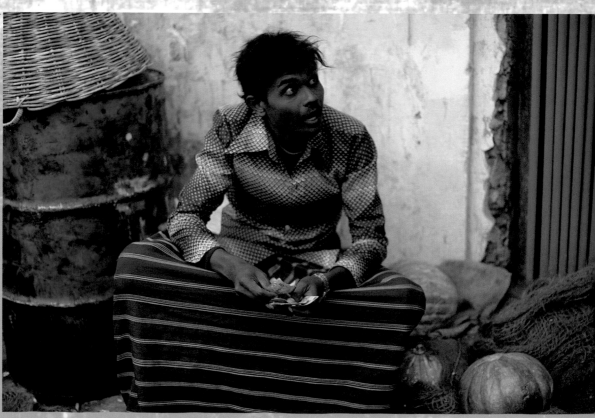

Technical Details
35mm SLR Camera with a 35–70mm zoom lens, an 81A warm-up filter and Fuji Provia.

Rule of Thumb

When you are shooting pictures in an alien environment you are bound to be the focus of attention for a while. It's best to spend some time just wandering around, not taking photographs and keeping your camera out of sight, until people become used to your presence and lose interest in you.

Michael Busselle spotted this shopkeeper, framed in his doorway in the souk of Marrakech, and was attracted by the brightly coloured pile of oranges beside him and the way the shaft of sunlight illuminated his profile, creating a strong diagonal line. He framed the shot quite tightly so that these elements were accentuated, and at the same time he was able to exclude some distracting details on the left of the scene.

Technical Details
▼ 35mm SLR Camera with a 80–200mm zoom lens, an 81A warm-up filter and Kodak Ektachrome 100 SW.

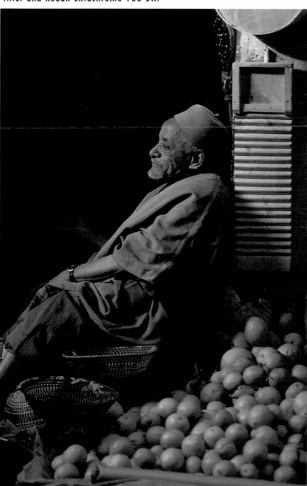

Busselle was interested in the way this young lady, seen in a street market in Bali, was preparing the food wrapped in palm leaves. Although she was aware of his presence, she was too engrossed in her work to take too much notice, and this allowed him to shoot a few frames without attracting her attention.

Technical Details
▼ 35mm SLR Camera with a 35–70mm zoom lens, an 81A warm-up filter and Fuji Provia.

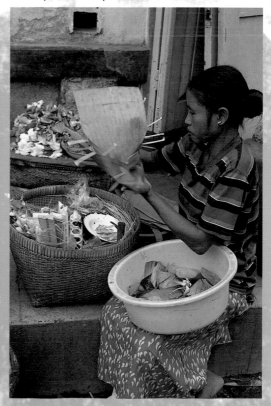

The Candid Camera

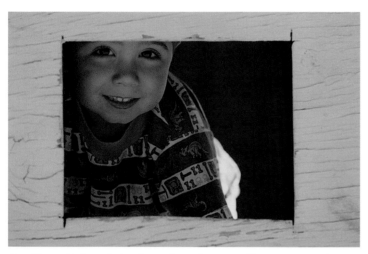

Terry Way used a long telephoto lens to frame this picture of his young son peeking through the window of a home-made playhouse. The window provided a neat frame within the frame, and the photographer waited patiently until the youngster positioned himself off-centre. He fired the shutter at exactly the right moment to capture the boy's cheeky grin.

▲ Technical Details
35mm SLR camera with a 200mm lens and Kodak TCN 400 chromogenic film.

Seeing
Philip Sprague was walking round an outdoor market when he came across this little girl accompanied by her mother and older brother. He immediately saw the potential of her large eyes and asked her mother for permission to take a couple of shots. The little girl was quite nervous because of all the people, as well as the camera, and clung to her brother's hand for reassurance.

Thinking
There were market stalls all around, providing colour as well as a lot of clutter, but Sprague wanted to keep the image simple. He realised the boy's dark clothing would make a good, plain background and that a tight composition would emphasise the little girl's eyes. He also realised he would have to work quickly or the moment would be lost.

Acting
He cropped in tightly with a 28–85mm zoom lens to isolate the girl's face from the distracting background. Throughout the very brief session he kept talking to her to get her used to the idea of having her photograph taken. The lighting was overcast afternoon daylight, which helped soften the tones and prevented any harsh shadows.

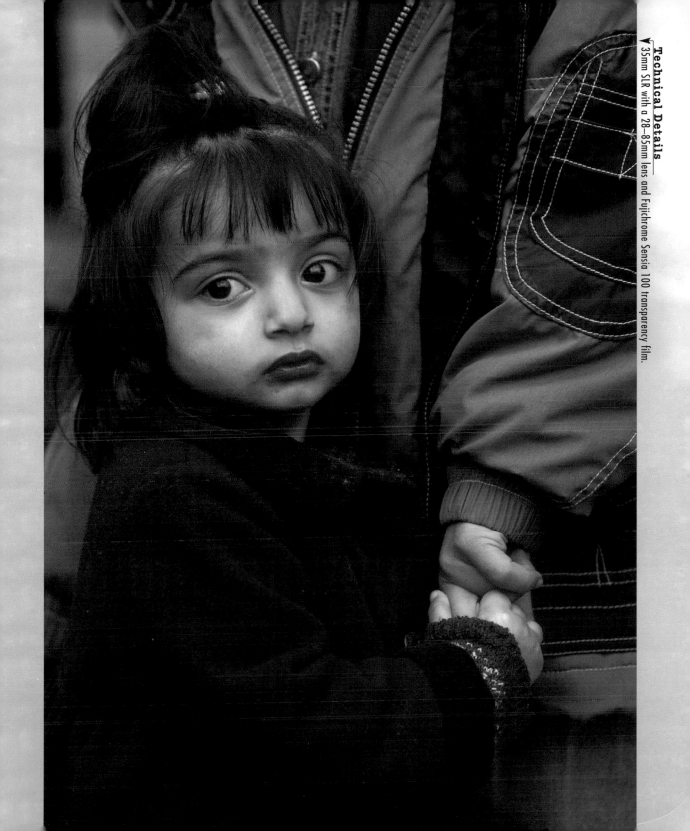

Technical Details
35mm SLR with a 28–85mm lens and Fujichrome Sensia 100 transparency film.

The Candid Camera

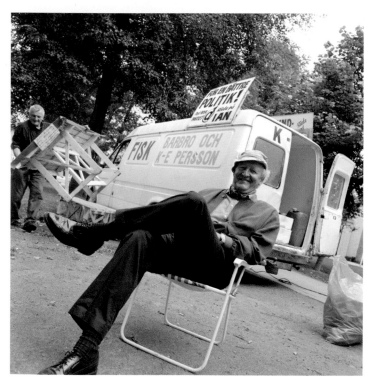

Rune Andersson was commissioned to follow the election campaign of a well-known Swedish politician. He caught the man in an unguarded moment as he and his supporters were setting up their stall at a new campaign venue. The photographer shot from a low viewpoint with a wide angle lens, and tilted the camera at a slight angle to create a dynamic composition with strong diagonal lines.

▲ Technical Details
Medium format camera with a 50mm lens and Kodak Tmax 100 b&w film.

Seeing

Terry Way was shooting a wedding when these two characters got up to play at the reception. It was a family tradition – they'd been playing at family weddings for decades and obviously loved performing. He wanted to capture the exuberance and spontaneity of their music making.

Thinking

To create something a little different from the standard wedding snap, Way fitted a 17mm wide angle lens on his SLR camera. The lens gave a very wide field of view, producing a feeling of immediacy when used up close to the subject, as if the viewer was in the thick of the action. It also offered extensive depth of field, meaning that much of the subject was sharp.

Acting

Although the photographer was up close to the musicians they weren't bothered by his presence – they were too engrossed in their own performance and the general party atmosphere. This left him free to snap away, capturing the actions of the two men and the changing expressions on their faces. This image caught the interaction between the two perfectly, capturing a moment when they appeared to be sharing a joke.

Rule of Thumb

Wide angle lenses are useful for bold candids taken at close quarters, while telephotos allow the photographer to stay discreetly at a distance. However, the candid photographer wants to be as unobtrusive as possible so a zoom, which can be quite small and still cover plenty of options, is a good general-purpose choice. A compact camera is another useful tool. You can't always carry your full camera kit around with you, but you can easily slip a small compact into a bag or a pocket.

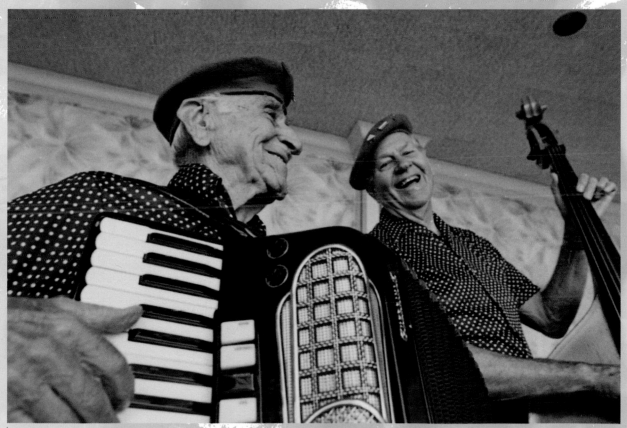

▲ Technical Details
35mm SLR camera with a 17mm lens and Kodak TCN 400 chromogenic film.

People at Work & Play

Taking photographs of people when they are occupied in some way has a number of advantages. Perhaps most importantly, it helps your subject to overcome the inhibited and self-conscious attitude which can often be adopted when a camera appears. Another major plus point to be gained from your subject actually doing something is that it will invariably add enormously to the interest and composition of an image, as well as help to reveal more about the person's character and interests.

Seeing

Michael Busselle saw this man tending his garden as he drove through a country lane near Ancenis in the Loire Valley, France. He was struck by the pleasing colour quality created by his blue work clothes and the rich green of his vegetable patch.

Thinking

He was working in a partially-shaded area and Busselle noticed that this created both a pleasing light on the man's face and also made his blue overalls stand out quite boldly from the more brightly lit background.

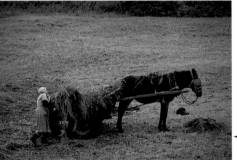

Michael Busselle saw this lady making hay as he drove along a country lane near Santillana de Mar in Cantabria, and he liked the bold shapes the scene created. It was an overcast day and the lighting was soft, but the image has enough contrast because the darker tones of the lady and her mule and cart stand out against the light tones of the meadow.

◄ Technical Details
35mm Camera with a 75–300mm zoom lens, an 81B warm-up filter and Fuji Velvia.

Rule of Thumb

When any degree of subject movement is involved, it is necessary to use a shutter speed which is fast enough to freeze it. Even just normal hand movements can create a disturbing degree of blur if a slower shutter speed is used, and this will be accentuated when subjects are close to the camera. As a general rule, you should try to shoot at speeds of 1/125 sec or faster when photographing people.

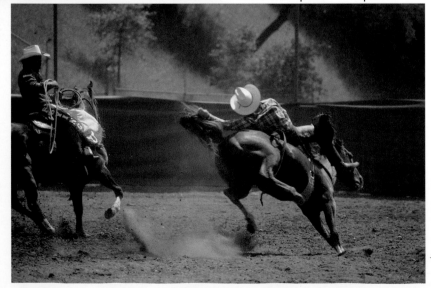

Busselle used a long-focus lens to obtain a good-sized image of this rodeo rider in California from a viewpoint some distance away, and used the fastest practical shutter speed to freeze the movement.

◄ Technical Details
35mm SLR Camera with a 300mm lens, an 81A warm-up filter and Kodak High Speed Ektachrome.

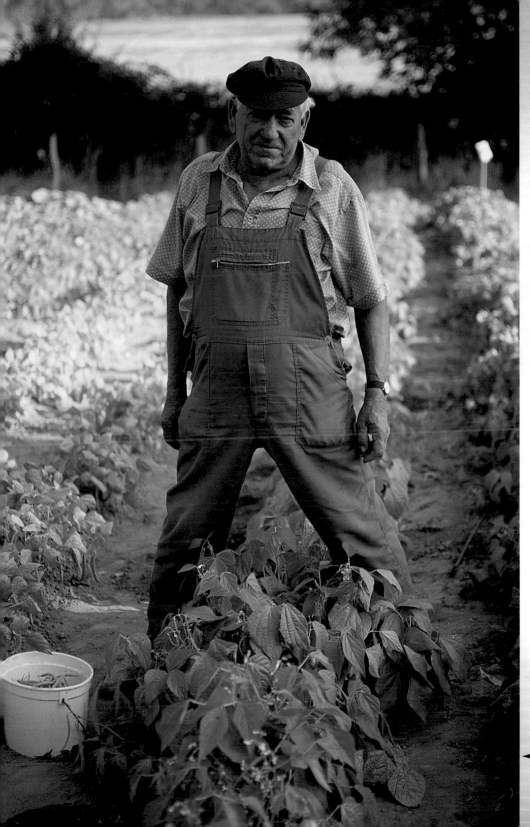

Acting

He was already standing in this position when Busselle interrupted him and he thought it made a **interesting shape**. Busselle chose a viewpoint which enabled him to shoot along the row of vegetables to make the most of his pose. Looking from his position, the man's head was set partly against the light tone of the distant meadow which has helped to give it more **prominence**.

◄**Technical Details**
35mm SLR Camera with a 35–70mm zoom lens, an 81A warm-up filter and Fuji Velvia.

Seeing

Michael Busselle saw this man setting up his easel in the **very early** morning while he was shooting pictures in Brussel's Grand Place, a location he knew would, **within a few hours**, be teeming with tourists.

Thinking

Busselle felt that he would not only make a very **interesting subject** for a picture, but would also add a very useful **element of scale** and composition to the pictures of the square.

Acting

He chose this **viewpoint** as, although it was a back view of the man, it showed clearly what he was doing and conveyed something of his **character** as well as allowing Busselle to use one of the square's medieval buildings as a background. He framed the shot in a way which placed his painting at the **intersection of thirds**, and this allowed him to include most of the building as well as his dog, which Busselle thought added a nice touch.

Technique

When photographing people in **action** there are usually periods where their movements are **slowed momentarily** and, by choosing these times to make your exposures, you can usually obtain a **sharp image** even when using slower shutter speeds.

Technical Details

▼ 35mm SLR Camera with a 75–300mm zoom lens, an 81B warm-up filter and Fuji Provia.

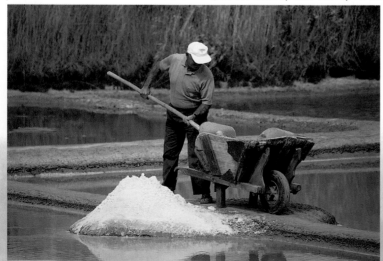

Michael Busselle found this man harvesting salt near Guerande in the Western Loire, and looked for a viewpoint which would enable him to place an area of golden reeds behind him to create an effective background. Busselle used a long-focus lens to frame the image so that the main focus of interest became the man with his pile of salt.

Technical Details
▼ 35mm SLR Camera with a 35–70mm zoom lens, an 81A warm-up filter and Fuji Provia.

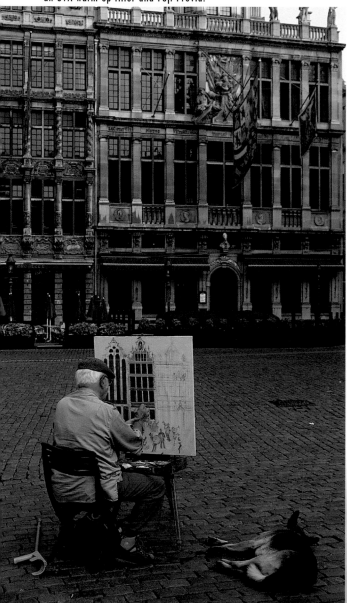

For Busselle, the appeal of this shot, taken at a goose farm in Gascony, depends upon the overall colour quality created by the almost purple shade of blue to be found in the woman's dress and apron, the soft light and the grey, shadowed background of the geese and their pen. For this reason, he decided to frame the image quite tightly to emphasise these qualities and placed the brightest part of the image, her straw hat, almost on the intersection of thirds.

Technical Details
▼ 35mm SLR Camera with a 35–70mm zoom lens, an 81A warm-up filter and Fuji Provia.

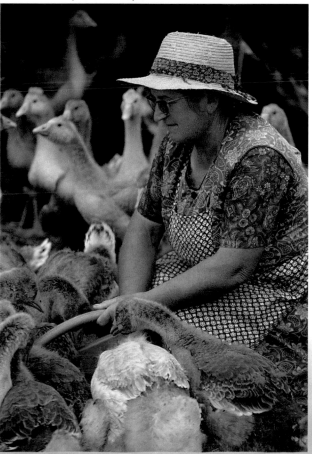

Shooting a Picture Story

Most photographs are taken as individual images, intended to stand alone and make a single statement. But it can be very satisfying to set out to take a series of photographs of a particular subject, or on a specific theme, in which each individual image is part of an overall story, almost like the tiles in a mosaic. In this way it is possible to adopt a more abstract approach and to focus on small details which, on their own perhaps, would not be very informative.

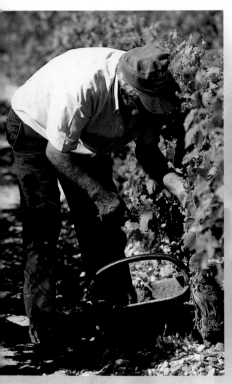

These pictures were taken in Pauillac in the Medoc, during the harvest in what is one of the world's most prestigious vineyards. Michael Busselle wanted to try to capture the mood of the occasion and the feeling of camaraderie which exists among the pickers, together with the sense of purpose which dominates the process.

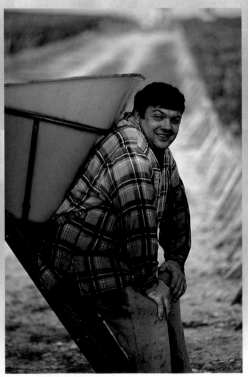

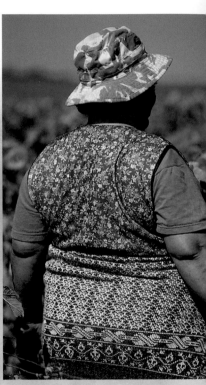

Technical Details
35mm SLR Camera with lenses ranging from 17mm to 200mm and Kodak Ektachrome 100 SW.

Rule of Thumb

When planning such a project, it helps to think in terms of a magazine feature, visualising how your images would work together on a spread and trying to ensure that each picture complements or enhances those alongside. Try to vary the colour quality of the individual pictures and use close ups, long shots, telephoto and wide-angle images to create a sense of pace and momentum in your narrative.

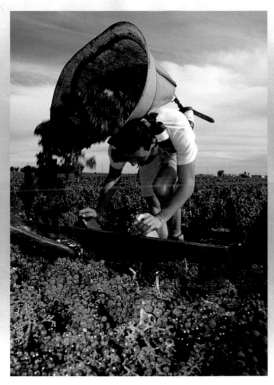

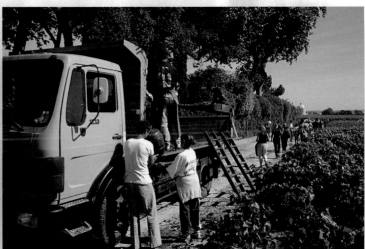

In the lesser wine regions grape harvesting is a largely mechanical process but here, where the truly great red wines are made, it's very much a hands-on business, a personalised activity where everyone involved has a sense of pride in the product.

Holiday Photographs

More pictures tend to be taken when families are on holiday than on any other occasion. But these are often extremely disappointing and uninteresting, of passing interest only to those who were there, and often very boring to those who weren't. The reason is simple. For most people holidays mean rest and relaxation, but if you want to take a good set of pictures it does require a little effort. It's time well spent, however, if at the end of the day you produce a set of pictures which provide a lasting and genuinely interesting record of a happy occasion.

Seeing

Michael Busselle saw this opportunity while shooting pictures on a cruise ship in the Caribbean. They were strangers, but even if they'd been his own family, it's the type of shot which he would always find more interesting and atmospheric than a picture of them sitting up and grinning at the camera.

Thinking

Busselle liked the shapes and patterns created by the prone bodies which seemed to capture the mood of sunbathing and relaxation. He also liked the single splash of magenta which created a bold point of interest in the otherwise bluish scene.

Acting

He took up a viewpoint some distance away and shot with a longer lens to compress the perspective. By framing tightly to make the picture very compact, he was able to emphasise the colours of the tanned bodies and the swimming costumes.

Technical Details

▼ 35mm SLR Camera with a 75–300mm zoom lens, an 81A warm-up filter and Fuji Velvia.

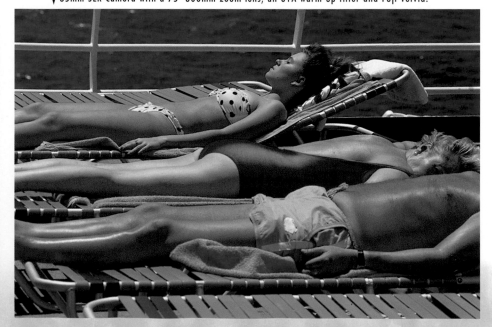

Technical Details
35mm SLR Camera 35mm lens, Kodak Ektachrome 64.

Busselle had to react quickly to capture this picture of his young son, Julien, striding along a beach in the Algarve wearing his little white sunhat.
He used a wide-angle lens to include the distant sea, and he shot looking down from eye level to emphasise the smallness of the child and the vastness of the beach.

Seeing

The River Gambia was the setting for this shot, and Michael Busselle wanted to take a portrait of the skipper of the small yacht he was travelling on. The calm, still water made a good setting, and the late afternoon sunlight had a very pleasing quality.

Thinking

He wanted the background to be as uncluttered as possible, so he asked the skipper to sit in the prow of the boat so that he could make the most of the river bank, the water and the sky.

Acting

Busselle used a wide-angle lens since his choice of viewpoint was quite restricted and he did not want his subject to appear too large in the frame. He also wanted to include as much of the setting as he could.

Technique

Many holiday photographs are disappointing because there is often an attempt to combine recognisable portraits of people with pictures of a scene, the classic snap of someone standing awkwardly in front of a famous landmark. These are usually neither fish nor fowl, and it's generally far better to concentrate on one element or the other.

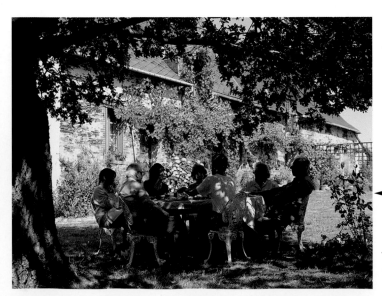

This picture was taken at a farmhouse in the Loire, and was an attempt to capture the atmosphere of a very relaxed alfresco lunch in the shade of a nice old tree on a beautiful hot, sunny day. Michael Busselle took a reading from the lighter tones of the background, then one from the shaded figures, and set his exposure between them.

◄ **Technical Details**
Medium Format SLR Camera with a 55–110mm zoom lens with an 81B warm-up filter and Fuji Provia.

Technical Details ►
35mm SLR Camera with a 20–35mm zoom lens with 81B warm-up and polarising filters and Fuji Velvia.

This shot was taken during a safari holiday in the Masai Mara, Kenya, and Busselle wanted to try and capture the atmosphere and experience of staying in this camp under these magnificent Acacia trees. For this reason he used a wide-angle lens and took up a viewpoint some distance away in order to make the setting the dominant element, with his companions there mainly to provide a sense of scale.

Technical Details →

35mm SLR Camera with a 20–35mm zoom lens with 81C warm-up and polarising filters and Fuji Velvia.

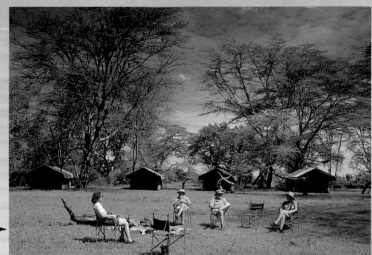

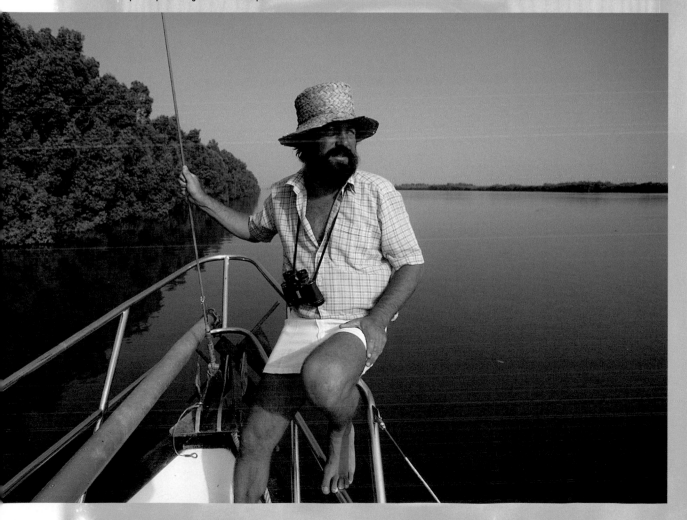

Photographing Children

There's an old saying among actors, which maintains you should never work with children or animals. This is simply because they can so easily steal the scene. Children especially make wonderful subjects for the camera, and the very young invariably have the same sort of heart-melting appeal you generally associate with kittens and puppies. Unlike most adults, there's the bonus that children are still likely to be uninhibited and spontaneous, but photographing them does require time and patience.

Seeing

Michael Busselle saw this young boy playing with his pet duckling in the doorway of his home as he drove through a small village in Andalucia, and felt that he had to see if he could photograph him.

Thinking

He thought that his best approach was to ask his mother if he could take a portrait of the boy, rather than attempt a more casual and spontaneous picture.

Acting

Once he had the go-ahead he asked the boy to move into the shade, and he positioned him so there was an area of plain wall behind to provide an uncluttered background. As the boy held the duckling out in front of him, Busselle was able to take a tightly-framed shot.

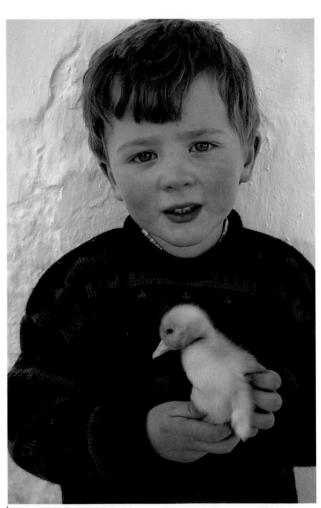

Rule of Thumb

When photographing children it's generally best to keep the image quite simple. Use soft lighting, plain uncluttered backgrounds and tightly-framed images to emphasise their expressions.

▲ Technical Details

35mm SLR Camera with a 35–70mm zoom lens with an 81A warm-up filter and Fuji Provia.

Michael Busselle photographed this little Moroccan girl in the shade of a wall which also provided a good background. She was very shy but he managed to take a few pictures while she was distracted by one of Busselle's companions.

Technical Details

35mm SLR Camera with a 80–200mm zoom lens with Kodak Ektachrome 100 SW.

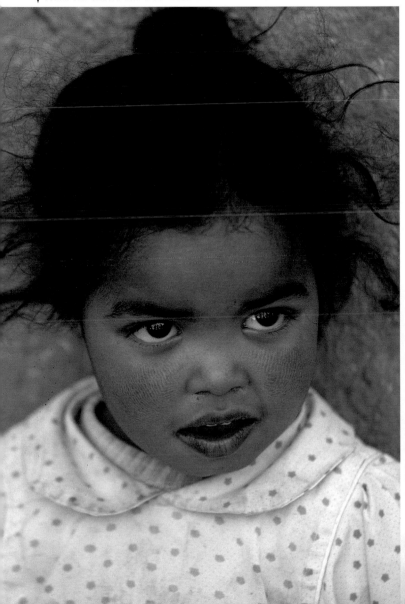

This little baby, seen in a village in the Gambia, was irresistible, sitting on her mother's lap in the shade of a small, mud-walled house. The soft lighting was ideal, and Busselle framed the image tightly to emphasise her expression and to exclude distracting details around her. He set his exposure at one stop less than the reading to compensate for her dark skin.

Technical Details

35mm SLR Camera with a 75–300mm zoom lens and an 81A warm-up with Fuji Velvia.

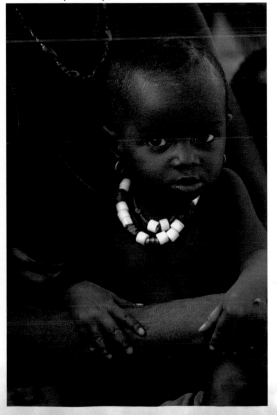

Rule of Thumb

When photographing small children it's often best to come down to their level. The normal eye-level viewpoint of an adult often creates an unattractive perspective, while it's also more difficult to show children's faces and expressions from a high viewpoint.

This spontaneous shot was taken during playtime at a primary school. Michael Busselle used a long-focus lens to enable him to isolate one or two children from the crowd without him having to approach too closely to them, and then he set a fast shutter speed to ensure that all their movement was frozen.

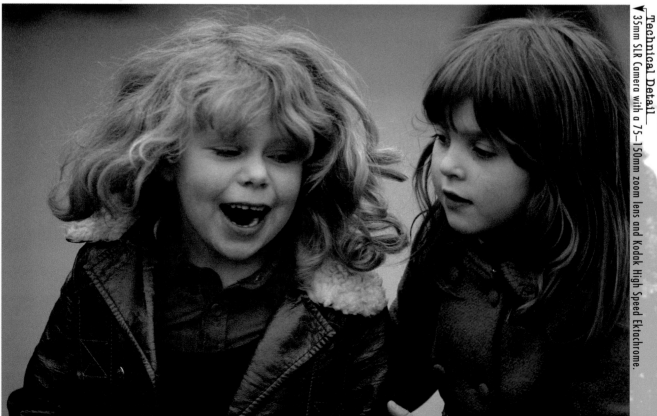

Technical Detail
35mm SLR Camera with a 75–150mm zoom lens and Kodak High Speed Ektachrome.

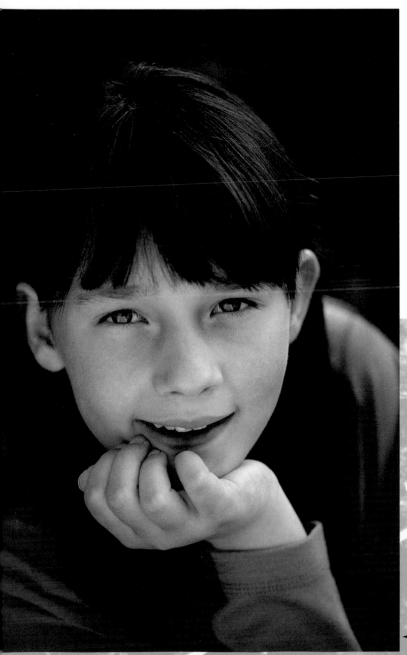

Seeing

Busselle took this portrait in his garden on a sunny day. The light was quite harsh and the background of sunlit foliage was very distracting.

Thinking

He thought that his best approach would be to shoot into the light and to use a reflector and an artificial background in order to create a more pleasing quality.

Acting

He asked his young model to sit with her back to the light and then draped a piece of curtain fabric some distance behind her. Busselle then placed a large piece of white polystyrene as close as possible to her to bounce light back into the shadows.

This diagram shows the lighting set-up for this shot.

Technical Detail
35mm SLR Camera, 75–300mm zoom lens and Fuji Provia.

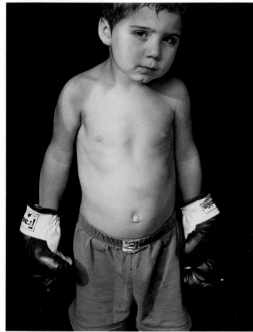

The boxing gloves came from a flea market – Terry Way bought them with the idea of using them as a prop in a photograph. His young son Colton liked wearing them and so he had plenty of opportunity to play around with the idea. This shot was taken towards the end of a sunny day, in a back-room studio in the family house. The late afternoon sunlight reflecting off the walls created quite a high degree of contrast, and Way framed the image tightly with an 85mm lens. The bright red gloves contrasted well with the boy's blue shorts, but his laconic expression really made the picture.

Technical Details ▲

35mm SLR camera with an 85mm lens and Fujichrome Velvia transparency film.

Seeing

Ronnie Bennett loved the way the little boy was dressed, in denim and dungarees. The clothes were neutral in tone and so didn't distract attention from his face and their textures provided a nice contrast with the wicker chair she kept in her studio. Bennett photographs a lot of children and finds that feet are particularly expressive, so she asked this youngster to take off his shoes and socks to have his picture taken.

Thinking

Photographer and subject had already had a boisterous outdoor session together and built up a fair degree of empathy. Now the photographer wanted to capture him at a quieter moment. She sat him down on the chair and demonstrated the pose she wanted him to adopt. He was fascinated by the studio, and this solemn expression was the response.

Acting

Bennett framed the image tightly with a 150mm telephoto lens. She lit the boy with a flashgun and softbox placed to the left of the camera and two white reflectors arranged in a V-shape to the right. The flash created catchlights in the boy's eyes while the reflectors filled in the shadow areas on his left-hand side to give a soft and even overall effect.

Rule of Thumb

When photographing people, pay close attention to the clothes they are wearing. If you're using black-and-white film, neutral, mid-tone clothes are the best choice. They are less likely to distract attention from the subject's features than outfits in which there are bold patterns or strongly contrasting tones. When you're shooting in colour, you can be more adventurous, using colours that complement or contrast with one another.

Technical Details
Medium format camera with a 150mm lens and Fuji Neopan 400 film.

Family Portraits

The family is an ideal subject for portraiture. Family portraits are treasured by relatives and passed on down the generations. As subjects, family members are usually happy to co-operate in having their picture taken and offer the added benefit of always being around. Everyone photographs their children, but there's no need to neglect the rest of the family. Grandparents, for instance, can make equally interesting subjects.

Technical Details
Medium format camera with a 150mm lens and Kodak ▼
Tmax b&w film rated at ISO 320.

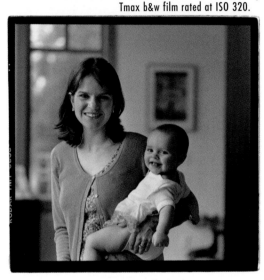

Paul Sanders caught happy, spontaneous expressions on the faces of both mother and daughter in this intimate family portrait. It was taken in the family home with available window light, which gave soft, even illumination, free of harsh shadows. The photographer included the window and the picture on the back wall to give background interest, but used a medium telephoto lens and a large aperture to throw them out of focus.

Seeing

Before they came into the studio, Ronnie Bennett had already shot several rolls of film of this pair and their older brother outdoors. Both brother and sister liked dancing, and they had brought along their ballet clothes to change into for the studio session. The photographer wanted a 'quiet' picture of the pair together, which reflected their interest in dance.

Thinking

The outdoors picture session had relaxed the two children, and they were perfectly at ease in the studio. Bennett wanted a close-up picture. She posed the two children on a chair, with the girl sitting on her brother's lap, and asked them to look away from the camera. They adopted the serious expressions naturally – the girl alert, the boy more dreamy and thoughtful.

Acting

Bennett framed tightly with a 150mm lens, which in medium format is a moderate telephoto. She used her standard studio lighting set-up, of a softbox on one side of the subjects and a reflector on the other to fill in the shadows, together with a plain grey studio background. When printing the image, she burned in the area on the left to create more contrast.

Rule of Thumb

With children, it's a good idea to prepare as much as you can beforehand. Set up your props and lighting the way you want them, and visualise how you want to frame the picture. That way, when your young subject is actually in place you'll spend less time setting up the image, which means less time for them to get bored or distracted.

Technical Details
Medium format camera with a 150mm lens and Kodak Tri-X b&w film.

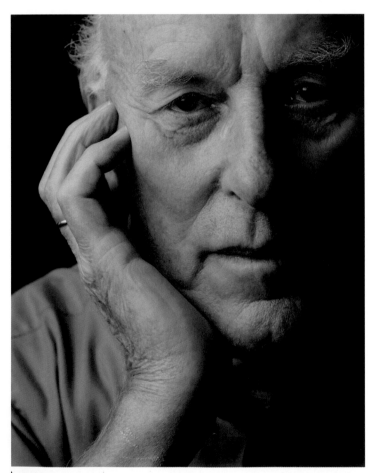

Seeing

Ton Hendriks approached this portrait of his 80-year-old father with psychological intent. His idea was to get under the skin of an older person in order to suggest what they might be thinking. To do this he decided on an **extreme close-up**, with a tight crop and the finest rendering of his father's skin he could achieve, focusing **attention** on every tiny **detail** of his face.

Thinking

His parents' living room served as the location. Hendriks sat his father on a chair at the dining table, which gave him a surface to rest his arm on. To create a **simple background** that would not distract attention from the subject, he hung a plain black cloth on the wall behind him.

Acting

To light the subject, the photographer placed a single **softbox** to the left of the camera, which illuminated one side of his father's face in fine detail but left the other partly **in shadow**. He framed tightly, using a telephoto lens. His 5x4in camera was fitted with bellows, which he extended to their maximum setting. This magnified the image and enabled him to focus closely.

▲ Technical Details

5x4in large format camera with a 210mm lens and Fujicolor NPS 160 colour negative film

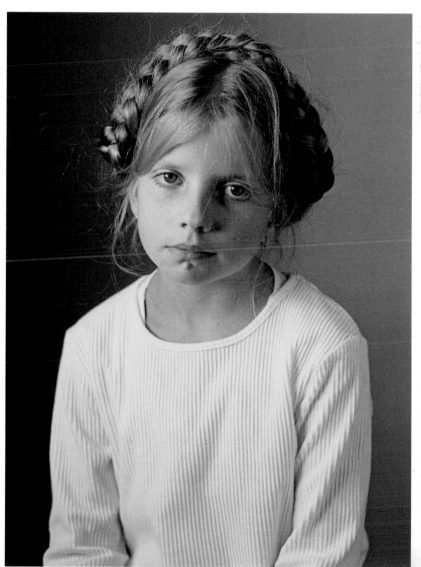

Rule of Thumb

Slow films, in both black and white and colour, give finer detail than fast films. The lower the film's ISO rating, the slower it is – a film with a rating of ISO 50, for example, is three stops slower than one rated at ISO 400. Slow films need plenty of light for correct exposure, but fast films can be used in lower lighting conditions. The faster the film, the more apparent its grain structure. This is a characteristic that can be exploited in low light conditions to give the image a grainy, soft-focus feel.

This little girl was quite a sensitive soul and Janna Dekker wanted to bring out her serious expression. She posed her against a plain background and cropped in closely with a 100mm lens fitted to her 35mm SLR camera. She used a relatively fast black-and-white film which showed a certain amount of grain, and developed both film and print herself so she could control the result. Illumination was provided by natural daylight falling through a window to the little girl's right, with a reflector placed on the other side to fill in detail on the left-hand side of her face. This avoided harsh shadows and softened the overall feel of the image.

▲ Technical Details
35mm SLR camera with a 100mm lens and Kodak Tri-X b&w film.

Family Portraits

Technical Details
▼ Medium format camera with an 80mm lens and Kodak Tri-X b&w film.

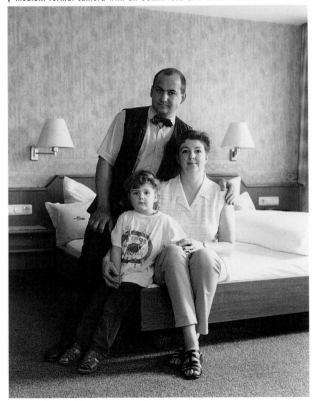

This family owned and ran a hotel and Wolfram Eder wanted to show them in the context of the family business. He used one of the hotel bedrooms as the location, shooting with available light coming through a large window. He posed the trio as a tightly-knit group, with the angles of their legs and bodies forming a geometric, triangular shape.

Seeing

In photographing this family group, Wolfram Eder wanted to convey the idea of the family as a living, growing organism. He chose a leafy and luxuriant natural setting, posing his subjects on a small wooden jetty surrounded by foliage on the edge of a small pond.

Thinking

As well as showing the family as a unit, he wanted to convey the idea that its members were distinct individuals, with unique relationships one to the other. So he arranged the group with the parents in the centre of the frame and their grown-up children fanned out around them. With this arrangement, the group as a whole forms a neat shape but the eye also involuntarily flicks around within it, from face to face.

Acting

With his camera firmly set up on a tripod on a piece of dry land on the edge of the pond, Eder shot the group with a standard 80mm lens on his medium format camera. Lighting was available daylight, which was relatively bright but overcast and provided even illumination without any strong highlights or harsh shadows.

Rule of Thumb

If you've been asked to take group shots at weddings or other family events, scout out the location beforehand and look for corners of the venue such as steps or staircases where you can pose your subjects. At weddings, it helps enormously if you know beforehand who is to be in each group. Enlist the help of someone in the know, such as the best man or the bride's father. If they can get all the necessary people together and help choreograph them into some sort of order, the photographer's job is made that much easier.

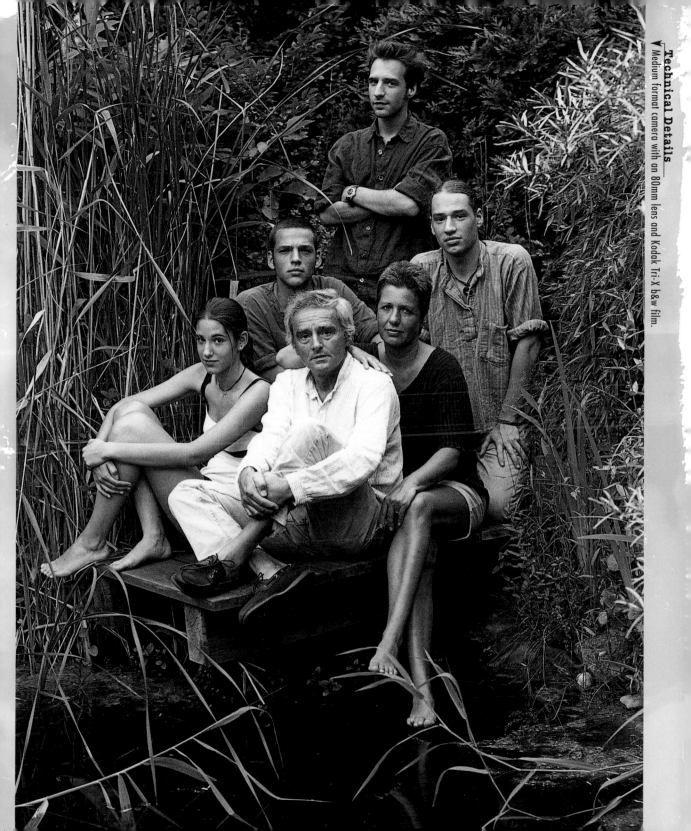

Technical Details
Medium format camera with an 80mm lens and Kodak Tri-X b&w film.

Some of the most enjoyable situations to photograph
people in are events such as fairs, festivals and
family occasions such as parties and weddings. Pictures taken in these circumstances
invariably have a sense of fun and good humour, and it's generally much easier to take
shots where your subjects are completely relaxed and the atmosphere is lending itself to the
taking of spontaneous and unposed photographs.

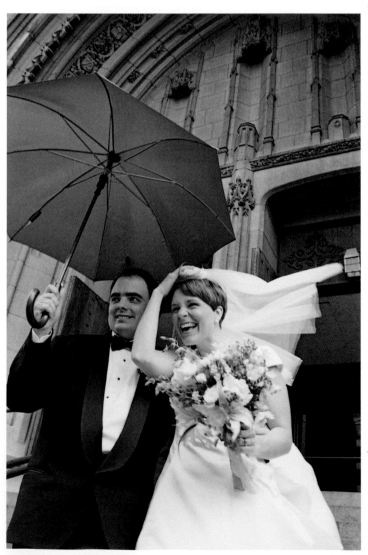

Seeing

Terry Way wanted to capture the excitement
of this bridal couple's big day and opted for a
documentary-style shot of them leaving
for the reception. Having scouted out the location
beforehand, he realised that the main doorway of
the old cathedral would make an excellent backdrop
for a picture.

Thinking

He positioned himself at the bottom of the cathedral
steps and waited for the couple to make their
way out of the building towards their waiting
limousine. It was a wet, blustery day but he made
the most of this by including their umbrella as a
prop. Besides adding visual interest to
the picture, it helped to tell the story of the day.

Acting

Way used a wide angle lens and framed the
image so that the couple were prominent but also so
that plenty of the background was visible.
He deliberately cropped out the waiting guests
so that attention was focused on the happy
expressions of the bride and groom. Once he had
made a black-and-white print, he toned it sepia to
give the image an old-fashioned feel.

◄ Technical Details

35mm SLR camera with a 24mm lens and Ilford
XP2 b&w chromogenic film.

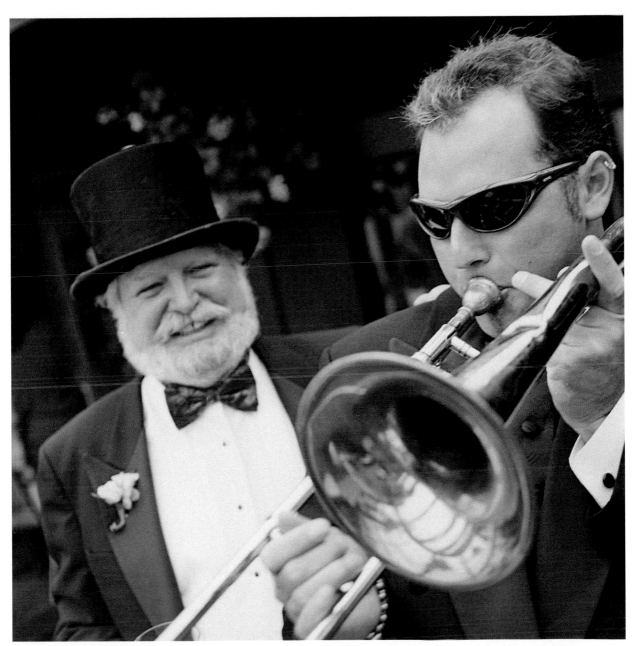

Terry Way tried another offbeat approach for this shot, taken at a friend's wedding. There was an old trombone hanging on the wall of the party venue, and he asked the groom to try playing it. The cheery gentleman in the background was the groom's new father-in-law. Using a medium format camera gave him a square image, and he simply tilted the camera slightly on its side to create this dynamic diagonal composition.

▲Technical Details
Medium format camera with a 70mm lens and Ilford XP2 b&w chromogenic film.

Technical Details
▼ 35mm SLR Camera with a 20–35mm zoom lens and a 81A warm-up filter with Kodak High Speed Ektachrome.

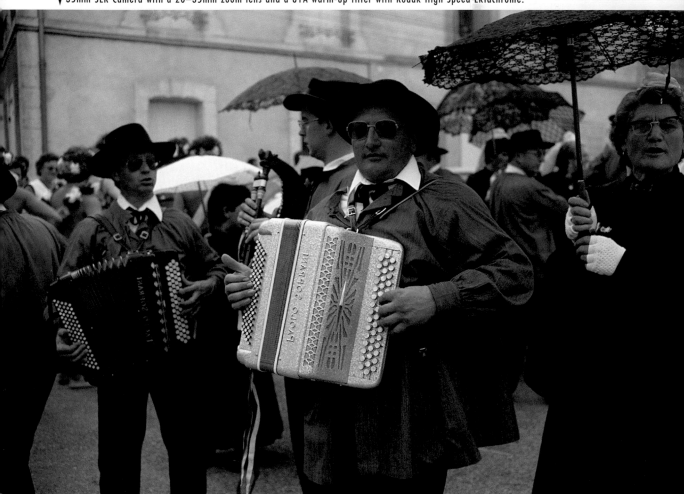

In some cases, the crowd at an event can provide a more interesting and photogenic subject than the activities taking place. Visiting the races in Nairobi, Busselle was attracted by the wonderful mix of faces and fashions to be found there, and he used a long-focus lens to concentrate on the most interesting section of the crowd.

Technical Details ➤
35mm SLR Camera with a 70–210mm zoom lens and an 81B warm-up filter and Fuji Provia.

Rule of Thumb

Finding a good viewpoint is one of the most important things to concentrate on when shooting at public events and, for this reason, it's a good idea to arrive early. That way you give yourself the opportunity to pick a good spot, one which seems likely to work in terms of lighting and background, and which will offer you a good view of the activities.

Seeing

This folk group was performing at a small village wine fair in the Dordogne, France, and Michael Busselle felt that with the right viewpoint they would make an interesting picture.

Thinking

Because it was a small, informal occasion he was able to get quite close to them and this seemed to be the best way of separating them from the bystanders and creating a more interesting composition.

Acting

He decided to use a wide-angle lens as this allowed him to get quite close to his subjects, while still including a reasonably large part of the scene around them. Busselle framed this shot so that the lady with the umbrella on the right and the blue costume worn by the figure on the far left helped to enclose the central accordion player.

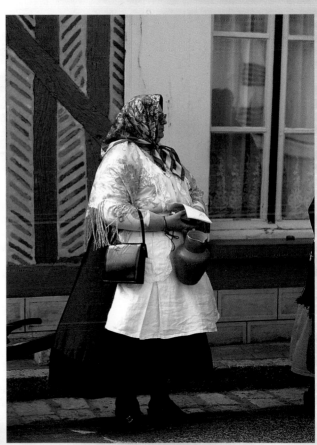

At a village festival in the Loire, Busselle was attracted by the triangular shape created by the lady in her period costume. To photograph her, he chose a viewpoint which placed her against a relatively plain area of background, framing the image quite tightly using a long-focus lens.

Technical Details
35mm Rangefinder Camera with a 90mm lens, an 81B warm-up filter and Kodak Ektachrome 100 SW.

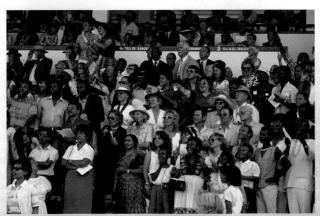

This shows how a slightly different viewpoint would have lessened the emphasis on the subject's face.

The viewpoint Michael Busselle chose for this shot, taken at a village wedding in Sri Lanka, placed this lady's face against the more distant white drum so that she stood out clearly. He used a long-focus lens to frame the image quite tightly and to exclude distracting details around her.

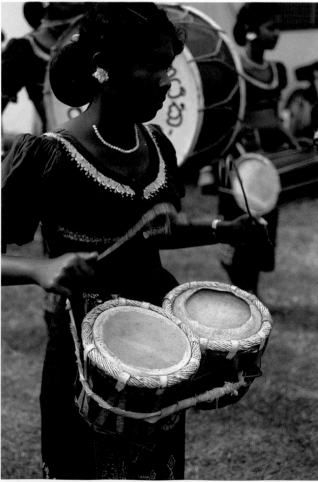

Seeing

The Changing of the Guard is a very popular and colourful event in London's Whitehall and must be one of the most photographed events in the world.

Thinking

Michael Busselle wanted to find a way to produce an image which was a little different from those he had seen many times before. He walked around the scene looking for a viewpoint which would give him a chance to do this and found that this back view of the guardsmen also offered him an effective background in the form of the distant building's facade.

Acting

He used a long-focus lens to isolate this small group of guardsmen and used quite a wide aperture to ensure that the distant building was unsharp enough to allow the main subject to stand out clearly.

Technical Details
35mm SLR Camera with a 75–300mm zoom lens, an 81B warm-up filter and Fuji Provia.

Technical Details
35mm SLR Camera with a 75–150mm zoom lens, an 81A warm-up filter and Kodak Ektachrome 64.

Technical Details
35mm SLR Camera with a 35–70mm zoom lens, an
81B warm-up filter and Kodak Ektachrome 64.

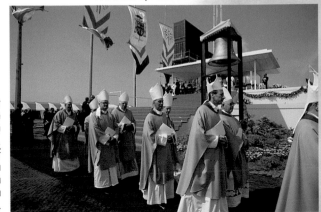

On a big occasion such as the Pope's visit
to Britain, the viewpoint is often the
decisive factor in deciding whether you
get successful photographs. In this case,
Busselle was lucky enough to find himself
close to the parading dignitaries, a
position which allowed him to use a
shorter focal-length lens to create a
pleasing perspective.

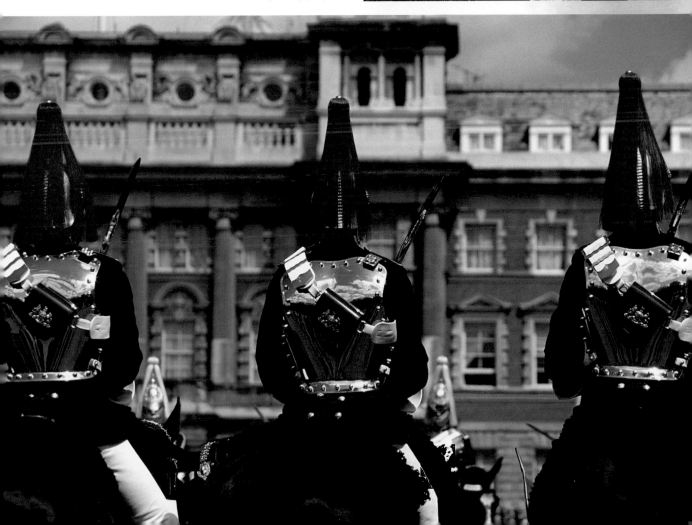

Character Portraits

Character is an elusive thing to define, but you know it when you see it. Older people often make good subjects for character portraits – they may no longer possess the freshness of youth, but their wrinkles indicate a certain amount of experience and often have a beauty of their own.

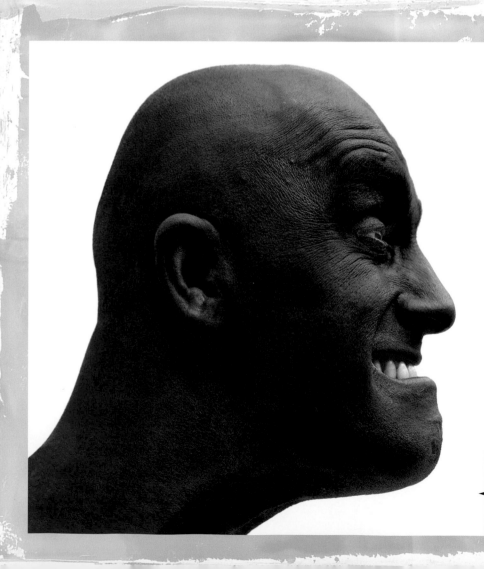

The blue man was an actor filming a television programme. Richard Lewisohn only had a few minutes to photograph him between takes, and so took him outside the studio and found a plain white wall to use as a background. The man's face was already painted blue for filming but Lewisohn scanned the image into a computer and used a digital effects software package to enhance the blue tone and 'repair' the gaps in his make-up. He also digitally removed a t-shirt the actor was wearing and, as a final flourish, stretched his neck slightly.

◄ Technical Details
Medium format camera with an 80mm lens and Fujicolor Superia 100 colour negative film.

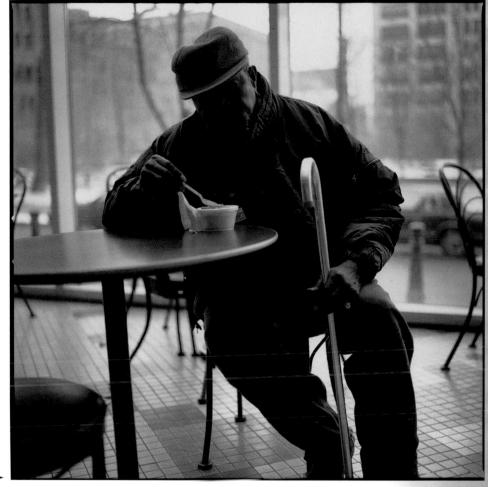

Technical Details
Medium format camera with an 80mm lens and Kodak Tmax b&w film.

Seeing

Gamini Kumara was photographing someone else when she noticed this old gentleman sitting alone in an empty café, eating an ice-cream. She could tell by his white cane that he was partially blind. She asked if he would mind her taking his picture and he nodded agreement.

Thinking

The man was sitting with his back to a large window, which let in a lot of natural daylight. This meant it was difficult to balance the exposure so that both his face and the background were properly exposed. Clearly the man's features were the most important part of the picture, so the photographer decided to expose correctly for that part of the frame and leave the window and background to overexpose.

Acting

She took incident light readings from the subject and the background and set the exposure accordingly. She selected a large aperture which also had the effect of reducing depth of field to concentrate focus on the subject. At the printing stage she dodged the area of the main subject (giving it less exposure) to retain detail, while burning in the background areas (giving them slightly more exposure).

Character Portraits

Technical Details

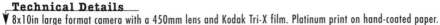

8x10in large format camera with a 450mm lens and Kodak Tri-X film. Platinum print on hand-coated paper.

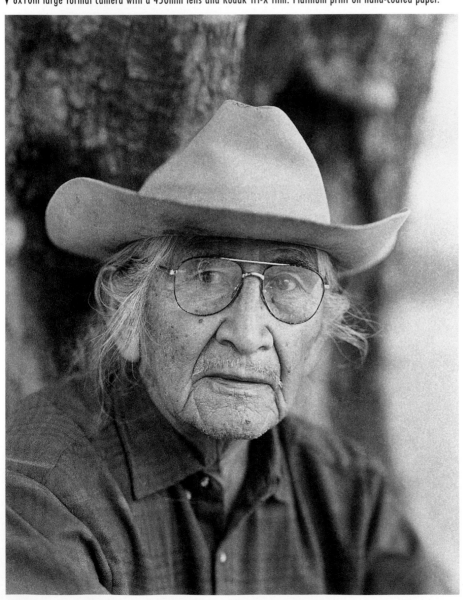

Gary Auerbach photographed this man, the leader of a Navajo drumming troupe, at an Indian craft fair in the American West. He approached him at the end of the afternoon when he had finished drumming, and found him happy to co-operate in a portrait session. The photographer positioned his subject under a large tree and framed tightly on his head and shoulders. The picture was lit by strong natural daylight, but Auerbach placed a small reflector disc to the right of the camera to throw some extra light on to the man's face, filling in the shadows cast by the branches of the tree and by the brim of his hat.

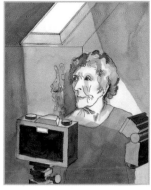

Gary Auerbach used natural daylight from a skylight to bring out the fine detail of the subject's face. A small flash unit placed to the right of the camera provided fill-in illumination.

Seeing

Gary Auerbach took this portrait as part of an assignment. The lady, Marion Degrazia, was the widow of a well-known Arizona artist. He wanted to show her in her own home and chose a spot under a ceiling skylight where there was plenty of natural daylight and where the plain walls provided a neutral background.

Thinking

With the camera firmly mounted on a tripod, he cropped in tightly on the subject's head and shoulders. He included the decoration hanging on the wall in the background to provide a perception of depth, but selected a large aperture to ensure it was out of focus.

Acting

The light from the skylight picked out the contours and wrinkles of the elderly lady's face in fine detail but, because it was falling from above, her neck and the side of her head were left in shadow. To compensate for this, Auerbach used a flash unit set up to the right of the camera to provide fill-in illumination. He used a special platinum process to make the print, which helped to emphasise the textures and detail of the subject's hair and skin.

▲ Technical Details
11x14in large format camera with a 450mm lens and Ilford FP4 film. Platinum print on hand-coated paper.

It's important to observe your subject carefully before deciding how best to approach the photography. Notice which facial features are strongest and make a note of distinctive gestures and expressions which you can incorporate into the pictures.

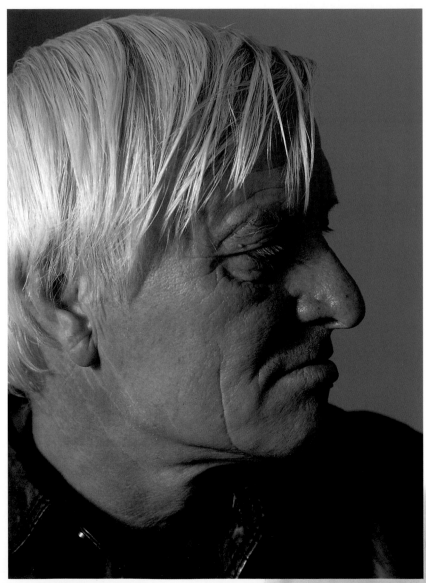

Michael Busselle wanted to emphasise this man's strong Slavic features and tried a variety of head positions and lighting angles before reaching this solution. He felt a profile showed greatest strength and he used a lightly-diffused flash from almost at right angles to the camera, so that the light slanted across the mans' face to emphasise his lines and skin texture. He placed a white reflector on the opposite side to make the shadows a little lighter and chose a grey background, making his skin tones the only positive colour.

Seeing

This young man's close crop and eyebrow piercing were very obvious features but he also has a finely-shaped head with good cheekbones.

Thinking

Michael Busselle wanted to try and accentuate all of these things and explored a variety of poses. Ultimately, he liked this best, with his head turned down to show his scalp and his eyes downcast which, Busselle thought, created a pensive mood.

Acting

He decided to use quite strong, directional light, which was a single flash placed a metre or so above the man's head at about 45 degrees to the camera and about two metres from him. Busselle diffused it lightly by placing a wooden frame covered in garden fleece (sold for protecting plants) quite close to the man. He aimed a small spot of light onto a grey paper background to create a degree of separation.

Technical Details
Medium Format SLR Camera with a 105–210mm zoom lens and Fuji Astia.

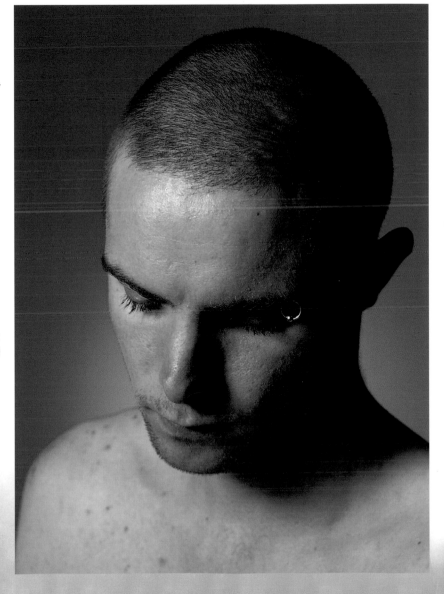

Technical Details
Medium Format SLR Camera with a 105–210mm zoom lens and Fuji Astia.

Formal Portraits

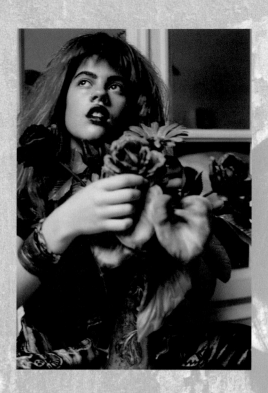

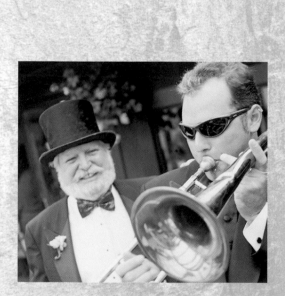

2

Formal portraiture calls for a degree of organisation and is often best executed as a collaboration between photographer and subject. There are many ways of doing this. A subject can be posed in a particular location, in the manner of an actor on a stage, or the photographer can adopt a documentary-style approach to record subjects in a more spontaneous manner. Imaginative use of backgrounds and props can help bring out the subject's character, and can also be used to inject humour into the image.

Using Backgrounds

The world is full of backgrounds, and different ones totally alter the mood of the image. Geometric patterns formed by man-made objects and architecture can be exploited to make bold, eye-catching compositions, while natural foliage and flowers give a far gentler feel to a picture. Even apparently desolate urban locations can be used as a backdrop to create portraits with a particular mood and sense of place.

Seeing

Carlo Chinca took this portrait of Salvador Dali at the artist's home in Figueres in Spain, to commemorate the opening of the Dali Museum. The artist was flamboyantly dressed and, true to form, more than happy to pose for the camera. The photographer spotted the elaborate candlesticks and the extravagant flower arrangement on a side table. He felt they reflected the larger-than-life personality of their owner.

Thinking

The photographer suggested that Dali pose in front of the flower arrangement and a chair was fetched for him to sit on. The arrangement of the items on the table was perfectly symmetrical and Chinca placed his subject in the centre of the frame, in front of the flowers. He asked him to lean back so that his body hid the flower vase from view. The result was that the stems appeared to be sprouting from the artist's head like a fantastic head-dress.

Acting

Chinca used a wide angle 28mm lens which allowed him to include a large part of the room and gave the image a dramatic perspective. The lens's extensive depth of field also meant that everything in the picture was sharp, from Dali's feet in the foreground to the objects on the back wall. To light the scene, Chinca used a hand-held flashgun angled upwards so that its light was bounced off the white ceiling.

Sometimes the most unprepossessing of locations can be used as an effective background for a portrait. Janna Dekker turned this concrete wall, peeling and scarred with graffiti, into a backdrop for an edgy urban study. The lighting was natural, overcast daylight and she used a 100mm lens which gave the image a slightly flattened perspective.

Technical Details

35mm camera with a 100mm lens and Kodak Tri-X b&w film.

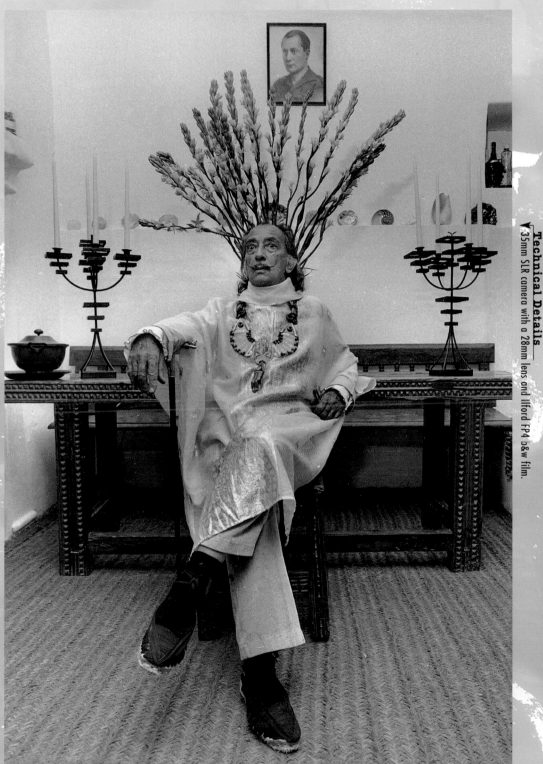

Technical Details
35mm SLR camera with a 28mm lens and Ilford FP4 b&w film.

Using Backgrounds

▲ Technical Details
35mm SLR with a 35mm lens and Kodak Tmax 100 b&w film.

Seeing

Prague, in the Czech Republic, has a very picturesque city centre full of old buildings, but outside the centre there are many huge, ugly constructions built during the country's socialist era. Guy Dondlinger was struck by the stark, forbidding lines of this massive hotel building and decided to use its endlessly repeated storeys as a backdrop.

Thinking

His model had naturally rather gaunt and angular features, which he felt echoed the architecture of the hotel, while the shirt he was wearing suggested military camouflage. He wanted a picture reminiscent of the propaganda posters of the communist era, in which workers and soldiers were portrayed in a heroic light.

Acting

He used a 35mm wide angle lens on his SLR camera, and crouched down to shoot from a low angle. He framed tightly to include just the subject's head and shoulders, filling the rest of the frame with the geometric lines of the building. The low viewpoint made the hotel appear even bigger than it actually was, while the wide angle lens created a rather dizzying perspective.

Rule of Thumb

Indoors you are at liberty to choose the background you want. You can buy ready-made studio backgrounds or you can create your own by painting walls, wood or sheets of card or paper to order. Fabrics such as silk, velvet and muslin also make good backgrounds. These can simply be pinned to a wall behind the subject or draped over a door or a piece of furniture.

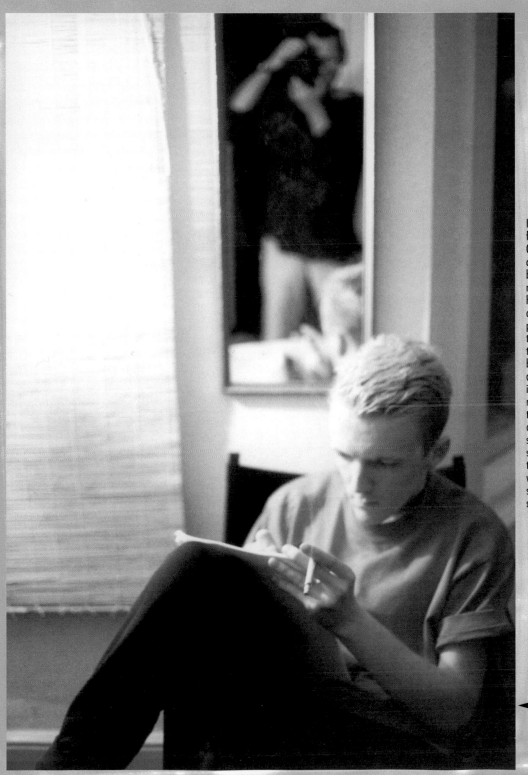

In this shot, taken in a friend's flat in London, Guy Dondlinger created a background by making use of a mirror which showed his own reflection. He can be seen taking the picture, which makes the viewer think about the relationship between photographer and subject. The interior was lit by natural daylight falling through two windows, one each on opposite sides of the room. The subject was caught in this cross-lighting, which evened out the shadows and gave a soft overall offect.

◄**Technical Details**
35mm SLR with a 35mm lens and Kodak Tmax 400 b&w film.

Using Backgrounds

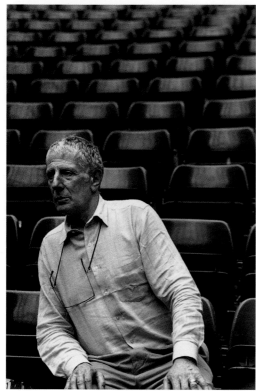

Carlo Chinca shot theatre director Jonathon Miller on location during rehearsals at a music festival. The natural daylight allowed him to select a large aperture, which meant the subject stood out in sharp focus against the background. The tiers of seating formed strong diagonal lines across the frame, so the photographer cropped in relatively close and waited until the subject leaned in the opposite direction.

Technical Details

35mm SLR camera with an 85mm lens and Ilford HP5 b&w film.

Seeing

This portrait was simple to achieve but still worked extremely well. Richard Lewisohn came across the mass of clematis in bloom and realised the flowers would make an excellent background. He asked his model to pose so that her face was framed by a natural gap in the foliage.

Thinking

He tried out various different framings, both horizontal and vertical, and shot a whole roll of film of the same subject. With a 28–105mm zoom lens he was able to crop quickly and easily in-camera, and assess immediately what the result would look like. This unusual vertical crop worked the best.

Acting

The lighting was natural daylight, bright but overcast, which allowed Lewisohn to work without any need for artificial fill-in. In the darkroom, he placed the negative in a carrier that had been filed down at the edges, and printed so that this was visible in the final image. This gave the image its own frame and enhanced its romantic mood.

Rule of Thumb

Keep an eye out for interesting backgrounds. Architecture, both modern and traditional, provides plenty of geometric lines and patterns. Flowers and foliage provide a softer atmosphere. In either case, however, avoid the classic trap of posing your subject in front of lamp-posts or trees that appear to be growing out of their head. Scan the scene through the viewfinder carefully before you take the picture.

Technical Details

35mm SLR camera with a 28–105mm zoom lens and Ilford HP5+ b&w film.

Using Backgrounds

Seeing

Michael Busselle passed this small shop while exploring the village of Lourmarin in Provence, and was attracted to both the shop front itself and the two lady proprietors who were watching the passers-by.

Thinking

He felt that both subject and background were of equal importance if the picture was to be a success, and because the two ladies stood out well from the darkened doorway, he could afford to let them be quite small in the frame.

Acting

He decided to shoot from the opposite side of the street using a wide-angle lens which allowed him to include most of the shop front. He framed the image so the two ladies were more or less in the centre of the picture.

Technical Details
Medium Format SLR Camera with a 55–110mm zoom lens, an 81A warm-up filter and Fuji Velvia.

It was largely the background that inspired this shot, which was taken in the Souk in Marrakech, Morocco. Busselle liked the colour and texture it offered, and was attracted by the way the colours in the man's robe were complemented. Had he been seated anywhere else Busselle would probably not have photographed him.

Technical Details
▼ 35mm SLR Camera with an 80–200mm zoom lens, an 81A warm-up filter and Kodak Ektachrome 100 SW.

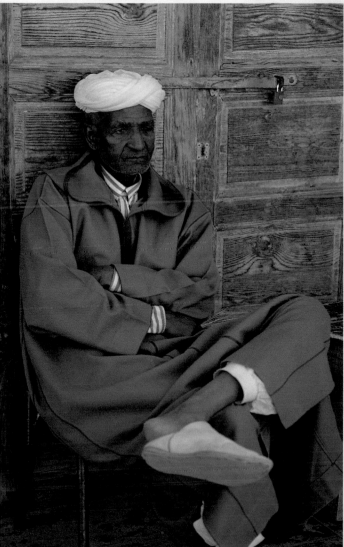

Busselle used a low camera angle for this portrait of a Moroccan man, partly to create a slightly unusual perspective but also to enable him to use the sky as a background. From eye level, the viewpoint included some distracting details in the background.

Technical Details
▼ 35mm SLR Camera with an 80–200mm zoom lens, an 81A warm-up filter and Fuji Velvia.

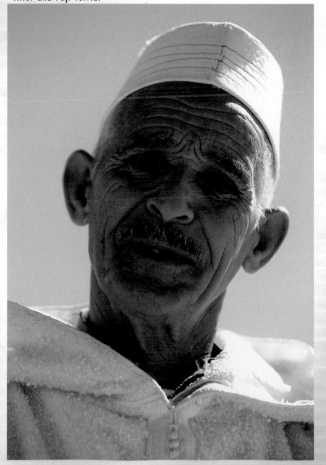

Rule of Thumb

Always scan the viewfinder carefully to ensure there are no distracting details, colours or highlights included which will draw attention away from the model's face. You should also ensure that there are no elements in the background which, when you see the final picture, will appear to be attached to the model, the distant tree which appears to 'grow' from the model's head being the classic example.

Seeing

While looking for a setting in which to place his model for this nude shot, Michael Busselle saw this strikingly-textured rock with its rich ochre colour and thought that it might echo the colour of the subject's tanned skin.

Thinking

With his model in position, it was clear that the two colours did indeed work well together, while the limited colour range of the image further served to heighten the textural effect of skin and rock, emphasising the difference between them.

Acting

He used a long-focus lens to frame the image quite tightly, while a polarising filter subdued some of the highlights on the model's body and increased the colour saturation.

Technical Details

Medium Format SLR Camera with a 150mm lens, a polarising and 81A warm-up filter with Kodak Ektachrome 64.

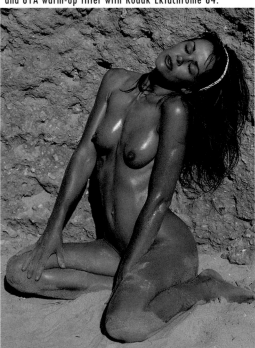

Busselle photographed this clown outside the tent of a small travelling circus, using the big top itself as part of the background. He felt the contrast of the clown's white shirt and blue trousers seen against the tent's red canvas would produce a degree of impact.

Technical Details

35mm SLR Camera with an 75–150mm zoom lens and Kodak Ektachrome 64.

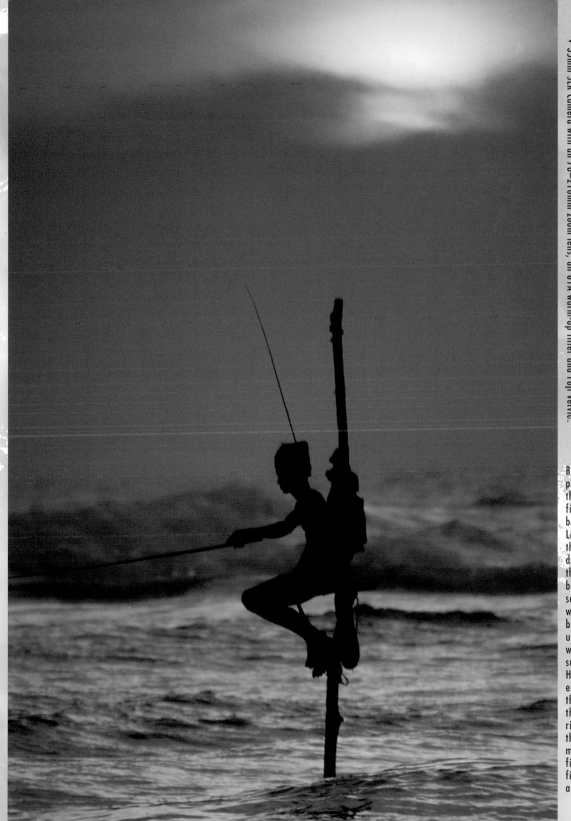

Technical Details
▼ 35mm SLR Camera with an 70–210mm zoom lens, an 81A warm-up filter and Fuji Velvia.

Busselle photographed this pole fisherman on a beach in Sri Lanka towards the end of the day, reckoning that the background of sea and sky would have been very uninteresting without the sunset colours. He took an exposure from the sky to make the most of the rich colours there, which made the fisherman's figure record as a silhouette.

Using Colour for Effect

Most photographers react strongly to a colourful subject, but unless some thought is given to the composition of the image, the results can easily be disappointing. For the greatest impact, colour should be used selectively in an image. Photographs which contain a broad range of colours tend to have a fussy and confusing quality which can easily overwhelm the subject.

Seeing

This shot of a **Balinese** lady making satay sticks appealed to Michael Busselle as much for the scene's **colour quality** as it did for the interest of the subject.

Thinking

The combination of **blue and green** is ubiquitous in nature but, for some reason, when it occurs in other circumstances Busselle finds it particularly **interesting**. It was the way these colours almost completely **dominated** this scene which made him react to it, while the small **contrasting detail** of the satays was also interesting.

Acting

He used a **wide-angle** lens from a fairly close **viewpoint** and framed the shot so that the woman was placed in **one half** of the image, while Busselle included part of the window frame on the opposite side to **balance** the composition.

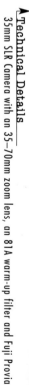

▲Technical Details
35mm SLR Camera with an 35–70mm zoom lens, an 81A warm-up filter and Fuji Provia.

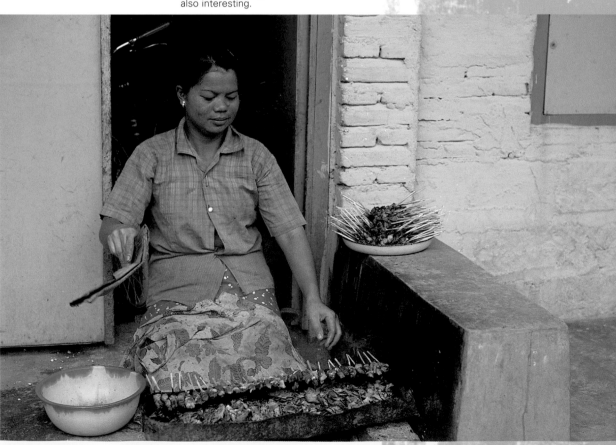

Rule of Thumb

One of the most striking ways of using
colour occurs when the main subject
contrasts dramatically with its background
or surroundings. In these circumstances
even a very small area of dominant colour
can, when it creates a bold contrast with
the background, have a very striking effect.

The juxtaposition of the shop sign and the smiling couple appealed to
Busselle in this shot, taken in Sri Lanka. But it was the bold colour
contrast between the sign and the boy's shirt which clinched it for him.

Technical Details
▼ 35mm SLR Camera with an 35–70mm zoom lens, an 81A warm-up filter
and Kodak Ektachrome 64.

It was the powerful, jarring contrast between the colours
of the robes worn by these two Moroccan ladies which
appealed to Michael Busselle. The fact that they were
facing away from the camera has heightened the effect,
as it has reduced them to just very bold-coloured shapes.

Technical Details
▼ 35mm SLR Camera with an 28–70mm zoom lens and
Kodak Ektachrome 100 SW.

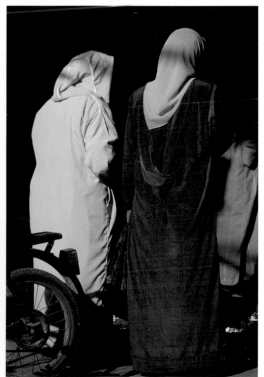

Using Colour for Effect

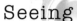

Seeing

This lady was studying form during a lull in the races at Longchamps during the Paris Grand Prix. It's very much the sort of shot which appeals to Michael Busselle, and it was an easy one to shoot unseen as she was so engrossed in her paper.

Thinking

His first thought was to zoom in closer so that she practically filled the frame, but he then took more notice of the fence behind her and the effect its colour and texture had when combined with the grass in the foreground.

Acting

He decided to switch to a wider angle, and to include much more of the fence together with a larger area of the foreground, framing the shot so that she was placed in the bottom half of the frame.

This was one of those fleeting opportunities seen in a Moroccan village. Busselle had already noticed the beautifully-coloured wall when he saw this schoolgirl approaching, and the sunlight on her yellow scarf created a bold contrast against the dark-toned wall.

▲Technical Details
35mm SLR Camera with an 70–210mm zoom lens, an 81A warm-up filter and Kodak Ektachrome 64.

It's important to appreciate just how much colour can influence the mood of a picture. Images in which the warm colours – such as red, yellow and orange – predominate will tend to have a cheerful and inviting quality, whereas photographs where the cooler hues of blue, greens and purple are dominant will generally create a more subdued and introspective mood. In a similar way, bright, bold colours will have a lively and assertive quality, while soft pastel colours will suggest a more gentle or romantic atmosphere.

Technical Details
▼ 35mm SLR Camera with an 35–70mm zoom lens, an 81A warm-up filter and Kodak Ektachrome 64.

It was a very dull day when Michael Busselle spotted this sub-aqua enthusiast contemplating a dive. The very soft lighting accentuated the contrast between his red wet suit and the dark grey water, creating an image with a considerable degree of impact.

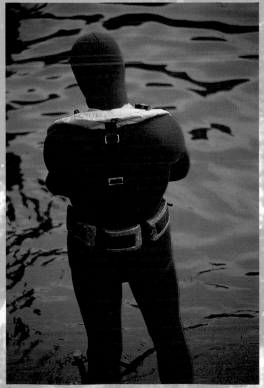

▲ Technical Details
35mm SLR Camera with an 35–70mm zoom lens, an 81A warm-up filter and Kodak Ektachrome 64.

Using Colour for Effect

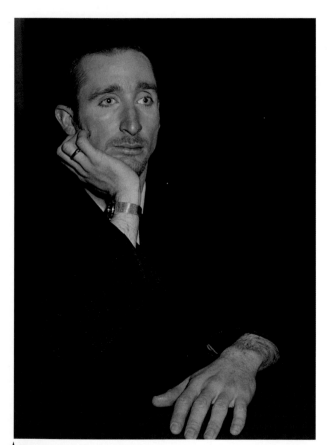

Seeing

Anna Fabres wanted to produce a straightforward portrait focusing on the model's strong features and melancholy expression, but was also on the look-out for a shape or colour that would add interest to the composition. The location was London's South Bank Centre, an arts complex notorious for its wide expanses of grey concrete, but the photographer's eye was caught by the **deep red** colour of the café table.

Thinking

She seated her model at the table and assessed the potential of the image through the lens. She was pleased with the contrast the bright red made with the **gloomy interior** and the dark grey of the man's coat. The sombre surroundings meant his face stood out distinctly against the background, with no clutter to distract attention. The red also **contrasted** subtly with the light blue of the man's eyes and the bright yellow of his shirt.

Acting

Fabres framed tightly with a 35–70mm zoom lens and shot the picture using a **camera-mounted flashgun.** This meant the subject's face was brightly lit, while the background retreated even further into the shadows. Using a print film with good **colour saturation** made the colours in the finished image stand out even more strongly.

▲ Technical Details

35mm SLR camera with a 35–70mm lens and Fujicolor Reala 100 colour negative film.

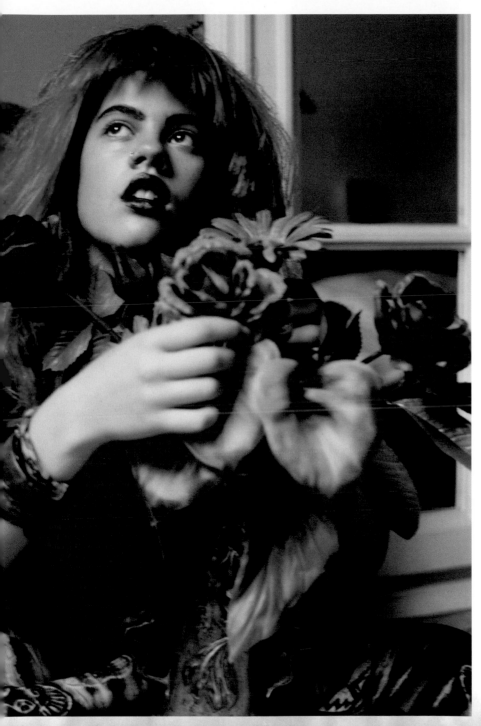

The vibrant colours in this shot look as if they've been enhanced or manipulated, but Anna Fabres merely recorded what she saw through the lens. She did however use a colour negative film known for its colour saturation to give the image extra punch. She also exaggerated the drama of the picture by getting in close to the subject and shooting from a low viewpoint, using the wide angle end of a 35–70mm zoom lens. The picture was taken in Paris and was lit by natural spring daylight falling through a window.

Rule of Thumb

Red eye is one of the most common hazards of photographing people. It's caused by flash light reflecting off the blood vessels in the subject's eye, causing that characteristic zombie glow. It mostly happens when the flash is mounted on the camera, because the lens is at the same angle to the subject. Avoid the problem by hand-holding the flash or mounting it on a separate stand, and connecting it to the camera via a flash sync cord. Alternatively angle your flashgun so that the light is bounced off a ceiling or wall.

▲ Technical Details
35mm SLR camera with a 35–70mm lens and Kodak Gold 100 colour negative film.

Using Shape, Form & Texture

The art of composition hinges on the ability to look beyond the subject, and to see it in terms of its visual components. The qualities of colour, form, texture, pattern and shape make up the essential structure of an image, and are the things which determine the basic nature of a composition. When these elements have been clearly identified, it becomes much easier to see how the image can be arranged within the frame to create the most impact.

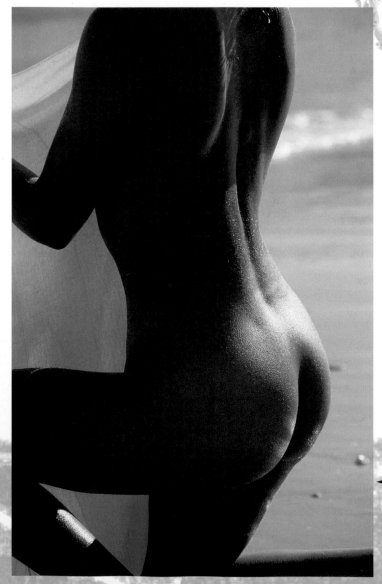

Seeing

Michael Busselle was shooting pictures of this male model for a holiday brochure when he saw him stretching his back between set ups. Busselle thought the combination of his well-tuned muscles and richly tanned skin had the potential for a semi-abstract shot.

Thinking

He wanted the picture to be impersonal, so he asked him to face away from the camera and then adopt this pose to create a more interesting shape.

Acting

He framed the shot quite tightly so that the model's trunks were not included, and used a polarising filter to increase the colour saturation of both his skin and the blue sky.

This shot depends on shape and form as well as texture for its effect. Busselle framed it tightly in this way to emphasise these qualities, and to depersonalise the image to make it more of an abstract than a portrait.

Technical Details
35mm SLR Camera with an 75–150mm zoom lens, an 81A warm-up filter and Kodak Ektachrome 64.

Technical Details
35mm SLR Camera with an 35–70mm zoom lens, polarising and 81A warm-up filters with Fuji Provia.

The contrast between the model's brown skin and the bright blue of the water has emphasised the element of shape in this nude shot, while the pattern effect created by the highlighted ripples has added a further degree of interest.

Using Shape, Form & Texture

Seeing

This man is one of several water vendors who can be found in the square of Jemma el Fna in Marrakech. Their purpose nowadays is to stand around to have their picture taken, but the light in the square is invariably harsh and the surroundings incredibly busy and cluttered.

Thinking

Michael Busselle wanted to photograph this particular man, but there was little chance of producing a worthwhile image because of the poor lighting and muddled background.

Acting

He asked the man to accompany him, for a modest fee, to a shaded area where there was a piece of canvas draped over a wall, and Busselle placed him in front of this. The plain background has helped to accentuate the shape of his extraordinary head gear, while the softer light has revealed the subtle textures of skin, fabric and metal.

Technical Details

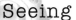 35mm SLR Camera with a 80–200mm zoom lens an 81A warm-up filter and Fuji Provia.

Busselle saw this small child in a Masai village in Kenya, and was instantly attracted by the bold colour contrast between her jumper and the surroundings. But he realised that the shapes created by the painted wall and the pole were also very striking, and so he framed the image to make the most of these.

It is the shape of this Arab man's strong profile which is the key element in this shot, and Busselle chose this viewpoint set against a dark, featureless area of the background, in order to accentuate it.

Technical Details
35mm SLR Camera with a 75–150mm zoom lens an 81A warm-up filter and Kodak Kodachrome 64.

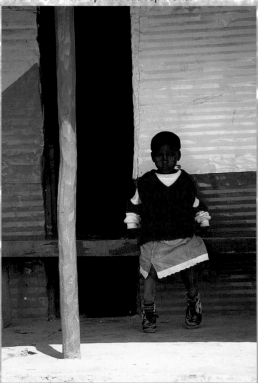

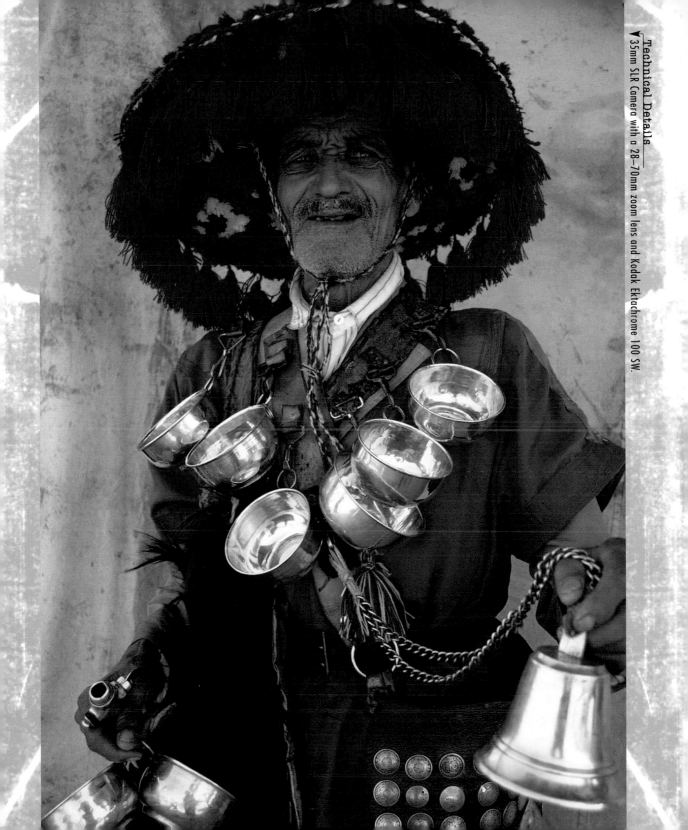

Technical Details
35mm SLR Camera with a 28–70mm zoom lens and Kodak Ektachrome 100 SW.

Using Props

Props can be simple everyday objects or they can be part of an elaborate set. There are many types of props with many different uses. Some relate to the subject's interests and activities – items used for work or as part of a hobby, for instance. Some are selected because their shape or colour fits in well with the rest of the image, while others are pressed into service simply to occupy the attention of a restless child. And many, of course, are used just because they raise a smile.

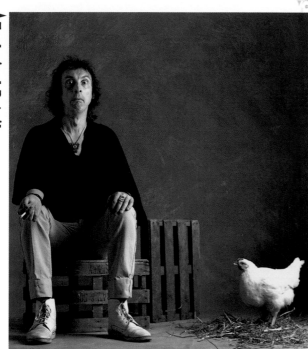

▲ **Technical Details**
5x4in large format camera with a 150mm lens and Ilford FP4 film rated at ISO 200.

The illustration shows the lighting set-up for this shot. The white reflector on the left filled in the shadows on the subject's face while the black one on the right softened the shadows on the background.

Seeing

This offbeat portrait by Carlo Chinca was a studio test shot for an album cover. The subject was Stan Webb, blues guitarist with the 1960s' band Chicken Shack. Chinca wanted quite a subtle image, but he also wanted to incorporate a humorous reference to the band – hence the live chicken!

Thinking

The photographer sat his subject on a wooden crate, with straw scattered around to suggest a farmyard atmosphere. The background was a roll of hand-painted paper. The camera was set up a couple of feet off the ground, at the subject's eye level. The aperture was large, giving a very shallow depth of field. To remain in focus, the chicken had to be on the same plane as the subject, and an assistant was on hand to steer it into position.

Acting

Chinca lit the picture with two flash units, set up on stands one above the other on the right-hand side of the frame but fitted with a screen of tracing paper to diffuse their light. A white polystyrene reflector placed to the left of the set bounced light back to fill in the shadows on that side of the subject's face, while a black-painted polystyrene sheet on the right helped soften the shadows on the background.

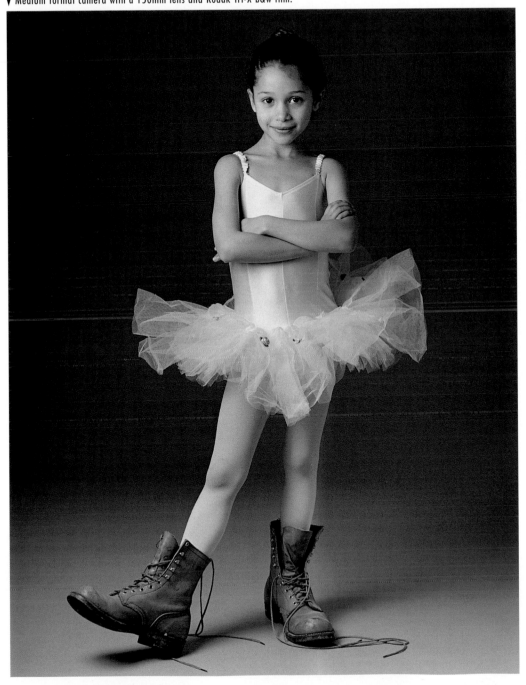

Ronnie Bennett shot this little girl, together with her two brothers, both outdoors and in the studio. As the session progressed and her subjects relaxed, it occurred to Bennett that her husband's old work boots would make an amusing contrast with the girl's lacy ballet costume. She asked her to put them on, but deliberately left the laces undone and coiling around the floor. She kept the studio background plain, and lit the subject with a softbox to the left of the camera and two white reflectors arranged in a V-shape to the right to fill in the shadows.

Using Props

▲Technical Details
Medium format camera with an 80mm lens and Kodak Vericolor 160 Pro colour negative film.

Seeing

This little chap was less than a year old when his mum brought him to Rossaline Lucock's studio. The glasses were his own and not a prop but the photographer thought they made him look rather intellectual, so she sat him down at a small desk and gave him a book to play with. When he started turning the pages she saw her picture.

Thinking

She quickly added the quill pen and the inkstand to the impromptu set and piled up some more of the leather-bound volumes to create the impression of an old-fashioned study. More books in the background, together with the pot plant and the mottled grey studio backdrop, added to the Victorian feel.

Acting

Lucock shot the picture with a standard 80mm lens on her medium format camera. A black vignette attachment on the lens darkened the edges of the frame, while a softening filter gave it a slightly soft-focus feel. Illumination came from one main studio light with a reflector to fill in the shadows, plus another, smaller light on the little boy's hair.

Rule of Thumb

It's a good idea to build up a stock of favourite props that you can use over and over again with different subjects. These come in especially useful with children, who often need distracting. A small stock of clothing is also handy, to be lent out when the need arises. Scan magazines and newspapers to get an idea of the kinds of objects you could use, but be prepared also to improvise with whatever comes to hand.

When this little boy came along for a portrait session he brought his violin with him, and Ronnie Bennett used the instrument and bow to create a dynamic diagonal composition. It also allowed her to use a favourite technique of getting the subject to tip down their chin and to look up at the camera from under their eyelids. The effect this creates is slightly earnest but very appealing, and it's a technique that works particularly well with children.

▲ Technical Details

Medium format camera with a 150mm lens and Fuji Neopan 400 b&w film.

Technical Details
▼ Medium format camera with an 80mm lens and Kodak Tmax b&w film.

In this double family portrait, Gamini Kumara used a chair as a simple prop. It was unobtrusive, yet provided a frame for the young subjects and gave the picture its shape. The lighting set-up involved two flashguns, one with a reflective umbrella throwing light on to the children, the other fired directly at the plain white background. The combined effect of this was to bathe the pair in light.

Rule of Thumb

Familiar objects help put people at their ease. If a person has a hobby, get them to bring along an object that represents that hobby. Your subject may play a musical instrument or enjoy riding a bike, for instance. Alternatively, choose objects that the subject uses in their line of work. Get gardeners to pose with a rake, hairdressers with a comb and scissors, or software experts with a computer keyboard. Use your imagination!

Seeing

In his portraits Ton Hendriks usually sets out to show something of the background of his subject, hinting at their profession and social status. When he was commissioned to photograph this musician for a magazine article, he had a ready-made prop in the shape of the double bass. He didn't want to show the musician actually playing the instrument, but he did want to demonstrate the close relationship he had with it.

Thinking

The bass was already leaning against the white wall. Hendriks seated his subject on a low chair and asked him to pose leaning to one side, in a way that balanced the head of the instrument leaning the other way. He framed tightly, so that the dark instrument and the dark hair and clothing of the musician formed simple, graphic shapes which contrasted starkly with the plain white of the background wall.

Acting

Hendriks placed a flash unit to the right of the camera, with a bright reflector that cast a hard shadow from the instrument on to the wall. However, he didn't want excessive contrast in the subject's face and so placed a second flash unit to the left of the camera. He set this flash to give around two stops less exposure than the first, and bounced its light back off a white umbrella to give a softer illumination.

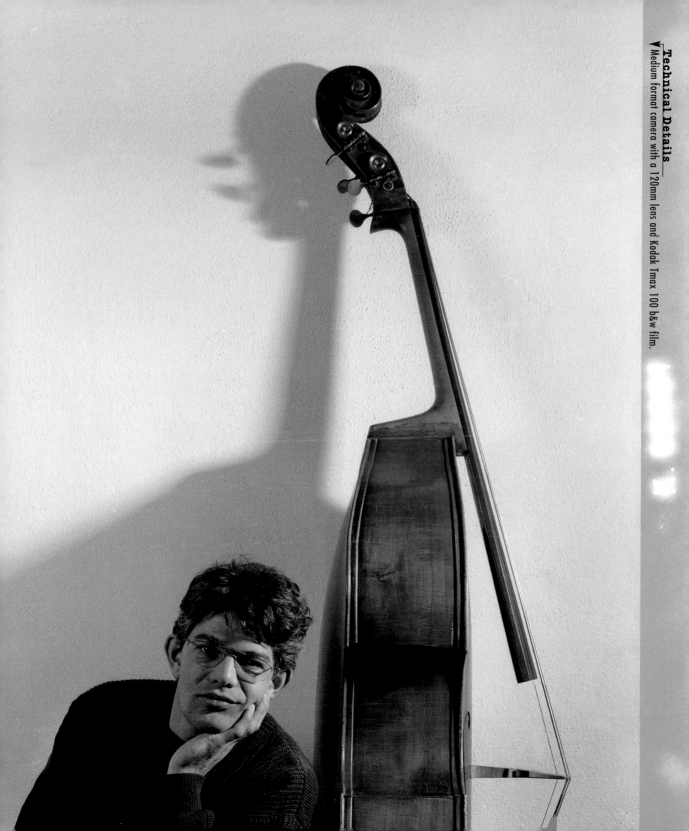

Technical Details
Medium format camera with a 120mm lens and Kodak Tmax 100 b&w film.

Beauty Photography

Beauty portraits lie at the other end of the scale from candids: instead of seeking to catch subjects offguard, the photographer aims to flatter them. Beauty photography often involves close collaboration between the photographer and the subject and careful forward planning in terms of lighting, colours and mood. Glossy magazines, featuring glamorous models and pictures by top fashion photographers, provide a good source of inspiration.

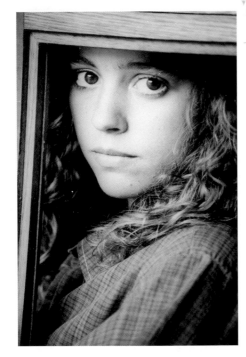

Daniel Stonek was struck by the large, expressive eyes of this particular girl and used a zoom lens to frame the picture so that they became its main point of interest. The wooden window frame provided a ready-made frame within the frame. Stonek used an ISO 400 black-and-white film but pushed it two stops to ISO 1600. This increased the graininess of the image, enhancing its gentle, moody feel.

Technical Details

35mm SLR camera with an 80–200mm lens and Ilford HP5+ b&w film pushed to ISO 1600.

Seeing

The model was an actress who was making a TV commercial. Richard Lewisohn was acting as on-set stills photographer and used the breaks in filming to take a few informal shots of her. Her costume of swimsuit and sunglasses already suggested glamour and sophistication but he wanted to create a sense of drama too.

Thinking

He asked the actress to crouch down on the grass and got down to the same level himself to frame the image tightly. The unusual viewpoint gave the picture impact while being so low down meant that more of the lawn was included in the frame, providing a ready-made backdrop. The late-afternoon sunlight added warmth to the scene and also reflected off the model's sunglasses to create highlights.

Acting

Lewisohn used a standard 80mm lens on his medium format camera. The unusual angle meant he dispensed with a tripod and shot the picture hand-held. He used a slow colour negative film, which gave fine detail and richly saturated colours. The resulting picture looked like it had a story to tell, as if it was a scene from a film.

Rule of Thumb

With 35mm camera systems, an 85mm lens is often regarded as the standard for portrait pictures. In medium format photography, the equivalent focal length is around 120mm. Few people, on the other hand, use a wide angle for portraiture. The exaggerated perspective of these lenses makes noses and chins stand out in a most unflattering way.

Technical Details
▼ Medium format camera with an 80mm lens and Fujicolor Superia 100 colour negative film.

This is a much gentler picture than the one opposite. Daniel Stonek posed the young girl, wearing her best dress, in a doorway and framed the image tightly with an 80–200mm zoom lens. The main source of illumination was natural daylight, but the photographer also used a burst of fill-in flash to even out the shadows and to create sparkle in the girl's eyes. So that the flash would not overwhelm the pastel colours, he set it at two stops below the indicated meter reading.

Technical Details

35mm SLR with an 80–200mm lens and fill-in flash, and Kodak Ektacolor 160 colour negative film.

Seeing

This girl was not a professional model but simply wanted some pictures of herself. Daniel Stonek wanted her to be as natural as possible, and so steered clear of complicated poses. He simply got her to look straight at the camera, and asked her to be herself.

Thinking

He shot the picture at sunset, when the light was warm and directional. The girl's yellow hair, her red clothing and the blue of the sky formed a strong set of primary colours. Stonek added further impact by framing the image tightly, using a zoom lens to try out different crops until he found the one that worked best.

Acting

To boost the warm colours a little further, he fitted a polarising filter over the lens. This removed unwanted reflections from the girl's skin and deepened the blue of the sky. He added extra punch to the image with a burst of fill-in flash, set at two stops below the indicated meter reading so that it would not be too strong. This highlighted the girl's face and created catchlights in her eyes.

Rule of Thumb

Even in bright sunlight, fill-in flash can be an invaluable tool. It evens out the harsh shadows caused by direct sunlight and adds sparkle to the subject's eyes. To get the exposure right, take a meter reading and set the flash a stop or two below the exposure indicated. This will make its light relatively weak, enough to brighten the scene but not strong enough to dominate it. If fill-in is used skilfully, the viewer probably won't even notice it's there.

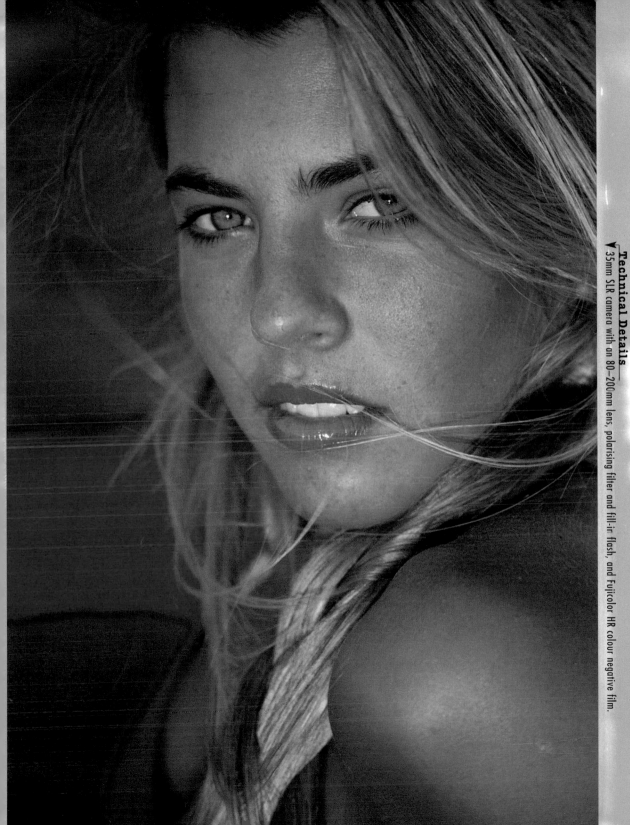

Technical Details
▼ 35mm SLR camera with an 80–200mm lens, polarising filter and fill-in flash, and Fujicolor HR colour negative film.

Beauty Photography

Rule of Thumb

A technique often used by
beauty photographers to create
flattering images and flawless
complexions is to ask the
model to wear a quite thick,
pale skin make-up with dark lip
colour and eye make-up and to
use a degree of overexposure
and close up.

Seeing

Michael Busselle wanted to capture the open,
sunny smile and the very fresh,
unselfconscious, girl-next-door looks of
the lady in this picture and decided to adopt a very
straightforward approach.

Thinking

But he also wanted the picture to have the sort of
quality one associates with magazine
covers and cosmetic ads and used the type of
lighting set-up which might be used for
these images.

Acting

He arranged two large white reflectors close
to her each side of the camera and angled
inwards, like a V shape, with a small gap for the
camera lens to see through. Using a boom arm, he
then suspended a flash behind her and aimed it
at the reflectors, using barn doors to prevent this light
spilling onto her, and ensuring that the lens was
shielded from flare. He also placed another
reflector under her chin.

This picture was lit by placing a soft box each side of the
camera lens with a reflector positioned close up under the
model's chin.

Technical Details
Medium Format SLR Camera with a
105–210mm zoom lens and Fuji Astia.

Technical Details
Medium Format SLR Camera with a 150mm lens and Kodak Ektachrome 64.

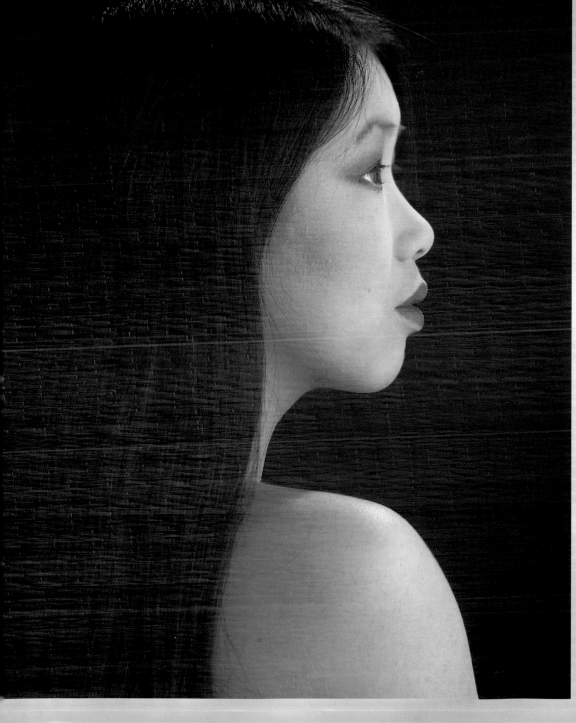

Technical Details
Medium Format SLR Camera with a 180mm lens and Kodak Ektachrome 64.

Michael Busselle used a large soft box from close to the camera lens to create a virtually shadowless light for this portrait of an Oriental model, giving half a stop extra exposure than was strictly correct in order to minimise the texture of her skin and to create a very flat, two-dimensional quality. The textured effect was produced by placing a cross-lit bamboo screen at right angles to the camera, reflecting it into the lens by the means of a piece of glass held at 45 degrees immediately in front of it.

Profiles

The profile is a classic approach to portraiture. Painters and miniaturists have been using it for hundreds of years – just take a look at the coins in your pocket! It's also an effective device in photography. Strong facial features can be emphasised to suggest the subject's character or, alternatively, a semi-profile can be used to create a softer type of image.

Seeing

Alain Paris wanted to bring out the richness of his model's dark skin and posed her against a dark background that helped focus attention on its **tone and texture**. The beads draped across her shoulder added contrasting textures. Influenced by the look and feel of old black-and-white movies, he chose a strongly **directional lighting** set-up and got his model to pose in profile, which seemed to suggest she had a story to tell.

Thinking

In Paris' experience, there is far less exposure latitude when photographing people with dark skin than there is with those of a lighter complexion. There is a particular risk of **overexposure**, which means that rich dark tones are lost, along with the detail of the skin's texture.

Acting

Paris got in close to the model to crop tightly using a standard lens. Lighting came from a **single flashgun** fitted with a Fresnel lens attachment, which concentrated the beam of light.

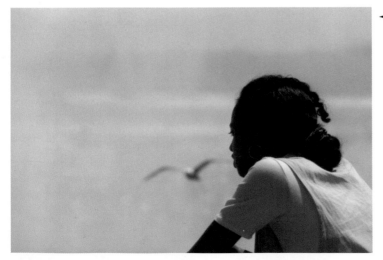

Technical Details
35mm SLR camera with a 30–200mm lens and Kodak Gold 100 colour negative film.

Rule of Thumb

When shooting profiles, automatic metering systems can be fooled into underexposure if the subject is backlit, especially by large areas of sky or water. To retain detail, take a spot reading from the subject's face, or open up the aperture a stop or two. Alternatively, you can exaggerate the effect by exposing for the background and leaving the face to fill in with shadow. This will create a silhouette effect.

Guy Dondlinger spotted this girl while on holiday at the Niagara Falls and used a long zoom lens to frame her in profile. The curtain of spray from the waterfall provided a plain, neutral background, which a large aperture threw completely out of focus. The seagull provided the finishing touch, flying into the frame at just the right moment.

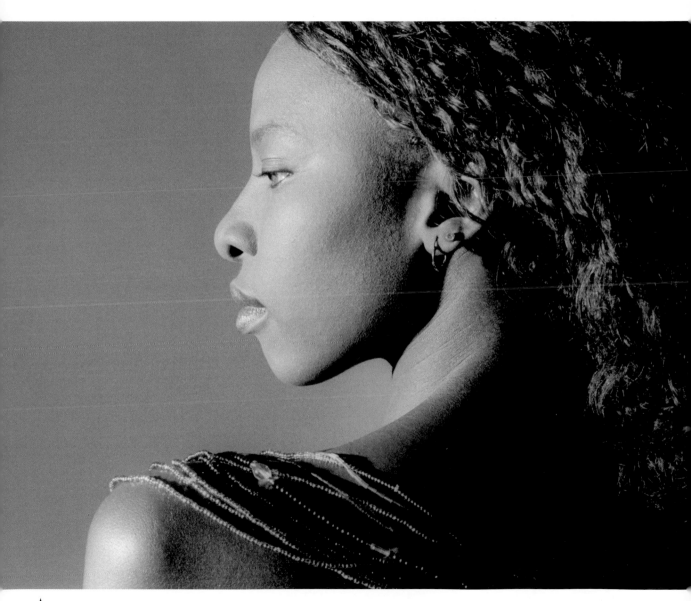

Technical Details
35mm SLR camera with a 50mm lens and Kodak Tmax 400 b&w film.

Location Portraits

Locations say a lot about a subject. A person photographed in their natural environment is likely to be more relaxed and to reveal more of their personality to the camera. Locations can be artificial, like a stage set, but they need not be exotic. Good, accessible locations include sports facilities, bars and restaurants, gardens, parks and public spaces.

Carlo Chinca was commissioned by a magazine to take a portrait of Leon Griffiths, creator and writer of the popular television series Minder. The series featured London underworld characters, so this old-fashioned London pub provided the ideal location. The interior was dark, but Chinca made use of the light streaming through the window. He chose black-and-white film to focus attention on the textures of the subject's lived-in face and those of the wood and glass around him. The cigarette and the drink provided the necessary touches of authenticity!

Seeing

Donna Dean took this shot as part of a degree project. She was looking for an unusual portrait that could be done without expensive lighting or equipment. She was also interested in the natural distortions of objects seen through water, and wanted to incorporate this effect into her picture. She chose a local municipal swimming pool as her location.

Thinking

The location made it difficult to set up any freestanding lights, and Dean didn't want to use flash as it would have given too hard an effect. Instead, after doing some test shots, she decided simply to use the available tungsten lighting of the pool building. The weight of the camera and the cold of the pool meant she had a problem with camera shake, so she enlisted the help of an assistant to steady her.

Acting

She stood over the model and asked him to submerge himself and then to raise his head slowly out of the water. Dean took three shots, bracketing half a stop each way to make sure the exposure was spot on. She used a black-and-white film with an ISO rating of 400, but pushed it to ISO 1600. This gave her more exposure latitude and also increased the graininess of the image.

Technical Details
35mm SLR camera with a 28mm lens and Ilford XP1 chromogenic film.

Technical Details
▼ Medium format camera with a 90mm lens and Ilford HP5+ b&w film pushed to ISO 1600.

This man was a member of a Navajo drumming troupe and, wanting to show him in a natural, outdoor setting, Gary Auerbach posed him against the trunk of a tree. He framed the image tightly and focused on the man's eyes, setting a very shallow depth of field. The lighting was available daylight but, to fill in the shadows under the tree, the photographer placed a reflector to the right of the camera.

Technical Details
8x10in large format camera with a 450mm lens and Kodak Tri-X film. Platinum print on hand-coated paper.

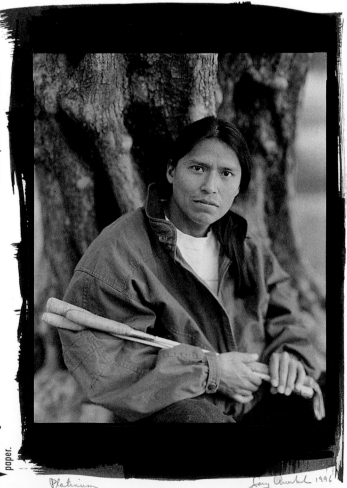

Platinum Gary Auerbach 1996

Seeing

Gary Auerbach spent two weeks on the set of a movie being shot in the old Western town of Mescal. To portray actor Douglas Rowe playing a US marshal, he wanted a full-length portrait that would include the old buildings of the town.

Thinking

He posed the actor in the dusty main street of the town, with the old clapboard buildings behind him. He selected a large aperture that kept the subject sharp but threw the background out of focus. He felt it was lacking something, however, so he had the black horse moved into shot behind the actor. This added just the right amount of background interest

Acting

It was a hot day with bright sunlight, which gave plenty of illumination but created harsh shadows on the subject's face. To even these out, Auerbach got an assistant to hold up a rectangular reflector six feet high, out of shot to the left of the camera. This threw plenty of light back on to the subject and evened out the shadows.

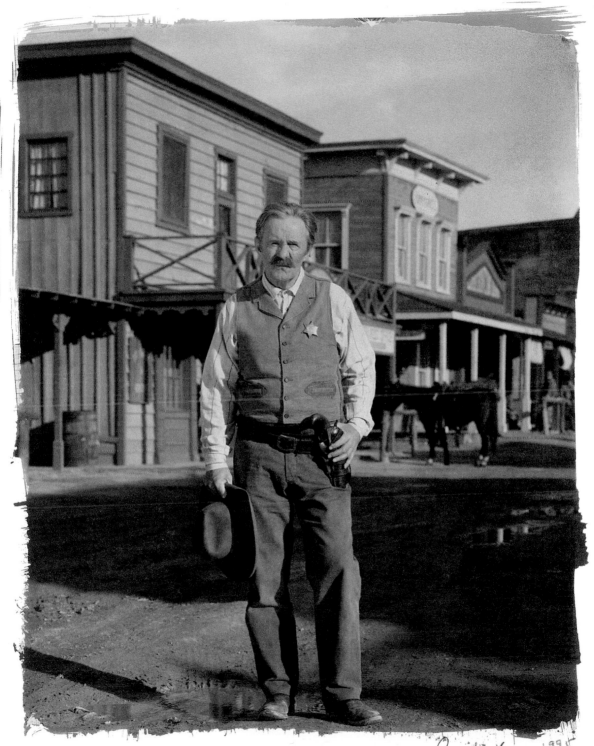

Technical Details

8x10in large format camera with a 450mm lens and Kodak Tri-X b&w film. Platinum print on hand-coated paper.

Cropping Effectively

The scene in front of the camera is the photographer's raw material. The skill lies in selecting the portion of that scene that will make an effective photograph. Every photograph involves cropping to some extent, but particularly bold crops can be used to add interest and impact to the image. This can be done in-camera at the time of taking the picture, or afterwards, when the image is printed.

Seeing

Carlo Chinca took this picture of showbiz character Ronnie Knight at his home in Spain for a magazine article. He asked his subject to sit on a chair in front of a plain wall, which provided a neutral background. He wanted to convey his **strong character** and so chose to crop in close on his face to emphasise his **chiselled** features.

Thinking

Working with a **hand-held** 35mm SLR camera, the photographer was able to move around the subject to try out different framings. He selected an **85mm** lens, which allowed him to get in close. He lit the picture with a single softbox, set up on a **boom stand** and angled so that it was slightly above the subject's face and to his left. He also placed a circular reflector to the right of the subject.

Acting

When Chinca actually took the picture he framed it horizontally, and included the whole of the subject's face and hair. However, later on he decided that the image would benefit from even tighter framing and so when he printed it, he **cropped** in extremely closely on the central portion of the negative. This created a vertically framed image that is **dominated** by the subject's strong facial features.

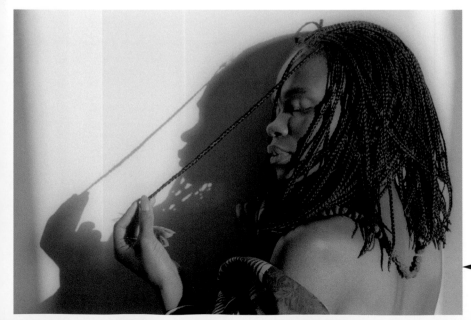

Alain Paris used a standard 50mm lens with a 35mm SLR for this tight horizontal crop. The model was placed off-centre but he balanced the composition with the graphic shadow that filled the left-hand side of the frame. There was no artificial illumination involved, just strong natural daylight falling into the room through a window. The plain white wall was all that was needed to provide the necessary background.

◄Technical Details
35mm SLR camera with a 50mm lens and Kodak Tmax 400 b&w film.

Technical Details

▼ 35mm SLR camera with an 85mm lens and Ilford FP4 film rated at ISO 200.

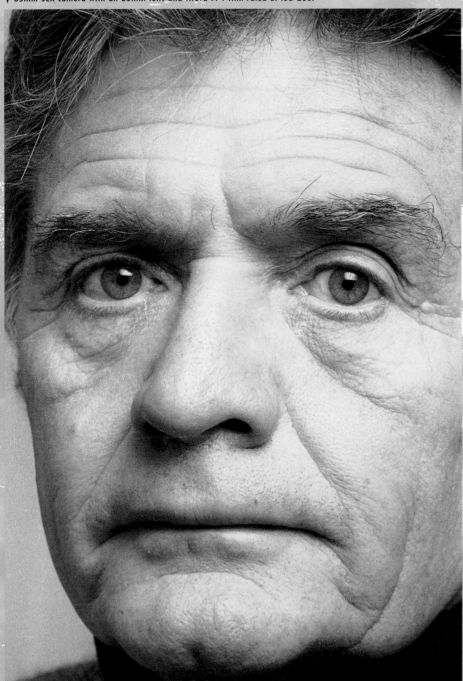

A softbox and reflector provided the illumination for this picture, which originally was framed horizontally. When he printed it, Carlo Chinca made a tighter, vertical crop which had a much stronger impact.

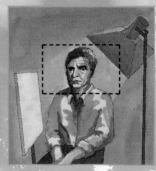

Cropping Effectively

Seeing

This was one of a **series** of portraits Ton Hendriks took of young homeless people, showing them in their **day-to-day** environments. He asked this young woman, whose name was Odelia, where she wanted to have her picture taken. She simply chose to sit in the space between the lockers.

Thinking

The cropping was done **in-camera**. Hendriks placed his camera at an angle of **45 degrees** to the subject so that the lockers **appeared** large in the **foreground**. He didn't direct the pose at all: the subject's wary gaze at the camera was quite natural.

Acting

For all the pictures in this series, Hendriks used **hard lighting** to underline the bleak moods and situations in which the young subjects found themselves. For this shot he used two flash units. The first, with a hard reflector and a **honeycomb grid**, he placed on the right-hand side, illuminating the subject's body and the left-hand side of her face. To fill in the shadows a little, he used a **second flash** angled upwards at 90 degrees, so that its light was diffused by being **reflected** off the ceiling.

◄ **Technical Details**
Medium format camera with a 90mm lens and Kodak Tmax 100 b&w film.

Rule of Thumb

The easiest way to crop in-camera is to use a zoom lens. This allows you to zoom in and out and try different ways of framing the image. The longer the range of the zoom the more options you have, but remember that the pay-off for a zoom's flexibility is usually a slight loss in image quality compared with lenses of a fixed focal length. However, images taken with a zoom still compare well with images created by cropping from a section of the negative. The bigger the blow-up, the more apparent the grain of the film becomes.

Technical Details
35mm SLR camera with a 55mm lens and Kodak Tri-X b&w film.

In this mother-and-son portrait, lit by a single photoflood unit, the little boy was prominent in the original image. However, Philip Winestone decided to concentrate attention on him even further by printing only a narrow section of the negative. He cropped in very tightly, and masked off most of the mother's face. However, there is still enough of her in shot for the picture to be a double portrait. Even though her face can't be seen, she is still a very strong presence in the background.

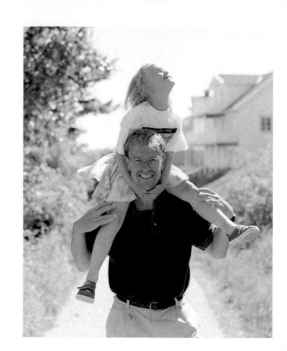

Lighting

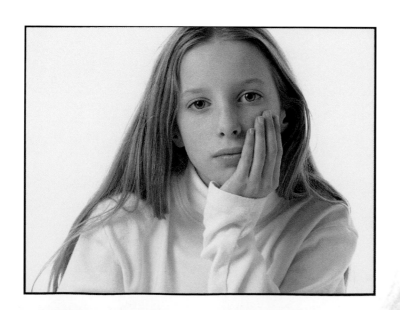

3

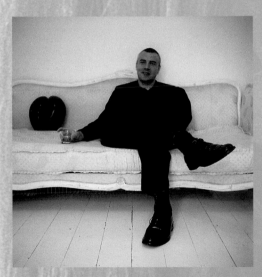

Light is the raw material of photography. Natural
daylight creates a huge variety of lighting situations,
ranging from bright sunlight illuminating the whole scene, to directional illumination slanting
through doors and windows, and all of these can be exploited to alter the mood and feel of
the image. Moving indoors gives the photographer the opportunity to experiment with studio
lighting. A simple home studio need not be expensive and gives a high degree of
control over the way in which the subject is portrayed.

Using Available Light

There are many occasions where flash is used when it would have been better to make use of the available light, whether it is normal room lighting, window light or a mixture of both. It has the big advantage of retaining the atmosphere of a room or situation, something which flash can easily destroy. It's largely the quality of the ambient light which should dictate the use of flash as with today's very fast films its intensity is seldom a restriction.

Seeing

This picture was taken in the Casino at Baden Baden and the room was lit by a mixture of artificial light and daylight from distant windows. The artificial light was an important factor as it contributed enormously to the room's atmosphere.

Acting

He used a fast daylight film and a tripod to allow the use of a fairly slow shutter speed, as the light was not very bright and framed the shot quite tightly so that the semi-silhouetted man in the foreground became the dominant element of the composition.

Thinking

The artificial light was brighter than the small amount of daylight and Michael Busselle considered using artificial light transparency film. However, he felt that the warm colour cast he would get from using daylight film would enhance the atmosphere and accentuate the rich colour of the gilded decor.

Rule of Thumb

When shooting with available light and the colour quality of the light sources are unknown, or mixed, and are not very bright, a fast colour negative film, such as Fuji Super G 800, can be the best choice as it is much more tolerant of colour casts and has greater exposure latitude than transparency film.

Technical Details
▼ 35mm SLR Camera with a 105mm lens and Kodak High Speed Ektachrome.

Busselle photographed this Parisian café scene on daylight transparency film at dusk when the interior artificial lights were brighter than the residual daylight, which resulted in the characteristic warm glow created by the colour cast.

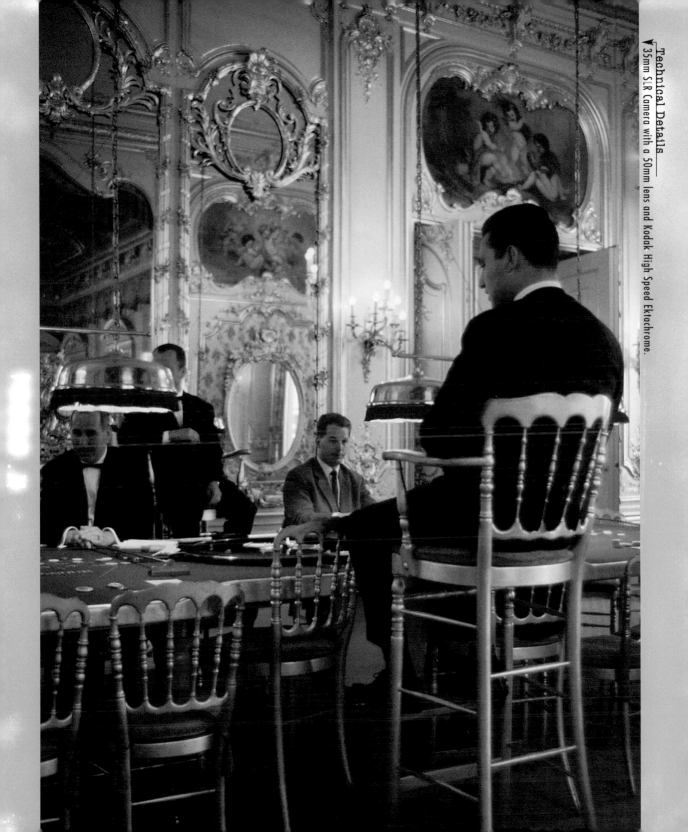

Technical Details
35mm SLR Camera with a 50mm lens and Kodak High Speed Ektachrome.

Using Available Light

Seeing

This lady was a sensitive but strong character, and Janna Dekker wanted a direct, **intense** picture that aimed to capture her personality. She chose to photograph her head-on, gazing straight into the camera. She kept the background **simple** and uncluttered, posing her subject against a plain wall that had a neutral tone.

Thinking

The lighting was available daylight from a **north-facing** window. Dekker placed her subject so that one side of her face was brightly lit while the other was largely obscured by shadow. The light was strong enough to create catchlights in both her eyes, in the way a flashgun would, giving her gaze a dramatic, piercing quality. The result was a painterly effect – apt, as the subject was an artist.

Acting

Dekker used a **100mm lens** to crop in close on the subject's face to make the portrait more intense. She used a **tripod** with a **swivel head**, which allowed her to tilt her 35mm camera on its side and frame the picture vertically. To avoid jarring the camera during exposure, she fired the shutter using a cable release.

◄ Technical Details

35mm SLR with a 100mm lens and Kodak Tri-X b&w film.

Carlo Chinca used available light for this picture of actor Sir Nigel Hawthorne when he was appearing in a stage production of The Madness of King George at the Theatre Royal in Bath. The strongly directional light, falling through a window, picked out one side of the actor's face in fine detail and created a catchlight in his eye, while leaving the other side in deep shadow.

Technical Details
35mm SLR with an 85mm lens and Kodak Tri-X b&w film.

Carlo Chinca took this shot of actor Tony Head in the subject's own home, using available daylight. The subject's shirt matched the green of the window shutters, and the photographer simply stood him next to the window. The directional light gave plenty of contrast in his face, while the interior of the room trailed off into darkness. However, light levels were quite low so the photographer had to set a slow shutter speed – 1/30sec – even with a relatively wide aperture of f4. This meant the subject had to stay quite still to avoid any movement blurring the image.

Technical Details
35mm SLR camera with a 50mm lens and Fuji Provia 100 colour transparency film.

Seeing

Richard Lewisohn photographed this actor, Grant Masters, between takes while he was shooting a television commercial. He wanted a clean, simple picture and was attracted by the contrast between the light-coloured tiles and the subject's dark suit.

Thinking

The sunlight was bright but was diffused through a veil of early morning mist. This overcast daylight was strong, soft and very even, almost as if the subject had been lit with a gigantic softbox. The photographer posed him simply on a chair out in the open air, and composed the picture quite tightly.

Acting

Lewisohn was using colour negative film, which has a far greater exposure latitude than transparency film and will generally produce acceptable results even when the exposure is not quite right. However, on this occasion he deliberately pushed the film a stop, setting the camera controls so that the ISO 100 film was rated at ISO 200. This had the effect of boosting the contrast.

Rule of Thumb

In low light situations, film can be 'pushed' to increase exposure latitude. Pushing involves setting the film speed dial at a higher rating than the film's nominal ISO speed. The film is underexposed but is developed for longer to compensate. This technique allows the photographer to select a faster shutter speed to avoid subject movement, or a smaller aperture to increase depth of field. It boosts contrast and also increases the graininess of the image.

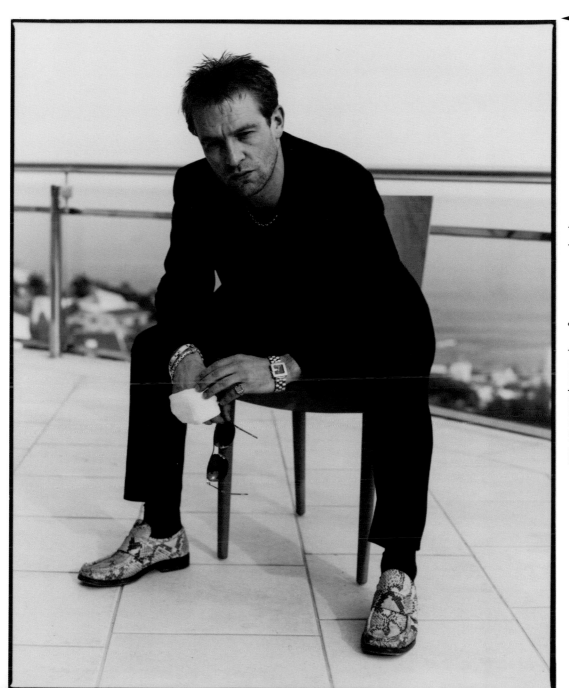

Technical Details
Medium format camera with an 80mm lens and Fuji Superia 100 colour negative print film pushed to ISO 200.

Using Available Light

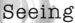

Seeing

When Gary Auerbach was first introduced to this 94-year-old Native American battle chief and his family at their home in Taos Pueblo, New Mexico, the old man was too tired to do any photography. Being patient, the photographer agreed to come back the next morning. The old man was fresher then and there was the bonus of bright morning sunlight falling naturally through his living room window.

Thinking

Auerbach wanted to photograph the old man in his own living space, but the small room was extremely cramped. Besides the table in the foreground, there was another table to the photographer's right and a wood-burning stove beyond that, behind the old man. There wasn't space to set up any artificial lighting, even a reflector to fill in the shadows, and there was no question of re-arranging the room. This meant he had only the window light to work with.

Acting

The old chief was anxious about what he should do, but Auerbach asked him simply to sit next to the window and turn his face towards it. As the photographer set up his camera, he relaxed in the morning sunlight and sat quite still. To get the exposure right, Auerbach opened up the aperture to record detail in the shadow areas of the subject's face and hands. Doing this, however, meant he could no longer control exposure in the highlight areas, so he left these to burn out slightly.

Rule of Thumb

Dodging and burning are common darkroom techniques for the black-and-white printer. Dodging involves covering up part of the image so that it receives less exposure from the enlarger and so prints lighter. A circular piece of card attached to a length of stiff wire makes a good dodging tool. Burning involves giving areas of the print more exposure so that they print darker, and is often used to fill in shadow areas. You can use pieces of card, or simply your hands, to mask off the rest of the image during exposure, but remember to keep them moving gently back and forth to avoid hard edges appearing in the finished print.

Technical Details ▶

11x14in large format camera with a 450mm lens and Ilford FP4 b&w film. Platinum print on hand-coated paper.

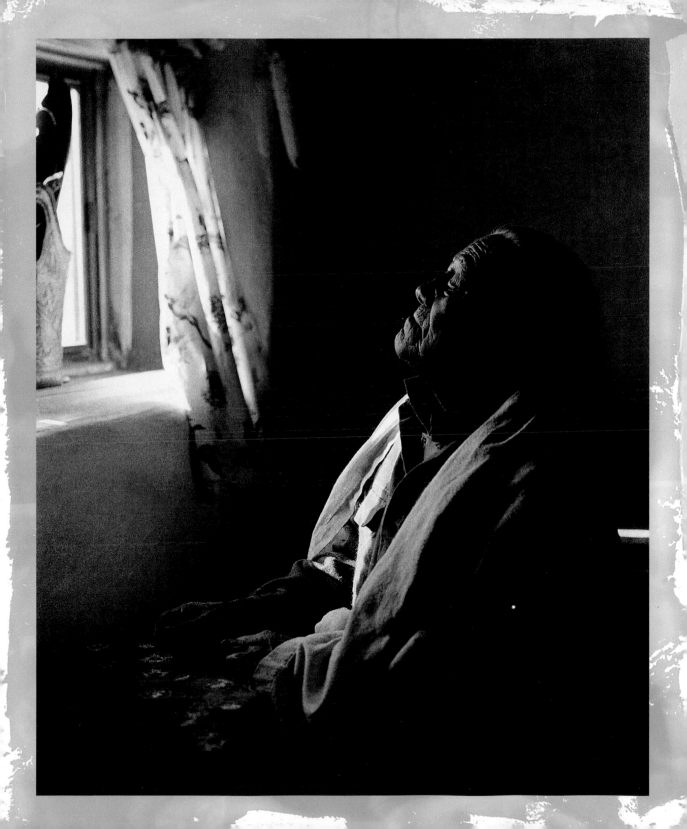

Using Window Light

Seeing

This was a rather elegant room with a large north-facing window which created quite a soft, even light and enabled Michael Busselle to shoot without having to use a reflector.

Thinking

Because the setting itself was so attractive, he opted to use a fairly distant viewpoint and wide framing in order to use the room's interior as part of the composition.

Acting

He framed the image so that the two models were placed in the lower half of the frame and switched on the table lamp in the background to contribute an inviting warm glow to a picture which would, otherwise, have a fairly cool, bluish quality, as well as adding some light to the more shaded background.

Rule of Thumb

You can exercise a considerable degree of control over the quality of window light by the use of reflectors to fill in shadows and by using diffusing materials, such as white net curtains or tracing paper, over the window itself. Its direction can be controlled by the way you place your model in relation to the window and this can be made easier if you have a readily movable background, such as a painted board, a roll of paper suspended from a light stand or a custom-made collapsible fabric background such as Lastolite.

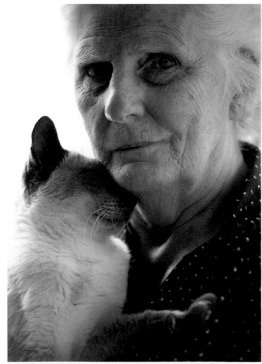

This portrait of Michael Busselle's mother with her favourite cat was taken by placing her inside a bay window on a cloudy day. Busselle liked the effect created by the soft light being directed from both sides of her and the burnt-out window behind creating a white background.

Technical Details
▼ 35mm SLR Camera with a 105mm lens and Kodak High Speed Ektachrome.

Technical Details
35mm SLR Camera with a 35–70mm zoom lens and Kodak High Speed Ektachrome.

Using Window Light

Seeing

This Moroccan man had invited Michael Busselle into his home and his mud-walled room was flooded with sunlight from two small windows and a partially open roof. It created a beautiful golden light because of the tinted walls, and Busselle was taken by the fact that the man's skin took on a colour which almost matched them.

Thinking

He had no reflector and was reluctant to use fill-in flash so he asked the man to stand in a spot where the light on his face was soft enough to create good modelling without excessive contrast and where there was just enough light reflected from an adjacent wall to reveal some detail in the shaded side of his face.

Rule of Thumb

Fill-in flash is a useful alternative to using a reflector when the shadows cast by window light are too dense and the image is too contrasty. But be careful not to overdo it, it's best to set the flash exposure to give about one stop less than the correct exposure to retain the effect of the window light and create a natural-looking quality.

Technical Details

▼ 35mm SLR Camera with a 75–150mm zoom lens and Kodak Ektachrome 64.

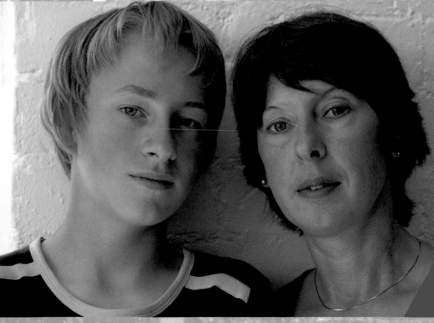

This double portrait was taken close to a large north-facing window on a bright sunny day and a small window opposite provided enough fill-in to avoid the use of a reflector. In normal circumstances, when shooting two or more people together, Busselle would arrange them so their heads were at different levels, but he rather liked the side-by-side effect of this mother and son picture.

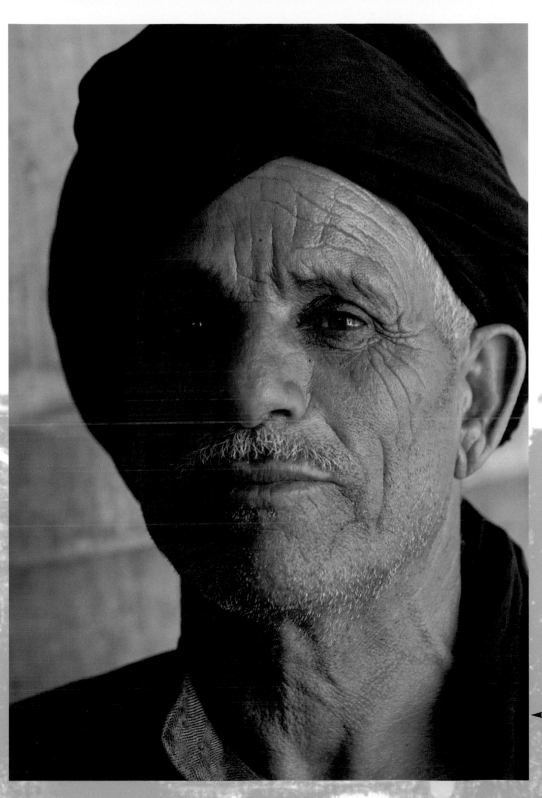

Acting
Busselle used a **long-focus** lens to frame the image quite tightly, from a fairly distant **viewpoint,** with just enough of the **background** visible to echo the flesh tones.

◄ Technical Details
35mm SLR Camera with a 70–200mm zoom lens and Kodak Ektachrome 200.

Using a Flash Gun

A flash gun is a very useful accessory as it enables you to shoot pictures when there is not enough light to make normal photography possible. But pictures taken by direct flash alone can be very disappointing, often with black, featureless backgrounds and little of the atmosphere which the situation possessed. However, with a little care, a flash gun can be used to create an attractive lighting quality and produce pictures where its use is not so obvious.

Seeing

Michael Busselle took this portrait of a clown in his caravan where the possibilities of both lighting and choice of viewpoint were very limited.

Thinking

One largish caravan window was covered with a net curtain and Busselle decided to use this as a background, as it was virtually the only plain area available.

This impromptu shot was taken at a children's party. The room was dimly-lit from a window at one side and by an overhead light fitting. These sources alone created an unattractive effect, so Busselle opted to use a flash gun bounced from the ceiling above his head. However, he also set a shutter speed which was slow enough to make some use of the ambient light and this has helped to create a more natural effect.

This illustration shows how the light from a flash gun can be bounced from a white ceiling to create a more natural effect.

Technical Details
35mm SLR Camera with a 70–200mm zoom lens and Kodak Ektachrome 200.

Acting

As the **ambient light** in the caravan was not creating an attractive **effect**, Busselle decided to use a flash gun and placed it slightly to one side of the camera, **diffusing** it with a small soft box. He set a **shutter speed** which was slow enough to make the window **burn out** and for the light from it to create a **highlight** on the side of the clown's face.

◀ **Technical Details**
35mm SLR Camera with a 35–70mm zoom lens and Kodak High Speed Ektachrome.

Studio Lighting

Studio lighting is infinitely variable and gives the photographer great control over the mood of the image, yet it doesn't have to be complicated. A flash unit or two, a reflector and a simple background are all the studio photographer needs to get started. Used in different combinations, these few items of equipment provide a great variety of lighting effects and the potential for many different kinds of image.

Richard Lewisohn created the harsh shadow behind the girl by placing a strong light high up to the left. He used a second light as a fill-in, bouncing it up off a sheet of polystyrene placed at an angle on the studio floor.

Seeing

Richard Lewisohn was aiming for a simple look with this shot, but a glamorous one. He liked the effect created by fashion photographers who worked with film lights used straight, without any form of diffusion, and decided to try the technique for himself. He arranged a session in a film studio that had a plain white wall he could use as a background. His model, Caroline, wore a simple, dark outfit.

Thinking

The photographer placed his main light, a tungsten film light, high up on a stand to the left of the camera, angled downwards. The strong light was undiffused, in order to create the hardest shadow possible behind the girl. To fill in some of the shadow areas on her body, he placed a 4x8ft sheet of white polystyrene on the studio floor, angled slightly upwards, and positioned a second, smaller tungsten film light so that its light was bounced up off it.

Acting

He asked the model to jump as high as she could as he fired the shutter. To freeze her movement in mid-air, he selected a large aperture and the fastest available shutter speed, which on his medium format camera was 1/400sec. It took many attempts to get a shot in which the girl's limbs and the shadow behind her were at just the right angles to create an effective composition.

Technical Details
Medium format camera with an 80mm lens and Ilford Delta 400 b&w film rated at ISO 800.

Anna Fabres wanted to portray her subject in a relaxed and self-confident fashion. She used a twin lens reflex camera positioned about ten feet away from the model and very close to the ground, an angle of view that made his feet appear large in relation to the rest of his body. The main source of illumination was available daylight flooding through the open studio door. Rather than use flash to supplement it, Fabres used three daylight lightbulbs, balanced to replicate natural daylight. One lit the ceiling while the others lit the two side walls. The light reflected back off the white surfaces created a bright but soft daylight effect.

Technical Details
TLR medium format camera with Fujichrome Provia 400 transparency film.

Seeing

This was one of a series of publicity shots that Richard Lewisohn created for the man in the foreground, who was a rap musician. He was looking for a moody and slightly mysterious feel to the picture, to match the artist's persona. Lewisohn also wanted to include the man's producer in the picture. The producer plays a rather shadowy but vital background role in the recording studio, and he wanted to represent this relationship in a visual manner.

Thinking

He used a large roll of plain grey paper to create a dark background. He took readings from the rapper's face and his white jerkin, and set his exposure so that those areas would be correctly exposed. He set up a single large softbox fitted to a studio flash head in front of the pair. This had enough power to light the men's faces, but the rest of the scene tailed off into darkness.

Acting

A relatively large aperture gave a shallow depth of field, meaning that there was only a narrow band of sharpness in the frame. Lewisohn focused on the rapper's face in the foreground. The producer, standing behind him, remained clearly visible but his face was thrown out of focus, precisely the effect the photographer wanted to achieve.

Technical Details
Medium format camera with an 80mm lens and Ilford Delta 400 b&w film.

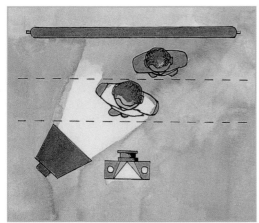

It can be tricky to get the exposure right for subjects with dark skin. Automatic meters generally take account of the overall scene, meaning that faces tend to 'fill in' and lose detail. To overcome this problem, take spot meter readings from the subject's face and set your exposure accordingly, maybe opening up the aperture an extra stop or two. Flash can be used to even out the shadows and to highlight features.

Richard Lewisohn set up a single softbox to illuminate the men's faces, but it wasn't strong enough to illuminate the dark background. Shallow depth of field meant that only the man in the foreground was in sharp focus.

Richard Lewisohn was experimenting with beauty lighting for this studio shot. He lit the girl with two long, thin softboxes, one placed above her face and one below, to create a flattering, shadowless illumination. He opened up the lens two stops above the indicated meter reading so that the subject's face lost detail while the dark shadow areas remained distinct. He boosted the contrast further by using a yellow filter.

Technical Details
Medium format camera with an 80mm lens and yellow filter, and Ilford FP4+ b&w film.

A softbox to either side and a reflector in front of the subject concentrated light on the subject's face and hands. The black sweater virtually disappeared against the black background.

◄ Technical Details
Medium format camera with a 150mm lens and Kodak Tri-X b&w film.

Seeing

This lady told Ronnie Bennett that she didn't usually like photographs of herself but, as she had recently survived a near-fatal car accident, she'd like to have some taken as she was glad to be alive. She was only free late in the evening so this meant the pictures had to be done in the studio.

Thinking

The subject arrived wearing a denim shirt but, as the session progressed, Bennett was struck by her extremely expressive hands and face, and decided to concentrate on these. To make them stand out, she lent the subject a black polo-neck sweater that blended in with the plain black background. To keep her animated, she carried on a lively conversation throughout the session.

Acting

The lighting consisted of a softbox positioned to either side of the subject and a reflector placed in front of her, quite low down. This set-up concentrated illumination on her face and hands to the extent that the black sweater virtually disappeared, creating a ghostly yet graphic effect. Bennett used a moderate telephoto lens which allowed her to crop in quite tightly, creating a diagonal composition.

Studio Lighting

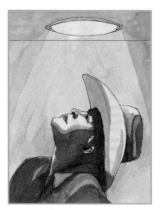

Simple but effective: a recessed ceiling light was the only illumination for this high-contrast shot.

Gamini Kumara let the subject direct the photographer for this shot, rather than the other way around. The cowboy hat was the model's own idea. The lighting was provided by a simple recessed ceiling light. Kumara stood the girl under the light and took a few shots, though without any clear idea of how the picture was going to turn out. When the model looked directly up at the light, however, it created this high-contrast effect, and the photographer knew she had her picture. She took her exposure reading with an incident light meter and shot with the lens wide open, which created a very shallow depth of field.

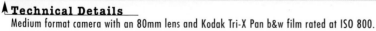

Technical Details
Medium format camera with an 80mm lens and Kodak Tri-X Pan b&w film rated at ISO 800.

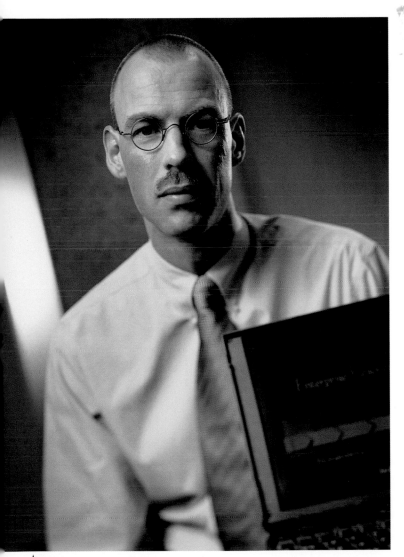

Seeing

Ton Hendriks was commissioned by a business magazine to photograph an executive who worked for a multinational computer corporation. Assignments like this are usually pretty dull so, photographically, he tried to get as much out of it as he could. Fortunately, the subject was quite interested in photography himself and so was happy to spend time setting up the shot.

Thinking

Hendriks put the man's laptop computer on top of a wastepaper bin placed on the table, which brought it up to the required level. He tilted the lens on his large format camera forward to its maximum angle and focused on the subject's eyes, so that his face was in sharp focus while the rest of the frame was blurred. He also tilted the camera slightly on its side to create a dynamic angle.

Acting

Hendriks placed one flash unit to the left of the camera, at an angle of about 45 degrees to the subject, and bounced it off an umbrella to light his face. To outline his head, he placed another, undiffused unit to the right and almost directly behind the subject. As an additional effect, he put a third flash unit in the room next door and fired it through a strip of glass in the partition wall. This created the band of light on the left-hand side of the frame.

▲ Technical Details
5x4in large format camera with a 150mm lens and Kodak Tmax b&w film.

Anna Fabres improvised a home studio for this shot. She wanted an intimate picture of the subject, suggesting a person lost in his own thoughts. She hung a piece of black fabric on her living room wall to create the dark background, and heaped cushions on the floor for the model to lean on. The lighting came from an ordinary domestic lamp with a 100w lightbulb, placed very close to the model's face. She framed tightly with a 35–70mm zoom, and afterwards toned the print a warm sepia colour.

Technical Details
35mm SLR camera with a 35–70mm lens and Ilford XP2 chromogenic b&w film.

Rule of Thumb

There are many different types of toner to provide finishing touches to black-and-white prints. Sepia, which creates an antique, old fashioned feel is one of the most popular, but blue and gold toners are also commonly used. They are applied in the darkroom in the form of a solution in which the print is bathed after the image has been developed and fixed. The toner colours the whole print evenly, but shows up most strongly in the lighter areas of the image.

Seeing
Jørgen Brandt used a model with a contemporary look, but wanted to create an antique feel to go with the camera he was using – a 100-year-old 5x7in mahogany camera with its original brass lens. He wanted a picture that would work well with sepia toning, and chose a classic single-flash lighting set-up that highlighted the model's features but also left areas of deep shadow.

Thinking
Using the old camera was a painstaking process and Brandt needed to make sure the model was comfortable while he was setting up the shot. Focusing and composition were done under a black cloth, with the image appearing on a ground glass screen. The image was upside-down and back-to-front and he had to compensate for this while arranging his composition.

Acting
Brandt made sure the model and the flashgun were in the positions he wanted, then turned out the light and inserted the film into the camera. The camera had no shutter, so he fired the flashgun manually to make the exposure, then removed the film from the camera before turning the light back on.

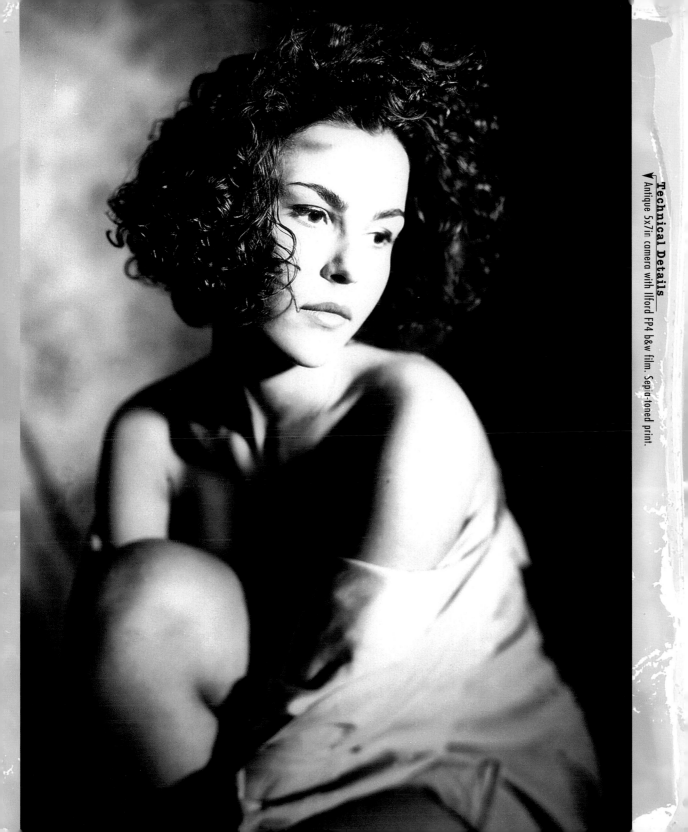

Technical Details
Antique 5x7in camera with Ilford FP4 b&w film. Sepia-toned print.

Studio Lighting

Seeing

Michael Busselle considered a number of **options** for photographing this little girl with her mother, but the idea of making it look more like a **fashion shot** than a conventional family portrait appealed to him most.

Thinking

As both mother and daughter were wearing **blue** he chose a blue **background** to echo this and to make the **skin tones** the only contrasting colour.

Acting

He placed a large white reflector at about 45 degrees to the camera on the left and **bounced** two lights off it so that it was **evenly illuminated** and flooded the couple with a very soft, even light. He placed them close to the background so that a soft **shadow** was cast. The white walls of his small studio provided enough **fill-in** to weaken the shadows.

Technical Details
▼ Medium Format SLR Camera with a 55–110mm zoom lens and Fuji Astia.

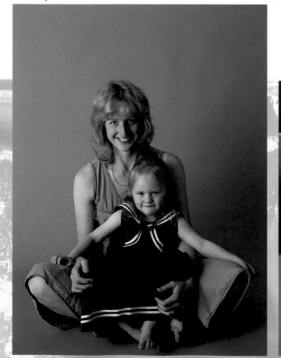

Busselle has a natural inclination to use lighting for people with well-matured faces which will accentuate the texture and lines which the years bestow. But in this instance, he decided to use the sort of very soft, frontal lighting which would normally be used for a beauty shot. He used a very diffused light source from as close to the model's face and the camera as he could place it with a white reflector very close to her on the opposite side.

Technical Details
Medium Format SLR Camera with a 105–210mm zoom lens and Kodak Ektachrome Professional 100.

Technical Details ➤
Medium format SLR 120mm macro lens and Fuji Astia.

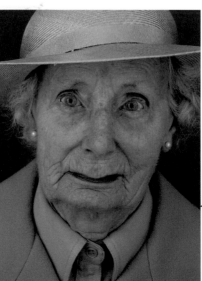

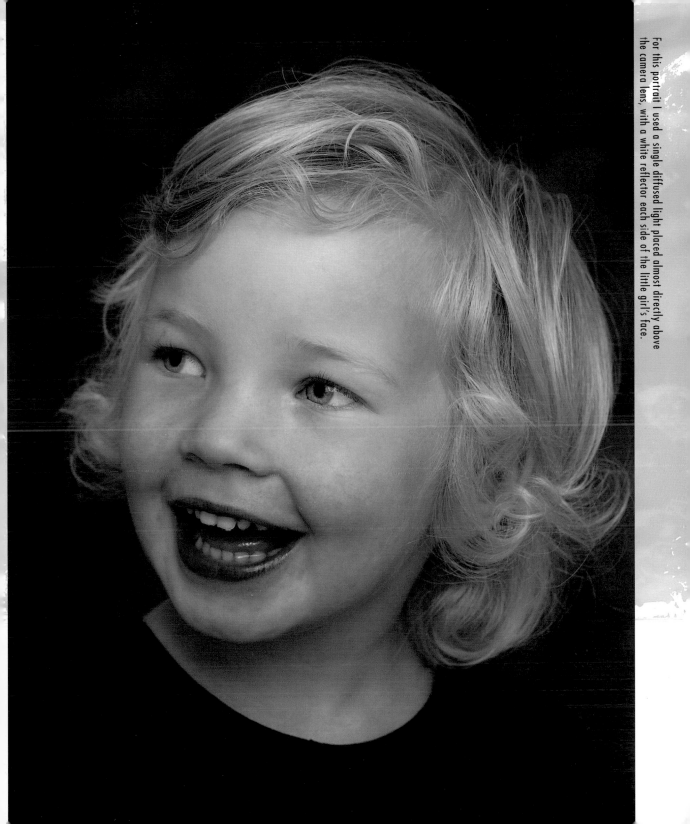

For this portrait I used a single diffused light placed almost directly above the camera lens, with a white reflector each side of the little girl's face.

Seeing

These three faces all have considerable **strength** and Michael Busselle wanted to combine them in a **family group** in a way which gave them **equal** emphasis.

Thinking

For this reason he opted for a **tightly-framed** image and needed to find a way of placing them so their heads were quite **close together** and on a similar plane.

Acting

They were lit in exactly the same way as the pictures on the opposite page but with the substitution of a **painted canvas** background which was lit by a **separate flash**. He asked the lady to take off her black top so the **image** consisted primarily of brown, orange and blue.

Rule of Thumb

When photographing two or more people together it usually helps to create a more balanced arrangement if you position them in a way which places their heads at different levels. Busselle often uses plastic bottle crates stacked to create a variety of levels; they can be covered with fabric to tone with the background if they are visible.

Technical Details
Medium Format SLR Camera with a 105–210mm zoom lens and Fuji Astia.
Technical Details
Medium Format SLR Camera with a 105–210mm zoom lens and Fuji Astia.

The lighting set-up for these portraits is shown here.

These two photographs were taken during the same session using the same basic lighting set-up. The close head shot was lit by a single, lightly-diffused flash placed at about 30 degrees to a line between the camera and model and Busselle placed a black reflector close to the model's face on the opposite side to prevent reflected light weakening the shadows. Another light was aimed at a roll of white background paper and he draped a piece of black fabric around her neck and framed the image so that the image was restricted to just black, white and brown.

The longer shot was lit in the same way but less tightly framed, to accommodate the model's pose, and with the black reflector removed to allow some reflected light to weaken the shadows and show more detail.

Studio Lighting

Seeing

Michael Busselle had been shooting some nudes of this model who, he thought, had a particularly lovely back and was exploring ways of photographing her in a way which emphasised it.

Thinking

He asked her to wear the black leather miniskirt and tights to create the sort of look you'd expect to see in a conventional glamour picture shot from the front. The red background was chosen because he liked the combination with the black.

Acting

But he felt the picture needed something more, so he asked the model to stand very close to the background and then lit her with a single, undiffused light from just below the camera lens, and slightly to one side, so that it cast an outline shadow from her body onto the background.

Technical Details

▼ Medium Format SLR Camera with a 150mm lens and Kodak Ektachrome 64.

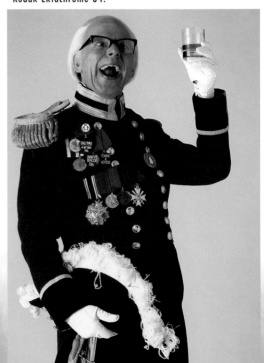

Busselle took this picture of the late John Wells in his role as Dennis Thatcher and because of his very colourful costume he decided to keep the image quite simple. He used a white background lit by two flashes on each side and balanced them so that a slight amount of tone remained. The key light was provided by a large soft box placed almost at right angles to the model with a large white reflector very close on the opposite side.

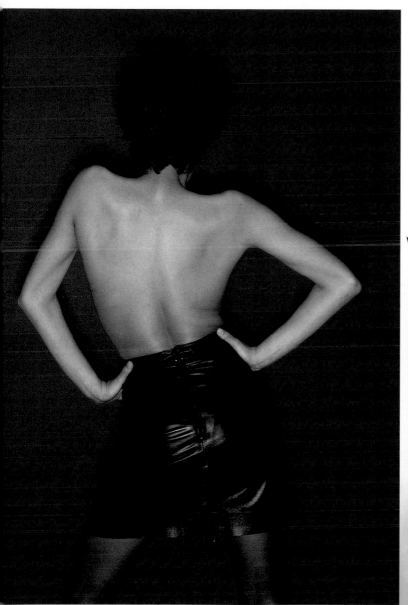

Technical Details
▼ Medium Format SLR Camera with a 150mm lens and Kodak Ektachrome 64.

Rule of Thumb

It's helpful to appreciate that the softness of a
light source and the nature of the shadows it
creates is dependent upon its size in relation
to the subject, as well as the way in which it
is diffused. In this way, a one-metre soft box
placed very close to someone's face will create
a much softer quality than the same light
source placed several metres away for a full-
length shot.

Busselle placed a large, heavily-diffused soft
box very close to this model and almost at right
angles to him, with a large white reflector on
the opposite side to bounce some light back
into the shadows.

Technical Details
▼ Medium Format SLR Camera with a 150mm lens
and Kodak Ektachrome 64.

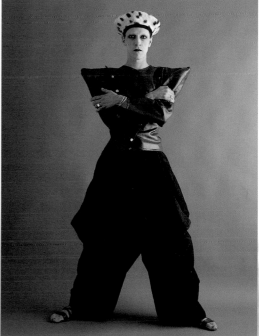

Soft Lighting

Soft lighting doesn't suit every subject, but is a particularly attractive option when photographing female subjects or small children. There are numerous ways to create soft lighting effects, either through the choice of lighting equipment or by using filters or diffusers over the lens or on the flashgun. Most soft lighting effects are best achieved in the studio, where the photographer has close control over the lighting set-up.

Seeing

Anna Fabres met this girl, whose name was Florence, at a hairdressing salon in London. From the moment she saw her, she imagined her long black hair filling the frame, and she persuaded her to model for some pictures. For the session, Florence wore white clothing and white make-up, and applied plenty of colour around her eyes.

Thinking

To make her hair look as if it was standing on end, as though electrified, Fabres got the girl to lie down on the studio floor and spread her locks out around her. She then set up a stepladder and framed the picture from the top of it, looking down on the subject. She adjusted the positions of the individual strands so that they neatly filled the frame.

Acting

Fabres thought a picture with a cold blue tone would be the best way to highlight the hair, and so used a tungsten-balanced film in a lighting situation that was dominated by natural daylight. The main light source was daylight coming through the open studio door. Supplementary lighting came from three daylight-balanced lightbulbs, one lighting the ceiling and one each of the two side walls, to give a soft overall effect.

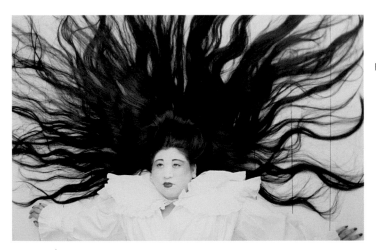

Technical Details
35mm SLR with a 35–70mm lens and Kodak Ektachrome 320 tungsten-balanced colour transparency film.

This picture was something of an experiment for Rune Andersson, who was trying out a new studio lighting set-up. His model had very blonde hair and a very fair complexion and, to make the most of these features, he wanted a portrait with soft, pastel colours. He sat the model, dressed all in white, on a stool in front of a plain white studio background, and lit her with a powerful studio flash unit. However, he diffused the light by bouncing it through a very large softbox, measuring six feet by nine feet.

Technical Details
Medium format camera with a 120mm lens and Fujicolor Reala colour negative film.

Soft Lighting

Janna Dekker simply used available light from a north-facing window and a plain background for this portrait. The slanting sunlight created catchlights in the girl's eyes and picked out the fine hairs on her arm. The simple white dress contributed to the gentle overall feel of the image.

Technical Details
Medium format camera with a 150mm lens and Fuji Neopan b&w film

Seeing

Ronnie Bennett was commissioned to photograph this young girl by her mother. The subject was slim and pretty but at an age when her teeth were not especially elegant. Therefore the photographer decided that a quiet, more serious picture with her mouth closed would be the most flattering way to portray her.

Thinking

Bennett envisaged a clean white background with soft, even lighting to emphasise the girl's delicate features and unblemished skin. However, the clothes she was wearing seemed a bit too bright, so the photographer gave her a white cotton polo-neck sweater to change into. This softened the overall feel of the image.

Acting

The subject was lit by a softbox positioned on her right-hand side and a reflector on the left, to fill in the shadows. Bennett also directed two flash units at the white background, with diffusers fitted over them to soften their light. This meant there was a lot of light bouncing around the studio, but very few harsh shadows. She moved in quite close with a moderate telephoto lens to frame the subject tightly.

Technical Details
Medium format camera with a 150mm lens and Fuji Neopan b&w film.

Soft Lighting

Rossaline Lucock wanted a soft, gentle feel for this studio portrait and so selected a plain white background together with a white cushion for the little girl to sit on. The lighting was chosen to accentuate the mood. One studio flash unit provided the main illumination while another picked out the girl's hair. A third was aimed at the background, reflecting back off it to bathe the scene in light. The effect was completed with a softening filter, which gave a slightly diffused quality to the final image.

▲ Technical Details
Medium format camera with a 150mm lens and Kodak 160 NC Portra colour negative film.

Rule of Thumb

There are plenty of soft-focus filters you can buy to give images a gentle, romantic feel, but it's easy enough to create your own soft-focus effects. Try attaching a sheet of tracing paper, a piece of muslin or a black stocking over the lens to soften the image. The simplest soft-focus technique is to mist up the lens by breathing on it, but make sure that everything is in place and you are ready to shoot before the misting clears.

Seeing
This girl's complexion was so strikingly clear and her hair so strikingly blonde that Gamini Kumara felt the only way to photograph her was with soft, even lighting that would emphasise those features. She made sure the girl was wearing a light-coloured top, and posed her in front of a plain white background. The intention was to create a luminous effect, almost as if the subject was lit from within.

Thinking
Kumara used a classic lighting set-up. She placed a single flashgun fitted with a softbox to the left of the camera. This provided soft illumination on the model's right-hand side, highlighting her long blonde hair. A reflector placed to the left of the subject threw light back on to that side of her face and body and filled in detail in the shadow areas.

Acting
The photographer asked the model to arrange her hands in this particular way and then just waited as the expression on her face changed. She fired the shutter when the expression seemed right, but only took three shots in all. When she printed the image, she dodged some of the hair areas, giving less exposure to the strands over the model's right shoulder so that they merged partly into the background. This helped give the luminous effect she wanted.

Technical Details ►
Medium format camera with an 80mm lens and Kodak Tmax film.

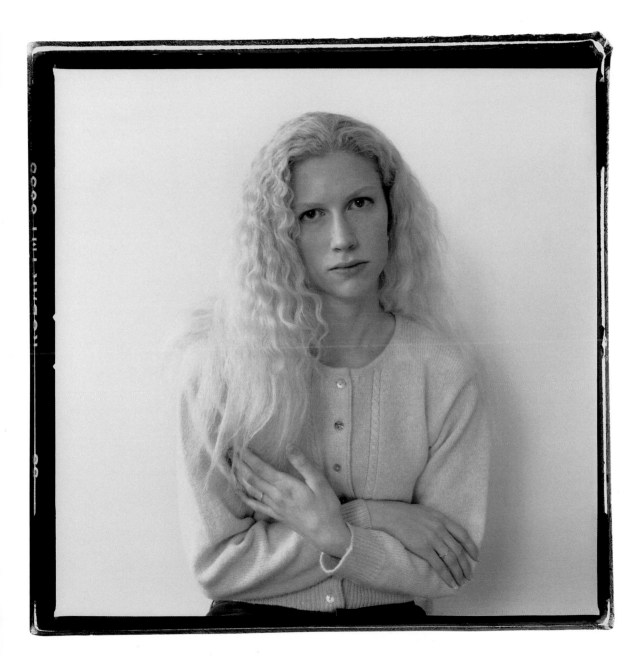

Shooting in Sunlight

Strong sunlight is not always best for shooting outdoor portraits, as it can create harsh shadows and force subjects to screw up their eyes against the glare. For these reasons, cloudy, overcast days are often better for outdoor sessions. However, with careful positioning of the subject, direct sunlight can be used to enhance outdoor portraits and make the subject sparkle.

Rune Andersson took this portrait as part of an assignment for an advertising client. He wanted a picture with a summery feel, so took his models to a seaside location on a bright, sunny day. He got the father and daughter to walk along a path that led down to the sea, walking backwards in front of them with an autofocus SLR. The sunlight was coming from behind them and to their left, providing strong backlighting. Andersson took spot-meter readings from the man's face and shirt and set his exposure so that detail was retained in those areas. He left the background to burn out, creating a luminous surround for the subjects.

Technical Details
35mm SLR camera with an 80mm lens and Kodak TCN 400 ▼ chromogenic film.

Seeing
Angela Read chose a warm spring day for this father-and-son portrait. She wanted to shoot the pair in an outdoor location where the landscape would provide a natural background. She decided on a local botanical garden as the venue and suggested they take a walk. This allowed her to scout for suitable backgrounds but at the same time helped to put the boy and his father in a relaxed frame of mind. Coming across this bed of reeds backlit by the sun, Read realised she had the perfect setting.

Thinking
She asked the pair to pose in the spot where the light was best, crouched down in the reeds. The backlighting created a warm halo around their heads but left their faces slightly in shadow, which meant they weren't forced to screw up their eyes against the sun. Many people's eyes are sensitive to direct daylight, with the result that they end up squinting painfully into the camera.

Technical Details ▶
35mm SLR camera with a 90mm lens and Fujicolor 400 colour negative film.

Acting

Read crouched down herself to shoot from a low angle, and included some of the foliage in the foreground to create a frame that extended all the way around the subjects. She chose a fast shutter speed, which allowed her to set a relatively large aperture. This meant the area of focus was shallow. Sometimes in lighting situations like this a reflector is needed to fill in shadows on people's faces, but here the photographer was able to do without.

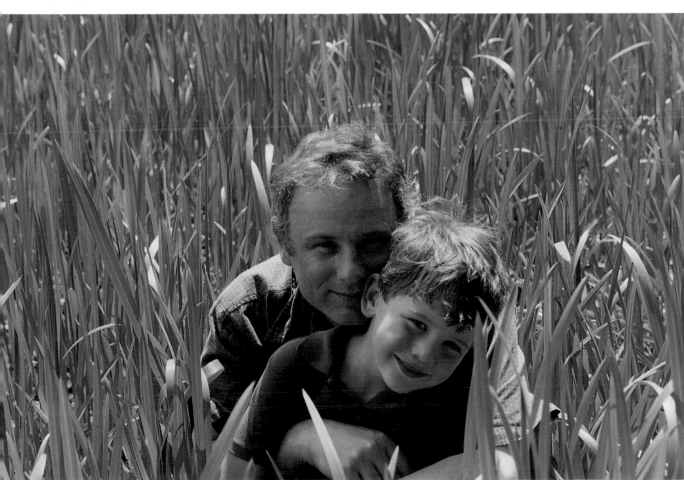

Shooting in Sunlight

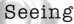

Seeing

This Spanish farmer was unsaddling his mule as Michael Busselle drove past his home, and he was struck by the **bold shapes** created by the pair of them when seen against the brightly-lit **whitewashed wall**. It was so perfect it almost looked like a studio set-up.

Thinking

It was afternoon and the sunlight, although **harsh** and strong, had mellowed slightly, and it was angled almost **directly** at them, creating only **small shadows** which had been weakened by the very reflective surroundings.

Acting

Busselle chose a **viewpoint** which placed the man's head **between** the strings of brightly-coloured red peppers and the **window grill,** and he framed the shot to include the latter together with the mule's tail.

Rule of Thumb

It's best to avoid direct sunlight for head and shoulder shots, especially for light-skinned people. As a general rule on a sunny day it is preferable to place your subject in an area of open shade, such as beside a wall or under a tree, or to shoot your pictures with the light coming from behind them.

Technical Details
35mm SLR Camera with an 35–70mm zoom lens, an 81A warm-up filter and Fuji Velvia.

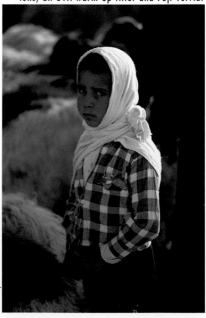

Busselle shot towards the light for this portrait of a young Arab boy, spotted in a market in Israel, in order to avoid the harsh effect of direct sunlight. This also had the effect of creating a distinct separation between the subject and his background.

Technical Details
35mm SLR Camera with an 75–150mm zoom lens, an 81A warm-up filter and Kodak Ektachrome 64.

<u>Technical Details</u>
↓ 35mm SLR Camera with a 28–70mm zoom lens and Fuji Velvia.

This shot was taken in the square of Jemma el Fna in Marrakech very late one afternoon, when the sun was at a low angle and its harshness had softened. Busselle chose a viewpoint from where the shadows cast by the sunlight were relatively small and unobtrusive.

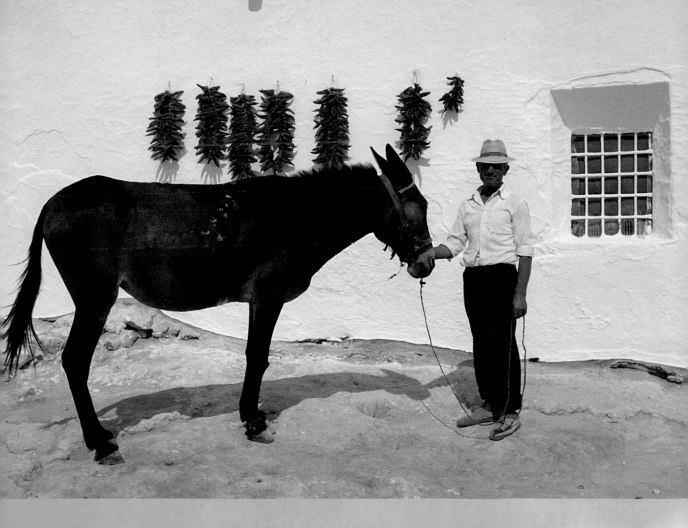

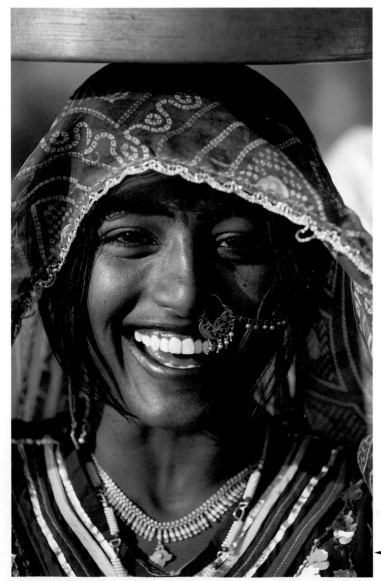

Seeing

Getting covered in sand was not intentional, and something normally to be avoided on a beach, but Michael Busselle liked the very tactile quality it created on the model's body as it seemed to accentuate the effect of her shiny, tanned skin.

Thinking

He first looked at the possibility of shooting into the light to create a softer, more flattering effect, but this greatly diminished the striking textural quality created by direct sunlight and he decided he liked the harsher quality of this better.

Acting

He asked his model to position herself so that the sunlight glanced at an angle across her body to accentuate the texture of the sand, but in such a way that the minimum amount of black shadow was created.

Busselle met this young lady whilst walking across the sand dunes at the Pushkar Camel fair in Rajasthan, and asked if he could take this impromptu portrait. He opted for a shot taken in direct sunlight, as he felt that her bright smile and dark skin would be enhanced by the quite harsh lighting which, at the time he took this picture in late afternoon, had partly mellowed, and was further softened by the reflective surroundings.

Technical Details
35mm SLR Camera with an 75–300mm zoom lens and Fuji Provia.

Technical Details
Medium Format SLR Camera with a 150mm lens and Kodak Ektachrome 64.

Controlling Contrast

Excessive contrast is one of the most likely
problems you'll face when shooting in
daylight, especially on sunny days and when shooting head-and-shoulder portraits. Too much
contrast results in images with little or no detail in both highlights and shadows. With portraits, it
can also create undue emphasis on skin texture and serve to
exaggerate blemishes, producing distinctly unflattering results.

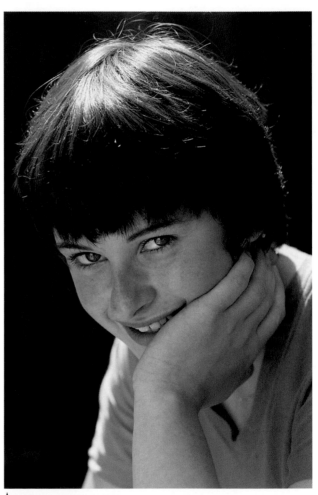

Seeing

This portrait was taken in very strong
sunlight and Michael Busselle needed to find a
way of reducing the contrast and create a more
pleasing quality of light.

Thinking

He asked his model to sit with her back to the
sun, which has created the highlights on her
hair and shoulders. But the main part of the image
was now in quite deep shadow and the
exposure required to produce a good skin tone
would have resulted in the highlights being
completely bleached out.

Acting

To overcome this problem Busselle placed a large sheet
of white polystyrene as close as possible
to the model, and angled it so that it reflected the
sunlight back into the shadows and reduced the
image's brightness range.

Rule of Thumb

The choice of viewpoint, the model's pose and
the way in which the image is framed can all
affect the overall contrast of the image. When
the subject is lit strongly you can limit the
contrast of the image by using these factors to
ensure that you either include only a small
area of highlight or a small area of shadow in
your frame, and you'll then have to calculate
your exposure accordingly.

▲ Technical Details
35mm SLR Camera with an 75–300mm zoom
lens, an 81A warm-up filter and Fuji Provia.

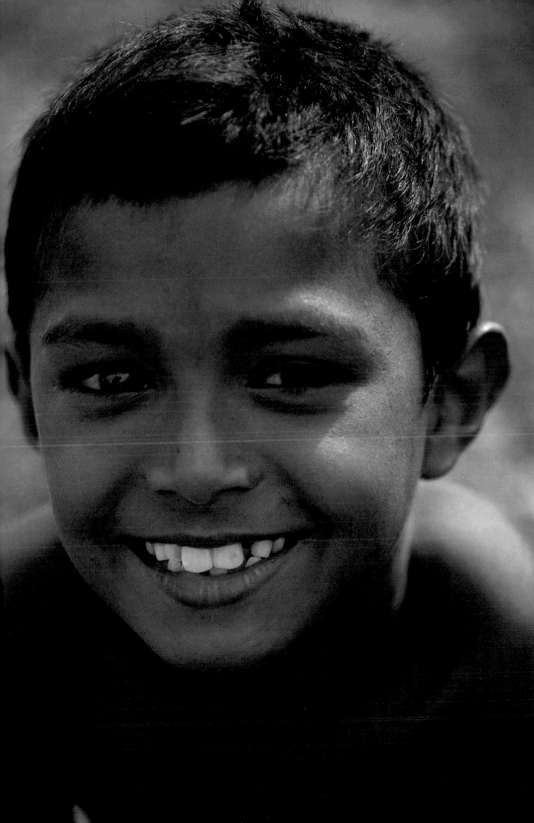

Technical Detail

▼ 35mm SLR Camera with an 75–150mm zoom lens and Kodak Ektachrome 64.

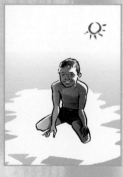

Afternoon sun was lighting this young Sri Lankan boy's face from almost a right angle and although it was fairly soft, the shadow it cast was too dense. To get the picture Busselle wanted, he asked the boy to sit on the ground, and the light reflected up from the bleached grass was just enough to weaken the shadow to an acceptable level.

Controlling Contrast

Rule of Thumb

Much can be done to reduce contrast by placing your model close to a naturally reflective surface, such as a white wall or table top. Do ensure, however, that such surfaces are fairly neutral in shade to eliminate the risk of colour, as well as light, being reflected into your picture.

Seeing

To photograph this vineyard worker sorting the grapes and to show what he was doing clearly, Michael Busselle needed to shoot from this viewpoint so that the grapes could fill the foreground and he could see the action.

Thinking

From this position, however, the strong, early-morning sunlight was very harsh, and it created an image with extremely high contrast, ensuring that the scene was impossible to photograph conventionally.

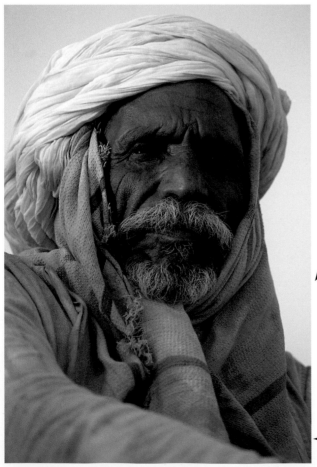

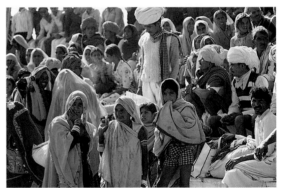

This strongly-lit and brightly-coloured scene, taken at the Pushkar Camel fair in Rajasthan, would have become harsh and discordant had Busselle shot with the sun behind him. Shooting into the light greatly reduced the contrast but he needed to compensate the exposure, giving the picture one-and-a-half stops more than the meter indicated to avoid his results being unacceptably dark.

Technical Details
35mm SLR Camera with an 75–300mm zoom lens, an 81A warm-up filter and Fuji Provia.

Lit from almost right angles, this man's face would have recorded as a very contrasty image in normal circumstances. But the soft light thrown by the slightly hazy afternoon sun, the reflective surroundings of the sand and his white robes, together with his dark skin, have produced an image with a pleasing quality.

Technical Details
35mm SLR Camera with an 75–300mm zoom lens and Fuji Provia.

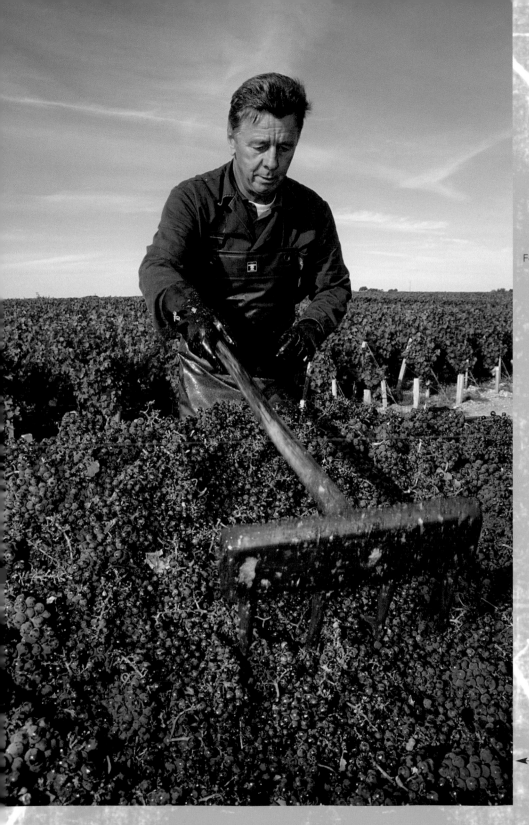

Acting

For this reason he decided to use **fill-in flash**, provided by a small portable flash gun mounted on the camera. He used the auto-exposure flash system, but set the flash **one third of a stop** down from its full setting to ensure that it lightened the scene without becoming detectable. By fitting a **wide-angle** lens and taking up a close viewpoint he was able to accentuate the **perspective** while ensuring that the flash was close enough to his subject to be effective.

Technical Details
35mm SLR Camera with a 17–35mm zoom lens and Kodak Ektachrome 100 SW.

Shooting on Cloudy Days

In many ways, a cloudy or overcast day is more suitable for photographing people. The light is softer and more flattering for head-and-shoulder portraits, and its quality helps subjects from becoming fussy and confusing, particularly the more distant and detailed ones. It's especially useful light to use when you're photographing subjects which have bold colours, or strong visual elements like pattern and texture, the effects of which can easily be diminished by the bright highlights and dense shadows which sunlight creates.

Seeing

Michael Busselle saw this old building in the French town of Arbois on a very dull, overcast day, when many possible subjects he had considered had simply been lit in too flat a way to produce a good quality image.

Thinking

He thought this scene might still work: despite the fact that it was very softly-lit and there were no strong colours, there was, however, a strong element of both texture and pattern and the very dark tones inside the windows gave the impression of more contrast.

Acting

He used a long-focus lens to isolate a small area of the scene and framed the shot so there was a feeling of symmetry within the image, while the viewpoint also allowed him to place the lady close to the intersection of thirds.

Although shot on a cloudy day with very soft lighting, this scene, taken in a narrow street in Colmar, contains enough contrast for the image to be pleasing, partly because of the subject's inherent tones and partly because the overhead lighting has created some well-defined shadows.

Technical Details
35mm SLR Camera with an 35–70mm zoom lens, an 81A warm-up filter and Kodak Ektachrome 64.

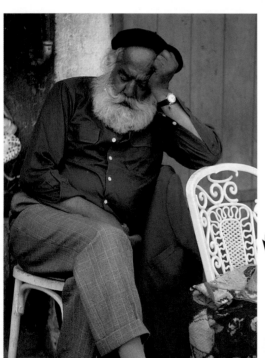

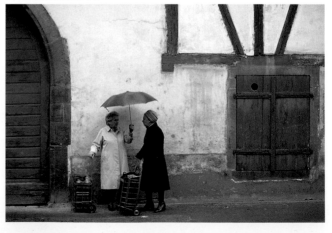

The soft light of an overcast day is ideal for subjects such as this one, seen at the Flea Market in Paris, as the inherent contrast and bright colours in the scene ensure a bright, punchy image while the absence of direct sunlight enables distracting highlights and shadows to be avoided.

Technical Details
35mm SLR Camera with an 75–300mm zoom lens, an 81A warm-up filter and Fuji Provia.

Technical Details
35mm SLR Camera with an 70–210mm zoom lens, an 81A warm-up filter and Kodak Ektachrome 64.

Lighting for Mood

Dramatic lighting can be used to create distinctly different moods. Effects can be created artificially in the studio or, alternatively, the photographer can make use of natural lighting conditions outdoors. Strong directional sunlight falling through doors and windows, as well as the harsh slanting light of autumn and winter, provide the photographer with raw material for portraits that tell a story.

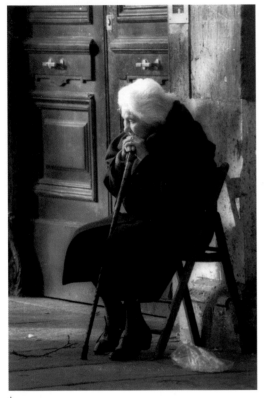

▲Technical Details
35mm SLR camera with a 300mm lens and Ilford HP5+ b&w film.

Seeing

It was autumn, traditionally a melancholy time of year, and Kobi Israel thought this old lady sitting outside an apartment building in Rome looked rather sad and lonely. He wanted to isolate her from the bustle of the street and concentrate attention on her pensive expression. The double doors and the wall behind her provided a suitably neutral background. He used black-and-white film for this documentary-style.

Thinking

In autumn and winter the sun is low in the sky and its light is directional, creating long shadows. The strong, slanting light picked out the old lady's white hair and walking stick and threw a shadow on to the wall behind her. Such light does not last long, however, before the sun dips behind buildings or clouds, so Israel knew he had to work quickly.

Acting

Not wanting to be intrusive, the photographer stayed at a distance and framed the picture with a 300mm telephoto lens. This allowed him to crop in close on the old lady, but he also included the littered pavement to emphasise the mood of melancholy. He completed the effect in the darkroom by toning the black-and-white print a light sepia.

Rule of Thumb

The season and the time of day strongly affect the nature of the available light you have at your disposal. Generally speaking, in the early morning and late evening, sunlight is warm and strongly directional. At mid-day the sun is overhead, creating a harsh, shadowless glare that is not very suitable for photographing people. In autumn and winter, the sun is low in the sky and can give rise to some interesting directional lighting effects.

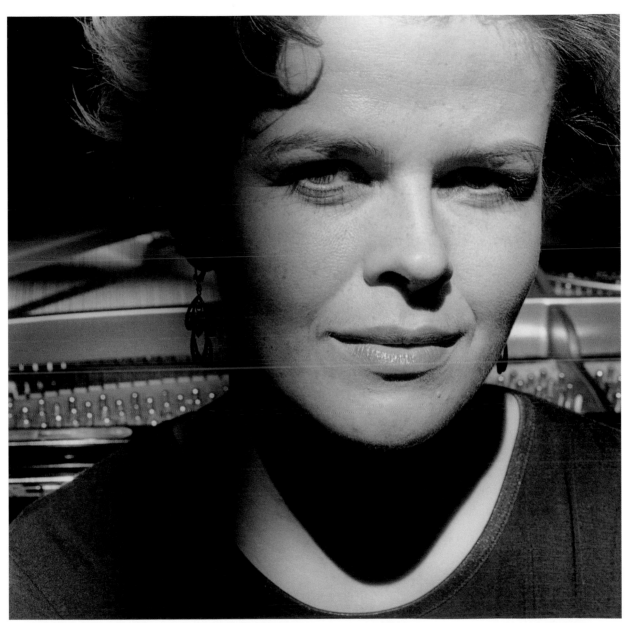

The woman was a pianist, and Staffan Jofjell wanted to create a mood of drama that emphasised her mastery of the instrument. The location was a concert room with a skylight in the ceiling, and he pushed the grand piano under the skylight, where the sunlight picked out its surfaces. With the piano as a background, the performer stood with the strong light falling directly across her face, creating dramatic shadows around her hair and chin. Her eyes were also partly obscured by shadows from her eyelids and lashes. The photographer came as close as he could with a standard 50mm lens, filling the frame with her face.

▲ Technical Details
35mm SLR camera with a 50mm lens and Kodak Tri-X b&w film rated at ISO 200.

Lighting for Mood

In most cases, lighting for subjects like portraits and nudes is designed primarily to show a model's features to the best advantage or to reveal character and emphasise qualities like form and texture. But there is also the possibility of using lighting with the prime intention of creating an unusual effect, or to establish a particular mood, and where the effect on the model is a secondary consideration.

Seeing

Michael Busselle wanted to photograph this model in a way which created an element of mood and started by using a soft, diffused light from one side with the intention of using a soft focus attachment over the lens to create a rather romantic atmosphere.

Thinking

He had a large piece of glass in the studio, bought for a still life, and thought he might be able to use this as a sort of texture screen. He found that by spraying this with a plant mister he was almost able to achieve the effect he wanted.

Acting

But he felt that something more was needed and this was done by bouncing a blue-filtered light from a large white reflector placed to one side of the glass angled so that it created a degree of flare. He then placed a pinkish filter over the light which illuminated the model.

Rule of Thumb

The photographic process has the ability to record detail with great clarity and to convey a great deal of visual information in an image. One way of creating moody images is to use techniques which limit this quality. Lighting which creates large shadowy areas, for example, or the use of soft focus to impair the picture's clarity, are both devices which can heighten the feeling of mood in a picture.

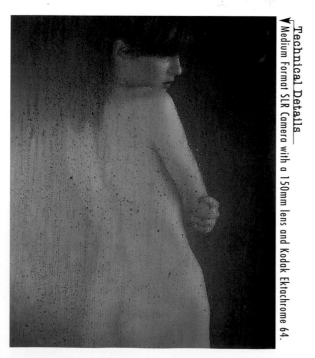

Technical Details
Medium Format SLR Camera with a 150mm lens and Kodak Ektachrome 64.

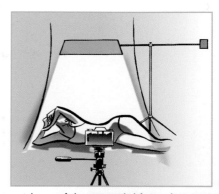

A large soft box suspended from a boom arm directly above the model has created quite a shadowy, atmospheric effect in this picture.

Technical Details
Medium Format SLR Camera with a 180mm lens and Kodak Ektachrome 64.

Medium Format SLR Camera with a 150mm lens and Kodak Ektachrome 64.

For this portrait, Busselle used pieces of coloured acetate over the light sources to create localised colour casts. The flashes were undiffused and fitted with honeycombs to concentrate the light into a small area; one with a red filter, placed behind the model to the right of the camera to create a rim lit effect, and the other, fitted with a blue filter, just behind the model on the opposite side.

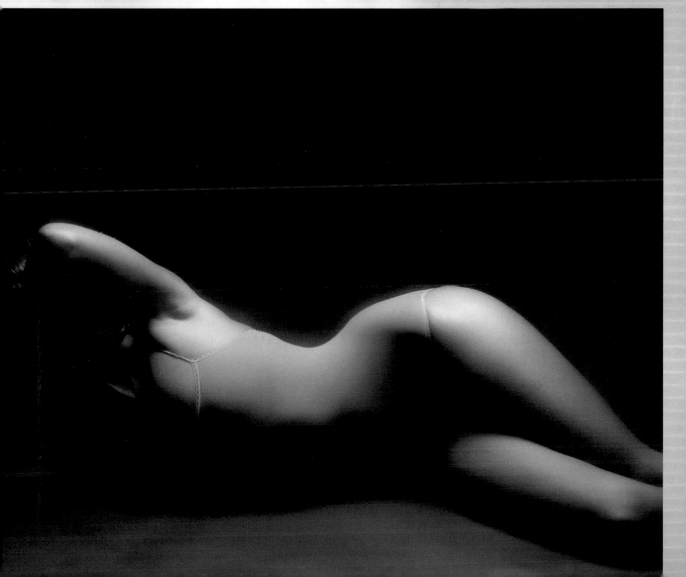

Lighting for Mood

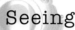

Seeing

Michael Busselle wanted to avoid the more conventional approach to portrait lighting for this picture and, while experimenting, decided it looked effective when only part of his subject's face was shown clearly.

Acting

To complete the effect, he then asked his model to wear a hat and a dark, polo-necked jumper so the skin tones were the only positive colour, and lit a white paper background to give a semi-silhouetted feel to the image.

Thinking

He placed a soft box close to his face and at right angles to it so that only one half was lit but had strong modelling. He then placed a black reflector very close on the other side to ensure the shadowed side of his face was quite black.

Rule of Thumb

Remember that items like props, clothes and backgrounds will all influence the mood of a picture and so too will the use of colour. It's a good idea to think about what you want to achieve and to assemble the items needed before the session begins. You can get some good ideas from studying the fashion and style magazines.

For this male nude, a large white reflector was placed almost at right angles to the model and a single flash was bounced from it to provide a very soft, diffused light. Busselle also placed a black-painted reflector on the opposite side to ensure the shadows remained black.

Technical Details

Medium Format SLR Camera with a 150mm lens and Kodak Ektachrome 64.

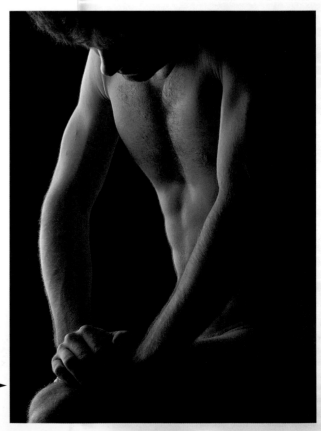

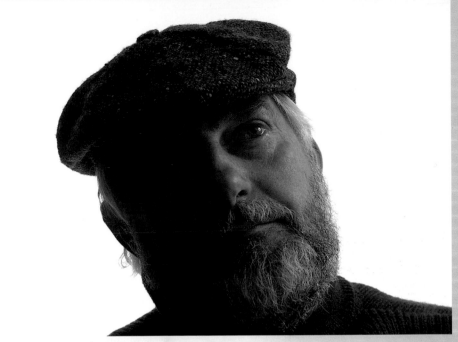

▲Technical Details
Medium Format SLR Camera with a 105–210mm zoom lens and Kodak Ektachrome Professional 100.

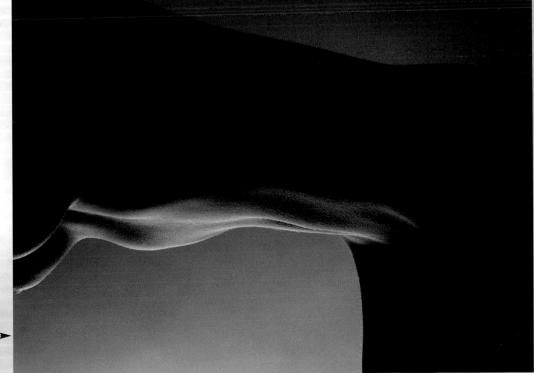

The effect for this nude was created by asking the model to kneel across two stools which were placed on a grey paper background. The lighting quality was achieved by aiming a single flash at the floor a metre or so below her so that it was bounced back under her body.

Technical Details ➤
Medium Format SLR Camera with a 150mm lens and Kodak Ektachrome 64.

Cameras & Equipment

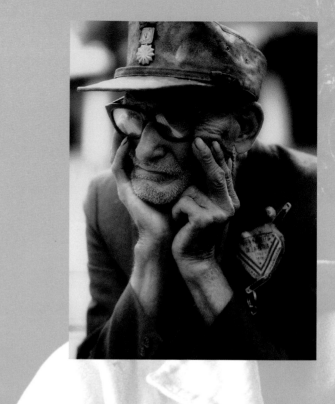

4

There's a wide range of film formats and camera
equipment on the market, but which should the portrait
photographer choose? Having the right tools for the job makes an enormous
difference to the end result, and it's important to understand the capabilities and
limitations of different items and how they can be used to influence the look of the
image. The photographer needs equipment that will serve his immediate needs but
can be added to and expanded as his skill and
experience grow.

Choosing a Camera

Any camera can be used to take portrait pictures. However, there are several distinct types of camera, each with different characteristics and capabilities. There is no single 'correct' camera to choose. You must decide which system best suits your needs, bearing in mind that you will probably want to expand it as your expertise develops. In the end a lot comes down to personal taste.

Types of Camera

The most popular film format is 35mm, which is widely used by both amateurs and professionals. 35mm gives a negative size of approximately 24mm x 36mm and encompasses both compact cameras and single lens reflex cameras, or SLRs. Compacts are ideal for taking snapshots and many come with built-in zoom lenses, but SLRs offer better image quality and far greater flexibility. There is a wide range of interchangeable lenses available for SLRs, which gives extensive control over the type of image that is recorded. There are also many other types of accessory for 35mm, such as flashguns and filters, and a wide variety of film types.

APS (Advanced Photo System) is a relatively new format, similar to 35mm but with a slightly smaller negative size. It is designed largely for snapshot photography. APS allows a choice of picture format while shooting, including panoramas, and processed films are returned with a handy index print that shows all the images on the film in miniature, making it easy to select reprints.

Medium format, or 120 roll film, is a step up from 35mm. Medium format cameras also have interchangeable lenses and a wide variety of accessories, but the images they produce are significantly larger than those of 35mm. Typical sizes are 6x4.5cm, 6x6cm, 6x7cm and 6x9cm. Many models have interchangeable film backs, which means the photographer can switch film mid-roll.

Large format, or view cameras, use a single sheet of film for each image. This is typically 5x4in or 8x10in in size, although there are other formats, including panoramic ones. Such cameras give superb image quality and have a number of controls that can be adjusted for fine-tuning. However, they are bulky, slow and quite tricky to operate.

Digital photography is fast gaining ground, although until recently issues such as cost and image quality have held it back. Images taken on a digital camera can be downloaded to a computer and manipulated to produce a wide range of weird and wonderful effects. Needless to say, you need to own a home computer and the related peripherals before you consider the digital option.

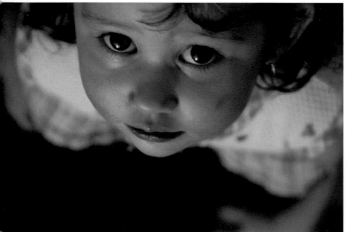

Tricia Timmermans met this little girl and her mother in La Paz, Mexico and asked permission to take some photographs. The toddler was amused by the sandals Timmermans was wearing and when she came to look closer, the photographer saw her chance. She quickly framed the shot using a 28–200mm zoom lens and, when the girl looked up, focused on her eyes and squeezed the shutter release. The zoom was set at around 50mm, which in 35mm photography is the focal length of a standard lens.

▲ Technical Details

35mm autofocus SLR with a 28–200mm zoom lens and Fujichrome Velvia film.

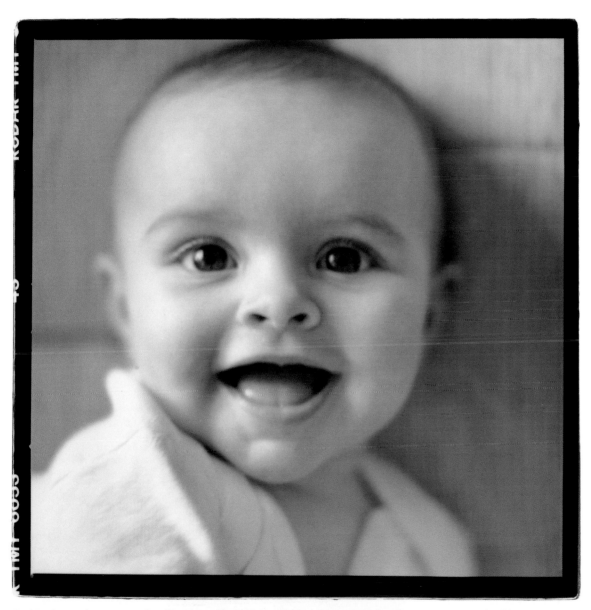

Paul Sanders used a 6x6cm medium format camera to capture this shot of baby Michaela. The picture was taken hand-held using available window light, with a piece of white card placed on the right to act as a reflector, filling in the shadows. The large aperture gave a very shallow depth of field, which helped concentrate attention on the little girl's sparkling eyes. Sanders emphasised the square format by printing part of the black film surround to provide a ready-made frame for the image.

▲ Technical Details

Medium format camera with an 80mm lens and Kodak Tmax b&w film rated at ISO 200.

Pros & Cons

For the portrait photographer, the main choice lies between 35mm and medium format. APS cameras can be useful for candid snapshots but because of their smaller negative size the quality of the image is reduced. This is especially noticeable when you make **enlargements**. Besides, most APS systems are designed only to use colour negative film, and the choice of accessories is limited.

The wide choice of lenses and accessories for 35mm SLRs makes them extremely versatile. Cameras are light and portable, and are suitable for use both in the studio and outdoors. Many have fully **automatic exposure** systems and autofocus, which makes picture-taking quick and easy. With SLRs, the image you see through the viewfinder is the one that will be recorded on film, so you can assess **immediately** what effect different lenses and accessories will have.

The slight drawback of 35mm is the size of the image. **Transparencies** need to be projected or viewed through a magnifier to be properly assessed, and when big enlargements are made from 35mm negatives the grain of the film becomes more noticeable.

Medium format cameras are almost as versatile as their 35mm counterparts, although the range of lenses and accessories for them is more limited. Virtually all medium format lenses have to be focused manually – only one or two camera models come with autofocus. Cameras and accessories tend to be more **expensive**, and film and developing costs are higher. Not all medium format cameras have through-the-lens viewing, which makes focusing and composition more difficult. Their greater size and weight mean that usually they need to be firmly secured on a tripod to avoid camera shake.

Their big advantage, however, is the better image quality given by the larger film size. Transparencies contain far more **detail** and negatives don't have to be enlarged to the same extent as in 35mm. This means grain is less of a problem, especially if you are enlarging from just a section of the negative.

Rule of Thumb

You can make your own simple pinhole camera from a cardboard box or tube. Punch a small hole in one side of the box or, with a tube, fit a piece of kitchen foil over the end and punch a hole in that. A piece of tracing paper at the back of the container makes a good focusing screen. As light travels in straight lines, the top part of the image will appear at the bottom of the focusing screen and the bottom part at the top, giving you an upside-down image.

Jørgen Brandt created this unusual portrait with a pinhole camera, a simple device that has a pedigree stretching back to the earliest days of photography. Brandt's wooden camera was specially made but consisted of little more than a box with a small hole in the front, through which the exposure was made. There was no lens and therefore no need to focus, but this also meant the photographer couldn't see through the camera and had to arrange his composition 'blind'. He used open flash, firing a single studio flash unit in the darkened room.

Technical Details
Custom-made 5x4in pinhole camera and Kodak Tri-X film at ISO 800. Sepia-toned print.

Richard Bailey pictured this war veteran as part of a project to photograph the people of Paraguay. He used a medium format camera which gave a nearly square image. The man was living in a government home for old soldiers. None of the veterans spoke English, but Bailey suggested poses for them to try and gave each a Polaroid print of himself. He took this portrait under a tree outside the home using natural daylight. He printed the negative through a soft-focus filter on to a fibre-based printing paper, and then sepia-toned it.

◄ **Technical Details**
Medium format camera with a 90mm lens and Ilford FP4 b&w film. Sepia-toned print.

Choosing Lenses

Interchangeable lenses are available for all the major camera systems. Lenses are classified according to their focal length. Different focal lengths have different angles of view and therefore affect the appearance of the image. Zoom lenses conveniently combine a number of different focal lengths in a single package.

Types of Lenses

A standard lens is one which gives an angle of view of around 45 degrees, which approximates to the field of vision of the normal human eye. The focal length of lenses is calculated in relation to the size of the film format, so lenses for 35mm and medium format systems have different focal lengths. In 35mm the focal length of a standard lens is 50mm, while in medium format it is around 80mm.

Telephoto lenses have a longer focal length and a narrower angle of view than standard lenses. They make distant objects appear closer, and have a slight flattening effect on perspective, making objects on different planes appear nearer together. A short telephoto is considered a good choice for portrait pictures – with 35mm cameras, an 85mm lens is commonly used and with medium format systems one of around 120mm. Other popular telephotos for 35mm cameras are 135mm, 200mm and 300mm.

Wide angle lenses have a shorter focal length and a wider angle of view. In 35mm systems, focal lengths of 35mm and 28mm are quite common, but there are also extreme wide angles that create a distorted, fisheye perspective. Wide angles can be used to include a subject's surroundings in the frame but, used close up, distort features in an unflattering way.

Zoom lenses combine a number of different focal lengths in a single lens barrel, which gives a large degree of flexibility. They are mostly made for 35mm systems, and 35–70mm, 28–85mm, 28–200mm and 70mm–210mm zooms are popular types. They allow the photographer to try out different framing options without having to carry around a bag full of separate lenses.

Macro lenses are designed to focus at close distances to produce an almost life-size image of the subject. They are most commonly used in flower and insect photography, but can also be used for close-up portraits.

Pros & Cons

Telephotos often have small maximum apertures which can restrict their use in low light situations. The longer ones are also quite heavy and likely to cause camera shake, which is exaggerated because of the greater magnification. This means they have to be used with a solid tripod.

Wide angles have larger maximum apertures and so can be used in lower lighting conditions. Because of their distorting effect, they are seldom used for close-ups unless the photographer is deliberately aiming for a humorous result.

Zooms also have restricted maximum apertures and, in most cases, the image quality they give is slightly lower than that of fixed focal length (or prime) lenses. However, their greater flexibility usually compensates for these disadvantages.

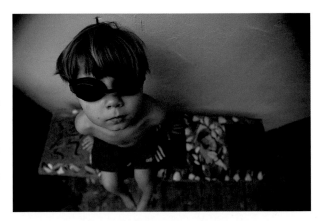

Wide angle lenses give a broad field of view and at the extreme end of the range begin to distort the image, making objects close to the camera appear very large and bending straight lines. They don't usually flatter the human face, but Terry Way used a 17mm wide angle to amusing effect for this picture of his young son. The warm lighting was provided by late afternoon sunlight.

Technical Details
35mm SLR camera with a 17mm lens and Kodak Ektachrome E100VS transparency film.

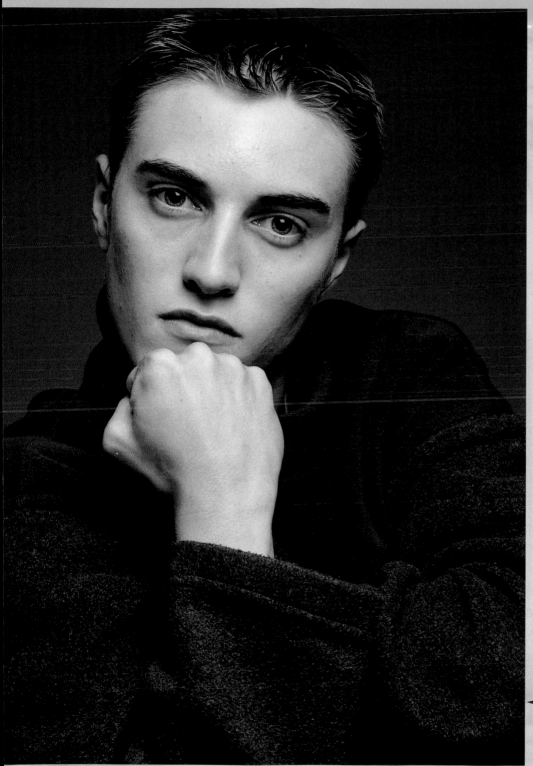

To shoot this young acting student, Ronnie Bennett used a medium format camera with a fixed 150mm telephoto lens. Bennett lit the picture with a softbox attached to a boom, which she angled so that the lighting came from the front and slightly above. This helped to emphasise the structure of the young man's cheekbones and his fine facial features.

◄Technical
Details
Medium format camera with a 150mm lens and Fuji Neopan 400 b&w film.

There are a huge number of accessories available, ranging from extension tubes to gadget bags. Some are important tools for portrait photographers, others are less vital. One of the first accessories to consider is a good solid tripod, while a small selection of filters can also prove indispensable.

A tripod is invaluable in portrait photography. It holds the camera steady, which is important as heavy medium format gear and long 35mm lenses are prone to camera shake. In low lighting conditions it allows you to select slower shutter speeds and wider apertures than you could shooting hand-held. It is also a good aid to composition, encouraging you to be more deliberate about framing the picture. And once you've taken your eye away from the camera viewfinder, you're freer to engage with the subject and more likely to capture natural expressions.

There are many different types of tripod. Most have adjustable legs and heads that can be tilted through 90 degrees, for taking vertical-format portraits. To avoid jogging the camera and tripod during exposure, it's best to use a cable release. This simple device screws into the shutter release button and trips the shutter when you press a plunger.

Certain filters are extremely useful. Polarisers, though normally used for landscape photography, are effective if your image contains areas of sea or sky in the background. They subdue reflections from the sun and increase colour saturation, especially that of blues. Neutral graduated filters can be used to darken background sky areas and enrich tones and colours.

When shooting in shadow the light sometimes has a blue cast, which makes skin tones look unappealing. An 81A or 81B warm-up filter will solve this problem. On the other hand, late afternoon sunlight sometimes makes skin tones appear too red. This can be corrected by using an 82A or 82B blue-tinted filter.

In black-and-white photography, red and orange filters help disguise skin blemishes while a yellow filter increases contrast. Blue filters emphasise skin texture and so are useful for character portraits, although not necessarily for beauty photography.

Extension tubes and teleconverters increase the focal length of lenses and are used for close-ups. They fit between the camera and the lens. A 1.5x converter, for instance, gives a 100mm lens a range of 150mm and a 2x converter makes it 200mm. The drawbacks are that you lose a certain amount of sharpness while the maximum aperture is reduced by a stop or two. A bellows attachment does a similar job, helping to focus the image in extreme close-ups.

Most medium format cameras have interchangeable film backs. These allow the photographer to switch films mid-roll – from colour to black-and-white, for instance. They are also widely used for test exposures using instant film, which allow the photographer to make any adjustments needed before shooting the picture for real.

The image was framed with the camera firmly secured on a tripod. Lighting came from a large, north-facing window on the left-hand side of the frame.

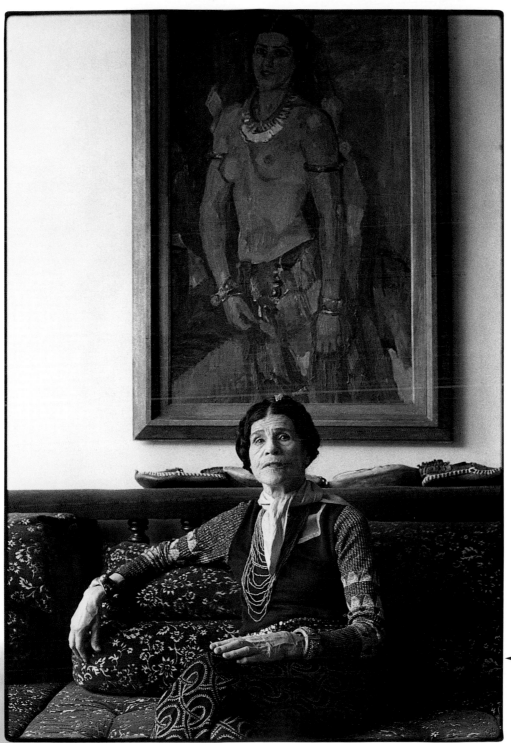

Janna Dekker posed the old lady, her former ballet teacher, in front of a portrait of her younger self. Although Dekker's camera is a lightweight 35mm SLR, she invariably uses a tripod with it. Apart from helping her to frame the image accurately, it gives her a better chance to build up a rapport with the subject. With the camera safely secured, she is free to talk to the person until they relax. Then she fires the shutter using a cable release.

Technical Details
35mm SLR camera with a 100mm lens and tripod, and Kodak Tri-X b&w film.

Lighting equipment varies in complexity from simple reflectors to sophisticated studio lighting set-ups which give the photographer total control over the finished image. Lighting does not have to be complex to improve the final result. Even a little fill-in light from a camera-mounted flashgun can add sparkle and lift an otherwise ordinary image.

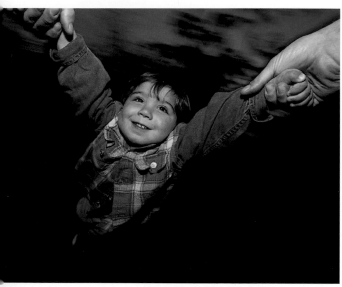

As well as providing extra illumination, a burst of flash can be used to freeze motion. Terry Way used a camera-mounted flashgun to capture his young son's gleeful expression as he span him around in the air. As the photographer had his hands full, he couldn't hold the camera or even frame the image accurately. So he used an extreme wide angle lens and taped the camera to his body to stop it bouncing around, then fired the shutter using the self-timer. The twilight sky gave the shot a rich background colour.

Technical Details

35mm SLR camera with a 17mm lens and camera-mounted flash, and Fujichrome Velvia transparency film.

Some 35mm cameras have a small flashgun built in. This is useful in an emergency or as a fill light on a bright day, but offers little in the way of creativity. An **accessory flashgun**, mounted in the camera's hotshoe, offers more power and versatility. However, avoid aiming flash directly at the subject's face. The lens will pick up light reflected off the blood vessels in their eyes, creating the dreaded **red-eye** effect. Instead, angle the head of the flashgun so that its light is bounced off a wall or ceiling, or fit it with a diffuser (a piece of tracing paper will do). Flashguns can be mounted **off-camera** and connected to it via a flash synch lead.

For studio portraiture, two or three lighting units and a small selection of **diffusers**, reflectors and stands is enough to get going. Even with this basic equipment, many different lighting effects are possible.

Lights can be **tungsten halogen** or photoflood lamps, or you can invest a little more in studio flash equipment. Reflectors are used to fill in harsh shadows on faces and balance out the lighting. You can buy various types of collapsible reflector, but it's just as easy to make your own. Large sheets of white **polystyrene**, available from DIY stores, are ideal, as are lengths of shiny kitchen foil, white card or even sheets of newspaper.

Softboxes are popular with photographers aiming for a soft lighting effect. A softbox is a kind of umbrella with a reflective interior and a translucent white screen through which the light is diffused. Lengths of gauze or muslin, or sheets of tracing paper, can also be used to diffuse and soften light.

Devices such as snoots, barn doors, scrims and honeycomb grids are also used to control studio lighting. These are all attachments that fit over the front of the lamp and can be adjusted to mask off some of its light output.

Backgrounds are important. You can buy ready-made ones in the form of large rolls of cartridge paper of various colours, either plain or graduated. These are mounted on stands and the paper draped on to the floor for the model to sit or stand on, creating a seamless background. You can paint your own backgrounds, or use sheets of fabric draped behind the model. Muslin, silk and velvet all make good backgrounds, depending on the mood you want to create.

Many flashguns have extendable heads which can also be tilted. This allows light to be bounced off ceilings or walls, avoiding the hard shadows and red-eye caused by flashguns that are head-on to the subject.

Richard Lewisohn used a special circular flashgun called a ringflash and combined it with a technique known as cross-processing to create this striking image. He got as close as he could to the subject so that the ringlight's characteristic circular catchlights appeared in his eyes. Lewisohn processed the colour transparency film in colour negative chemicals to produce the surreal colours. The pink background was, in reality, orange.

▲ Technical Details

Medium format camera with an 80mm lens and ringflash, and Fujichrome Astia Pro 100 transparency film cross-processed in C-41 chemicals.

Apertures & Shutter Speeds

Apertures and shutter speeds are the basic tools with which the photographer controls exposure. The aperture determines how much light hits the film, while the shutter speed determines how long the film is exposed. Besides these basic functions, apertures and shutter speeds have characteristics that can be exploited to alter the look of the image.

The aperture of the lens determines how much light gets through to the film. Apertures are indicated by f stop numbers, which you will find engraved on the barrel of your lens. The sequence of f stops runs f2, f2.8, f4, f5.6, f8, f11, f16, f22, f32, with f2 being the largest and f32 the smallest. Not all lenses are capable of the whole range, but you should go for the largest maximum aperture you can afford.

Each stop up doubles the amount of light hitting the film, while each stop down halves it. An exposure at f8, for example, is twice as bright as one at f11, but only half as bright as one at f5.6.

Apertures also control depth of field. This is the distance in front of the subject and behind it that appears in sharp focus. The larger the aperture, the smaller the depth of field. For example, with an aperture of f22 the whole frame may be sharp from front to back, while with an aperture of f2.8 only a small area around the subject will be in focus. Large apertures are used to highlight the subject, making it stand out sharply against a blurred background. The effect is more pronounced with telephoto lenses.

Technical Details

35mm SLR camera with a 24mm lens and Fujichrome Velvia film.

Rule of Thumb

Different combinations of aperture and shutter speed give different results. The exposure value (EV) given by a setting of 1/30sec at f22, for example, is the same as that given by one of 1/2000sec at f2.8. However, the first picture may contain some subject movement and will have a wide depth of field, with even distant objects appearing sharp. In the second picture, any movement will be frozen dead and the depth of field will be very shallow, with the subject standing out sharply against a blurred background.

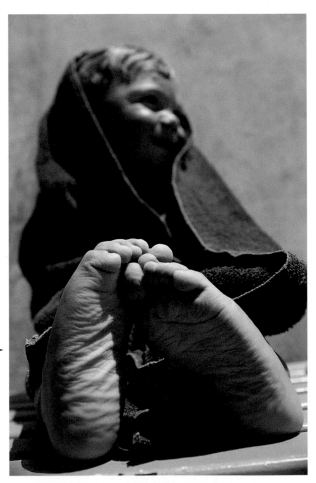

The wider the aperture, the shallower the depth of field. For this shot of his young son Connor, Terry Way got right down to ground level and focused on the boy's wrinkled feet as he dried off after a swimming lesson. The wide angle lens made the feet prominent but Way exaggerated the effect by selecting the largest aperture he could. This gave an extremely shallow depth of field.

With slow shutter speeds, movement registers as a blur. When a fast shutter speed is selected, movement is frozen and the subject appears sharp. Terry Way used a fast shutter speed to capture his son Colton on a swing. Using a wide angle lens with a large maximum aperture meant that more light was available when setting the exposure, so he was able to choose a shutter speed fast enough to freeze the action.

Shutter speeds determine the length of time for which the camera's shutter remains open. Typically, their range runs from one second to 1/4000sec and some cameras have a dial which shows the range of settings. As with apertures, each change in shutter speed halves or doubles the amount of light allowed through to the film. At 1/125sec, for instance, exposure is twice as bright as at 1/250sec, but only half as bright as at 1/60sec.

Fast shutter speeds can be used to freeze a subject in motion. For example, 1/1000sec is usually enough to record sharp detail in the limbs of a person running or a child on a swing. With slow shutter speeds, on the other hand, movement records as a blur. This is sometimes used to deliberate effect but is usually to be avoided in portraits. As long as the subject is relatively static, a speed of 1/60sec or upwards should be enough to avoid a blurred image.

At very slow shutter speeds, below 1/30sec or so, the photographer's own movement is likely to be recorded in the form of camera shake. This is why in low lighting conditions it's essential to use a tripod.

▲ Technical Details
35mm SLR camera with a 15mm lens and Fujichrome Velvia transparency film.

Understanding Exposure

Once apertures and shutter speeds are understood, the photographer can start dealing with different lighting situations. In general, bright lighting calls for less exposure and dull lighting for more, but in reality things are often more complicated.

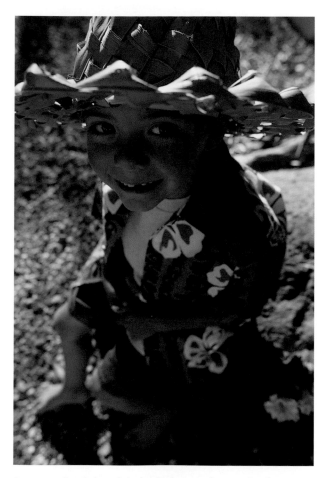

Many cameras have fully automatic exposure systems which, most of the time, will produce perfectly adequate, well-exposed pictures. However, leaving it up to the camera means letting go of your creative control. And many lighting conditions – scenes containing extremes of light and dark, for example – are likely to fool automatic meters. You need to learn how to set exposures to compensate for such conditions.

Exposure meters work on the assumption that the subject in front of them is a mid-tone. The standard tone is calculated as 18 per cent grey, based on the reflectance of the subject (i.e. the amount of light it reflects). Most of the time this works fine, but problems occur when the main point of interest differs strongly from the mid-tone. When there are large areas of shadow around the subject, for example, an automatic system will average them out against the brighter areas, with the result that the subject is overexposed. To avoid this happening, decrease exposure by a stop or two from the indicated reading.

When the light is very bright, the meter can be fooled into underexposing the subject, especially in situations where sunlight is reflected off snow, sand or water or when there are large areas of sky in the frame. Like the human eye, the meter is blinded by the glare into exposing for the overall scene, and stops down the aperture to cope. In such cases, you need to open up the aperture a stop or two above the average reading to keep detail in the subject, even if that causes the background to burn out. Alternatively, you can use a burst of fill-in flash to lift the subject.

A mixture of sunlight and shadow in the same frame makes for a tricky exposure, which is what Terry Way had to contend with when he photographed his six-year-old son Connor posing in his new Hawaiian party outfit. In particular, the shadow cast by the brim of the hat partly obscured the boy's face. To compensate for this, Way opened up the aperture slightly. This meant that some of the highlights on the hat brim burned out, but the boy's face was correctly exposed.

▲Technical Details
35mm SLR camera with a 17mm lens and Fujichrome Velvia film.

Terry Way took this shot of his young son Colton on his first day out on the ski slopes. The sunlight reflecting off the snow was dazzling, and the risk with automatic exposure systems in situations like this is that they will expose for the bright areas and leave the subject itself underexposed. Way could have opened up the aperture a stop or two to retain detail in the subject, but instead used fill-in flash to compensate for the strong backlighting.

Technical Details
35mm SLR camera with a 24mm lens and Fujichrome Provia 100 transparency film.

Rule of Thumb

Most colour negative films have a great degree of exposure latitude, meaning that if you get the exposure slightly wrong, you'll usually still get away with it. You can also make corrections at the developing or printing stage. The same is true for black-and-white films. Colour transparency films, however, are much less forgiving. More than half a stop out either way usually spells ruin for the image. For that reason it's essential to get the exposure spot on.

Exposure meters are either built into the camera, or are separate, hand-held accessories. All use light-sensitive cells to measure the amount of light present in a scene. Most 35mm SLRs have TTL (through the lens) metering systems, which can be programmed to set exposures automatically and usually offer several different modes (centre-weighted and spot metering are common ones). Medium format users are more likely to use separate light meters. One common type is an incident light meter, which is used to measure the light falling on to a subject rather than the light that is reflected off it.

Most TTL systems split up the frame into a number of different areas. Exposure is calculated by taking readings from each of the different segments and then either averaging them out (a system known as **evaluative metering**) or weighting the exposure towards a particular segment of the frame. Simple systems typically split the frame into a circular area in the centre surrounded by four quadrants, but many are considerably more sophisticated than this.

Different types of reading are possible, depending on the subject. A **centre-weighted reading** assumes that the main area of interest is in the centre of the frame and sets the exposure correctly for that area. A **spot reading** allows the photographer to take a **precise** reading from a small part of the image area, and is especially useful if the frame contains areas of high contrast.

Many **cameras** have an **exposure compensation** button. This adjusts exposure up or down when using automatic exposure systems, and is used to deal with extreme lighting conditions (strong backlighting, for instance) or subjects with an unusual tonal range.

Rule of Thumb

Bracketing is a technique that is used as a kind of insurance policy in tricky lighting situations. It involves taking a number of pictures of the same subject, at different exposures that straddle the indicated meter reading. This should ensure that at least one exposure is spot on. The technique is most commonly used with colour transparency film, as with colour negative the film's built-in exposure latitude is usually enough to deal with slight errors.

The diagram shows how the typical automatic exposure system splits the frame into zones. The camera takes a reading from each zone and calculates an average, or alternatively weights the exposure towards a particular area. Many systems are considerably more sophisticated than this basic model.

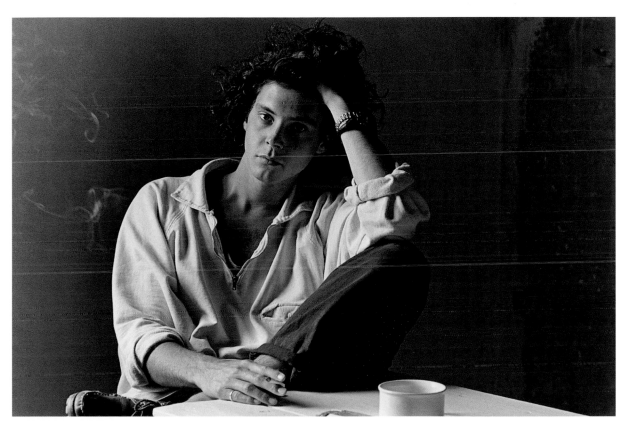

Janna Dekker took this portrait indoors, using available light from a north-facing window. There was strong contrast between the light and dark areas but she needed to ensure that the young man's face was correctly exposed. In a lighting situation like this an average reading is of little use as the camera's automatic exposure system will even out the light and the dark, destroying the contrast. It's better to take a spot reading from the main point of interest (in this case the right-hand side of the young man's face) and set the exposure accordingly.

▲ Technical Details

35mm SLR camera with a 100mm lens and Kodak Tri-X b&w film.

There are many different types and brands of film, each with its own characteristics. Choice of film can greatly affect the appearance of the finished image, so decide carefully according to the effect you are aiming to achieve. At the same time, however, remember that film is relatively cheap so don't be afraid to try out different types.

Black-and-white film tends to concentrate attention on textures and tones and often has a more subtle effect than colour. For this shot of my friend Mark clowning around in a Turkish café, I used Ilford XP1, a chromogenic film. Chromogenic films are black and white films which have a very wide exposure latitude and are developed in C-41 chemistry, normally used for colour negative emulsions.

Technical Details
35mm SLR camera with a 35–70mm lens and Ilford XP1 chromogenic b&w film.

Films are graded according to film speed, denoted by an ISO (International Standards Organisation) number. Most films fall within the ISO 25 to ISO 3200 range, and the most commonly used types are ISO 50, ISO 100, ISO 200 and ISO 400. Each increase in ISO rating means that the film needs half the exposure, and each decrease means it needs double. An ISO 400 film, for example, needs only a quarter the exposure of an ISO 100 one, meaning it can be used in much lower lighting conditions.

Films with high ISO ratings are known as 'fast' films; films with lower ratings are known as 'slow' films. The advantage of slow films is that their grain is less apparent, meaning that the image is recorded in finer detail. In some cases, however, you might want to show grain as a deliberate effect, in which case a fast film is preferable.

The most popular brands of film are manufactured in different sizes to fit the different camera formats. In 35mm and APS, a system called DX coding is used to set the film speed. The ISO rating is encoded in a chequerboard pattern on the film canister and automatically read by the camera.

Colour negative film is used to produce prints, while colour transparency (or reversal) film produces slides. Generally speaking, negative film is more tolerant of minor exposure errors and can be manipulated at the processing stage, while transparency film demands more accurate exposure and cannot be corrected later.

Black-and-white films too produce negatives from which a print is made, although there are a few black-and-white transparency films on the market. The other major film type is instant print film, which is used by studio photographers to shoot test prints. These develop within minutes and show what, if any, adjustments need to be made to the lighting set-up or exposure setting.

Richard Lewisohn used infrared film for this studio shot. Infrared film has the interesting property of rendering skin a luminous white, even when the skin tone is dark (it has the same effect with leaves and foliage outdoors). Getting the exposure right, however, can be difficult, so it's a good idea to bracket exposures. For lighting, Lewisohn used two softboxes, one placed either side of the subject.

↑ Technical Details
Medium format camera with an 80mm lens and Konica Infrared 120 film.

Finishing & Presentation

Once you've gone to the effort of creating a memorable image, you don't want to shut it away in a drawer. Good images deserve to be seen. Framing and mounting, properly done, can really make a print, while a good projection system enhances the impact of transparencies. You also need to make sure that your valuable archives are properly protected.

First of all, be ruthless when editing your images, especially if you are submitting them for competition or exhibition, or for publication. One or two images that are compositionally weak or technically imperfect can drag the whole selection down. It's far better to submit just a few images of high quality than a lot that are mediocre. Try also to vary the nature of the images and cut out repetition. Choose the very best of each situation; discard the rest.

Negatives are best stored in acid-free paper sleeves, which can be bought from your local photo store. Try always to handle negatives by the edge of the strip without touching the image area and don't leave them lying around, or they will quickly pick up dust and scratches.

The easiest way to store transparencies is in viewpacks, which are clear plastic sheets with individual pockets. Typically they hold 20 or 24 transparencies of 35mm format, fewer of larger sizes. They can be stored in ring-binders or in suspension files in a filing cabinet, and are easily handled for viewing on a lightbox.

A more stylish way of presenting transparencies is in a card mount. These are black cut-out sheets of card of different sizes, holding a single transparency or up to 20. A clear plastic sleeve with a frosted back can be slipped over the mount for protection and for easy viewing.

There are numerous types of slide projectors and screens which allow you to project your transparencies for home viewing. Projectors get hot, so don't screen the same transparency for too long at a time. A glass mount can protect the slide and prevent it from buckling in the projector, but never send glass-mounted trannies through the post. They shatter easily and can cut the fingers of whoever opens the envelope.

Prints can be mounted in an album, which is fine for family viewing but doesn't really show them to full effect. Select your best prints for mounting and framing. This need not be expensive, and a striking image well presented can provide a focal point for your living room or office.

Prints are normally dry-mounted on a flat piece of card and then finished with a cut-out card surround under a sheet of glass, all held together with a wooden, metal or plastic frame. You can make your own mounts or buy them ready-made from photo-finishers, craft shops and home decor stores. Different frames and mounts have subtle effects on the way the image is perceived. Try out a variety of different ones, and select the combination that suits the print best.

Rule of Thumb

Many black-and-white photographers reckon that taking the picture is only half the battle: much of the image is made in the printing. Techniques such as dodging and burning are used to control the exposure of the print, while coloured toners can alter the mood and feel of it completely. The choice of paper is also very important. Resin-coated and fibre-based papers give extremely rich tonal ranges and can increase the impact of the image considerably.

The size and colour of the frame has a subtle
impact on the way the image appears. Try out
a variety of different frames and mounts to
see which suits your image best.

Rune Andersson is a Swedish photographer with a wide range of styles and a varied client base. He takes editorial-style portraits for newspapers and magazines, as well as shooting book covers and doing commercial work for advertising clients. His customers include household names such as florist Interflora and car manufacturer Volvo.
Address: Photographic Production, Omvägen 21, S-41275 Gotenbourg, Sweden.
Tel/fax: +46 31 409860
E-mail: rune_fotograf@yahoo.se

Gary Auerbach, based in Tucson, Arizona, specialises in commissioned portraiture and also works on personal projects for gallery representation. His favourite subjects are Native American portraits and cityscapes. For the past eight years he has used the platinum printing process, which involves contact-printing negatives on to sheets of watercolour paper hand-coated with platinum palladium chemicals. This 100-year-old process gives a rich tonal scale and is especially suitable for archival prints.
Address: 2730 N. Pantano Road, Tucson, Arizona 85715, USA.
Tel: +1 520 906 6730
E-mail: auer@azstarnet.com
http://www.platinumphotographer.com

Richard Bailey has been a freelance photographer for eight years, and specialises in corporate brochures, annual reports, portraiture and children. He has travelled around the world working on personal projects, of which his trip to Paraguay was one. His book *The Road to Glory: A Portrait of Britain's Paralympians* has won many awards and pictures from it have been exhibited around the UK. It was part of *Britain's*

Sporting Heroes, a 1998 exhibition at the National Portrait Gallery in London. Some of his work is held by the picture agency Corbis; more can be viewed on his website.
Address: Richard Bailey Photography, 36 Olive Road, London NW2 6UD, UK.
Tel: +44 (0)20 8450 4148
Mobile: +44 (0)7956 971520
E-mail: richard@richardbaileyphotography.co.uk
http://www.richardbaileyphotography.co.uk

Diane Barker studied art history at the University of East Anglia and visual communication at Birmingham School of Art and Design. She has exhibited widely in the UK as a painter, and in 1992 began taking photographs of the Tibetan exile community. Her photographs have appeared in many magazines and books, have been used by charities and campaigning organisations, and have featured in exhibitions, audiovisual presentations and education packs. She has travelled widely in the Himalayas and her exhibition of photographs, *Free Spirits: Tibet in Exile*, has been staged in both the United Kingdom and India.
Address: The Old Swan, Alfrick, near Worcester, Worcs WR6 5HY, UK.
Tel: +44 (0)1886 832245
E-mail: dianebarker@hotmail.com
http://www.spirit-of-tibet.co.uk

Ronnie Bennett took up portrait photography as a second career in the mid-1990s, after completing a City and Guilds Professional Photography course. Since then she has won more than 40 awards, including a Fellowship from the Royal Photographic Society, an Associateship with the British Institute of Professional Photography, the 1998 Fujifilm

Portrait Photographer of the Year award and the 1999 Kodak Children's Portrait Photographer of the Year prize. She is also a member of the Association of Photographers. Over the past five years she has worked mainly for private clients but plans to diversify into advertising and editorial portrait work.
Address: Orchard House, West Tisted, Alresford, Hampshire SO24 OHJ, UK.
Tel: +44 (0)1962 773140
Fax: +44 (0)1962 773141

Jørgen Brandt trained at Gloucestershire College of Art and Technology in the UK in the early 1980s and is now an advertising photographer based in Copenhagen, Denmark, where he has run his own studio since 1987. Besides advertising, he produces portraits and fashion work as well as personal work for exhibitions.
Address: JB Studio, St Kongensgade 110B, 1264 Copenhagen K, Denmark.
Tel: +45 33 15 03 03
Fax: +45 33 15 03 35
E-mail: jb@jbstudio.dk

Carlo Chinca was born in Bath in 1953. He began working as a freelance photographer in London in the mid-1970s and won a Nikon Gold Medal for black-and-white photography in 1986. After five years in Spain and a short spell in Africa he returned to the UK, where he now concentrates on producing illustrated articles. His photographs have been published by Comic Relief, the BBC's *Radio Times*, the *Telegraph Magazine, Life, Country Life, The Independent* and Footprint Handbooks. He is currently working on two book projects: *Heart of Africa*, a contemporary view of Uganda and

its people, and *Under the Moon*, which portrays the people of Andalucia in Spain. His photographs of Uganda were exhibited at the Commonwealth Club, London over the summer of 2000.
Address: 7 The Daglands,
Camerton, Bath BA3 1PR, UK.
Tel: +44 (0)1761 470258

Donna Dean took a degree in multimedia, majoring in photography, at the University of London. She specialises in unusual portraits, including pictures of children, underwater shots and publicity photographs. She has had work published in *The Times*, *Music for the Movies*, *Making Music* and *Film Score Monthly*. As well as working on private commissions, she has held two exhibitions of her work in London, in Chelsea and Highgate.
Address: 13 Northfleet House,
Newcomen Street, London SE1 1YX, UK.
Tel: +44 (0)20 7207 4632
E-mail: donna@deedee45.freeserve.co.uk

Janna Dekker took up photography in 1985 after studying Spanish at the University of Leiden. She learned the basics from a friend who was an advertising photographer, and now specialises in portraits, nudes, still lifes and travel subjects. Since 1995 she has also been making videos. Her photographs have been exhibited in many galleries in Europe and also in the USA.
Address: V. Oldenbarneveltstraat 125B,
3012 GT Rotterdam, The Netherlands.
Tel: +31 10 4146330
E-mail: JannaHJ@ipr.nl

Guy Dondlinger was born in Luxembourg but now lives in Berlin, where he works as a graphic designer. He takes many of his photographs as raw material for his graphic work, manipulating them afterwards. Others, however, he leaves untouched. Most of his pictures are candid portraits of people, taken in various corners of the world.
Address: Wissmannstrasse 14,
12049 Berlin, Germany.
Tel: +49 30 621 1420/+49 30 34007 214
E-mail: gdon@berlin.snafu.de
http://www.geocities.com/gheedon

Wolfram Eder was born in Geissen, Germany in 1955. He studied communication and design and in 1982 had his first exhibition of black-and-white portraits at the Frankfurter Kunstverein. Since then he has undertaken portrait work for the press, for advertising agencies and for private clients. His work has been widely exhibited and he has published several books. He lives in Aschaffenburg, where the portraits in this book were taken.
Address: Wolfram Eder Fotodesign,
Herstallstrasse 20, 63739 Aschaffenburg, Germany.
Tel/fax: +49 (0)6021 29277

Anna S Fabres studied photography in Paris in 1989/90 and subsequently trained on *Elle* magazine. Most of her photographs are of people. Her CV includes editorial work for magazines such as *Vogue Living*, *GQ Spain*, *Le Moniteur* and *Carta Capital*, together with various newspaper publications, film stills and book and CD covers. Her work has also appeared in a number of exhibitions, including that of the Royal Photographic Society.
Address: 55 Burnfoot Avenue,
London SW6 5EB, UK.
Fax: +44 (0)20 7371 5975
E-mail: annasfabres@hotmail.com

Ton Hendriks was born in 1953 in Hilversum, Holland. He studied philosophy at university in Amsterdam but on graduating resolved to become a photographer. He began as a newspaper photojournalist, specialising in documentary photography before gravitating towards portraiture. Since then he has worked for a variety of magazines, and has completed several personal projects with a social documentary theme. These include portrait series of the young homeless, the mentally handicapped, migrants, gypsies and the people of Surinam.
Address: Nienke van Hichtumstraat 35,
1064 MH Amsterdam, The Netherlands.
Tel/fax: +31 (0)20 6144456
E-mail: tonhendriksfotografie@hetnet.nl
http://www.homepages.hetnet.nl/~foton

Kobi Israel was born in Tel Aviv in 1970. He studied photography and cinematography at the Academic School of Art in Tel Aviv and the New York Film Academy. He has photographed more than 30 CD sleeves for Israel's leading record labels and supplies pictures of recording artists to the international press. His travel pictures have appeared in a number of books and magazines and have won several awards. In 1997 he staged a solo exhibition, *Cities That Never Sleep*, which was shown in Tel Aviv and on the Internet.
Address: PO Box 5353,
Tel Aviv, 61053 Israel.
Tel: +972 3 53 26 66 63
Fax: +972 3 6825 333
E-mail: to@kobi-israel.co.il
http://www.kobi-israel.co.il

Staffan Jofjell's fascination with photography was first sparked by family photograph albums, with their pages of small black-and-white prints. As a photographer himself he aims to capture the mood of the moment. He studied photography at the Christer Strömholm photography school, and backed this up with a number of courses and a lot of practice. His photographic work includes exhibitions, slide presentations, video and advertising.
Address: Bildverkstan,
Munkerudsvägen 15,
S-684 32 Munkfors, Sweden.
Tel/fax: +46 (0)563 528 50
E-mail: s.jofjell@telia.com

Gamini Kumara is a fine arts photographer who specialises in portraiture. She studied at Minneapolis College of Art and Design, where she was inspired by the work of photographers such as Richard Avedon, Robert Frank, Diane Arbus and Eugene Atget. She now works in computer imaging for pre-press and graphic design while pursuing her photographic interests. Besides portraiture and fine arts photography, these include digital photo manipulation and photography websites. She has had her own website since 1994.
Address: 6921 Olson Memorial Hwy,
Golden Valley, MN 55427, USA.
Tel: +1 763 595 9548
E-mail: gamini@visi.com
http://www.visi.com/~gamini/index.html

Richard Lewisohn spent a year studying photography at the London College of Printing. Since then he has been shooting studio and location editorial portraits as well as corporate work, including annual reports, both in the UK and in Europe.
Address: Richard Lewisohn Photography,

15 Moorhouse Road, London W2 5DH, UK.
Tel: +44 (0)20 7229 6752
Fax: +44 (0)20 7243 4689
E-mail: richard@lewisohn.co.uk
http://www.lewisohn.co.uk

Rossaline Lucock is a member of the Master Photographers Association with some 30 years' experience. Together with her husband Tony, also a photographer, she left London in the mid-1980s for rural Cornwall, where they opened Grindley Studios. She specialises in portraits, covering everything from children to make-overs, families, musicians and CD covers.
Address: Grindley Studios, Tregrehan,
St Austell, Cornwall PL25 3RJ, UK.
Tel: +44 (0)1726 812472
Fax: +44 (0)1726 816277
http://grindley-studios.youruk.com

Alain Paris has devoted himself to making images of Africa for the past 15 years, particularly Senegal. Some pictures he takes while travelling around the continent, others he creates in the studio. Bush Studio, a series of portraits taken with a medium format camera in a daylight studio, grew out of his attachment to Kafountine, a small village in Senegal. Other projects include Seetsi and Black Mirages. He has also produced Montreuil on the Stage, a study of the African population of the small French town of Montreuil.
Address: 26 rue Pierre Dulac,
94120 Fontenay-sous-bois, France.
Tel: +33 (0)6 09 02 53 87
E-mail: ap@blackmirages.com
http://www.blackmirages.com

Kris Rackham studied graphics but turned to photography at the age of 20 after assisting

photographer John Braeckmans on a number of shoots. Since then he has worked on numerous commissions and has had many pictures published. He works exclusively in black and white, and mostly in the studio. The key to successful portrait photography, he believes, is making subjects feel good about themselves.
Address: Kantstraat 2 bus 2,
B-2500 Lier, Belgium.
Tel: +32 (0) 34809871/+32 (0)477495132
E-mail: kris.rackham@advalvas.be
http://www.ping.be/rackham

Angela Read has been involved with photography since the age of 14. She has worked in many different capacities, including fashion stylist, photographer's assistant and press photographer on newspapers and magazines. She combines a fine arts education with sound commercial experience.
Address: Angel Eyes,
342 Keewatin Avenue, Toronto,
Ontario, Canada M4P 2A5.
Tel: +1 416 486 6080
Fax: +1 416 486 6315
E-mail: angelise@istar.ca
http://www.portfolios.com
http://www.lafondphoto.com/angelaread

Paul Sanders graduated from Art Center College of Design in Pasadena, California, and began his career as a fashion photographer in Milan. He later opened an advertising photography studio in Los Angeles, serving major clients such as American Express, Hilton Hotels, MCA/Universal, Microsoft, Nissan and Toshiba. He has won numerous industry awards for his advertising work, including awards from New York Art Director's Club, Northwest Addys, Beldings, Best in the West, the One Show and an award of excellence from

Communication Arts. His work has been widely published.
Address: Paul Sanders Photography,
11738 Kallgren Road NE,
Bainbridge Island, Washington 98110, USA.
Tel: +1 206 780 5152
(toll-free: +1 888 323 7374)
Fax: +1 206 780 5161
E-mail: paulphotog@aol.com

Philip Sprague, born in 1962, has been a photographer for more than 20 years and has won numerous awards in exhibitions, both in the UK and internationally. He is self-taught, and enjoys all kinds of photography, particularly travel and landscapes. Joe Cornish, Galen Rowell and Sebastiao Salgado are among the photographers whose work he admires. In 1998 he visited a number of countries including Tibet, New Zealand, Namibia and Zanzibar, and a selection of images from this trip can be viewed on his website.

Tel: +44 (0)1889 576000
E-mail: click.photography@virgin.net
http://freespace.virgin.net/philip.sprague/index.html

Daniel Stonek was born in Montevideo in 1955 and acquired his first SLR when he was 25. He did a two-year photography course and learned from working with more experienced photographers. He has participated in many competitions and exhibitions and has won a number of awards. Since 1994 he has specialised in a combination of digital and commercial photography, with a client list that includes Philip Morris, Wella Uruguay, Aventis Pharma and Seagram.

Address: Studio Stonek,
M Cervantes 2174,
11600 Montevideo, Uruguay.
Tel: +598 2 487 0363/+598 9 966 1741
Fax: +598 2 486 0353
E-mail: stonek@royal.net

Tricia Timmermans is Australian by birth but lives in Canada. She graduated in photojournalism from the Western Academy of Photography in Victoria, British Columbia in 1996. She specialises in photographing people and places, and has travelled to South East Asia, Africa, Mexico, Brazil, Nepal and India. She is also a freelance writer, with two editions of a travel book (*British Columbia off the Beaten Path*) to her credit. She is working on two further books, one about her father's experiences in the Second World War, the other a collection of photographs and stories.

Address: Photo-J Inc.,
106-2768 Satellite Street, Victoria,
British Columbia, Canada V8S 5G0.
Tel/fax: +1 250 592 5088
E-mail: photo-j@home.com
http://www.photo-j.com
http://portfolios.com/photo

Terry Way is a freelance photographer based in Santa Cruz, California. He began taking sports and action pictures at a very early age, inspired by a love of surfing, and later moved on to photographing musicians and recording his travels around the world. Besides portraits, he specialises in documentary-style wedding photography and in garden and tropical plant photography. His images have featured in major advertising campaigns both in the US and internationally and he is represented by several stock photo agencies. Since becoming a father, his two young sons have become his main photographic subjects.

Address: Terry Way Photography,
1825 Rodriguez St, Santa Cruz,
CA 95063, USA.
Tel: +1 831 464 0939
Fax: +1 831 464 6845
E-mail: postmaster@terryway.com

Philip Winestone was born in Glasgow, Scotland and spent a number of years working in engineering and computing. He discovered his talent for photography while still a student, and evolved his very minimalist style while studying under New York photographer Barry Ashley. He has now been taking pictures for more than 25 years, specialising in people but also taking still lifes and landscapes. His commissions include magazine and advertising work in New York and Toronto, as well as gallery exhibits and private portraiture work.

Address: 95 Peckham Avenue, Toronto,
Ontario, Canada M2R 2V4.
Tel: +1 416 221 0150
Fax: +1 416 225 5755
E-mail: philip.winestone@home.com

Glossary

Aperture priority

An auto-exposure setting in which the user selects the aperture and the camera's exposure system sets the appropriate shutter speed.

APO lens

A highly-corrected lens which is designed to give optimum definition at wide apertures and is most often available in the better-quality long-focus lenses.

Ariel perspective

The tendency of distant objects to appear bluer and lighter than close details, enhancing the impression of depth and distance in an image.

Auto-bracketing

A facility available on many cameras which allows three or more exposures to be taken automatically in quick succession, giving both more and less than the calculated exposure. This is usually adjustable in increments of one-third, half or one stop settings and is especially useful when shooting colour transparency film.

Auto Exposure Lock

Camera feature which, in automatic exposure mode, allows the user to take a spot reading and set an exposure for a particular part of the frame before recomposing the image.

B Setting

Bulb setting, a shutter speed which allows the shutter to be held open for long exposures with a cable release.

Barn Doors

Device resembling a pair of shutters that is attached to a studio lighting unit to restrict its lighting output.

Bellows unit

An adjustable device which allows the lens to be extended from the camera body to focus at very close distances.

Black Reflector

A panel with a black matt surface, used to prevent light being reflected back into shaldow areas in order to create a dramatic effect.

Burning

Darkroom printing technique in which areas of the print are given extra exposure to darken them.

C-41

The chemical process used to develop colour negative films.

Cable release

A flexible device which attaches to the camera's shutter-release mechanism and which allows the shutter to be fired without touching the camera.

Colour cast

A variation in a colour photograph from the true colour of a subject which is caused by the light source having a different colour temperature to that for which the film is balanced.

Colour temperature

A means of expressing the specific colour quality of a light source in degrees Kelvin (K). Daylight colour film is balanced to give accurate colours at around 5,600 degrees K but daylight can vary from only 3,500 degrees K close to sundown to over 20,000 degrees K in open shade when there is a blue sky.

Cross processing

The technique of processing colour transparency film in colour negative chemistry, and vice versa, to obtain unusual effects.

Data back

A camera attachment which allows information like the time and date to be printed on the film alongside or within the images.

Daylight Bulbs

Lightbulbs balanced to give illumination close to natural daylight.

Dedicated flash

A flash gun which connects to the camera's metering system and controls the power of the flash to produce a correct exposure. It will also work when the flash is bounced or diffused.

Depth of field

The distance in front and behind the point at which a lens is focused which will be rendered acceptably sharp. It increases when the aperture is made smaller and extends about two-thirds behind the point of focus and one-third in front. The depth of field becomes smaller when the lens is focused at close distances. A scale indicating depth of field for each aperture is marked on most lens mounts and it can also be judged visually on SLR cameras which have a depth-of-field preview button.

Dodging

Darkroom printing technique in which areas of the print are masked off during exposure so that they print lighter.

DX coding

A system whereby a 35mm camera reads the film speed from a bar code printed on the cassette and sets it automatically.

E6

Chemical process used to develop colour transparency films.

Evaluative metering

An exposure meter setting in which brightness levels are measured from various segments of the image and the results used to compute an average. It's designed to reduce the risk of under or overexposing subjects with an abnormal tonal range.

Exposure compensation

A setting which can be used to give less or more exposure when using the camera's auto-exposure system for subjects which have an abnormal tonal range. It is usually adjustable in one-third of a stop increments.

Exposure latitude

The ability of a film to produce an acceptable image when an incorrect exposure is given. Negative films have a significantly greater exposure latitude than transparency films.

Extension tubes

Tubes of varying lengths which can be fitted between the camera body and lens to allow it to focus at close distances. These are usually available in sets of three different widths.

Fill-in flash

A camera setting for use with dedicated flash guns which controls the light output from a flash unit and allows it to be balanced with the subject's ambient lighting when it is too contrasty or there are deep shadows.

Film Speed

Indicated by the ISO rating of the film (ISO 50, 100, 200, 400 etc.). The lower the number, the slower the film. Slow films give finer detail but require more light. Fast films can be used in lower lighting conditions but their grain is more apparent.

Filter factor

The amount by which the exposure must be increased to allow for the use of a filter. A x2 filter requires an increase of one stop and a x4 filter requires a two stop exposure increase.

Flash Meter

An exposure meter which is designed to measure the light produced during the very brief burst from a flash unit.

Flash Sync Lead

Short cable which connects a flashgun to a camera when the flashgun is not mounted in the camera's hotshoe. Allows synchronised flash exposure.

Grey card

A piece of card which is tinted to reflect 18 per cent of the light falling upon it. It is the standard tone to which exposure meters are calibrated and can be used for substitute exposure readings when the subject is very light or dark in tone.

Guide Numbers

Indicate the power output of a flashgun, based on the correct exposure for a given film speed, aperture and distance from the subject.

Honeycomb Grid

Grill-like device which fits over a flashgun or studio lighting unit to restrict its output and limit light spill.

Hotshoe

Slot on top of the camera in which flashguns and other accessories are mounted. The hotshoe contains electronic contact points which automatically synchronise camera and accessory operations.

Hyperfocal Distance

The closest distance at which details will be rendered sharp when the lens is focused on infinity. By focusing on the hyperfocal distance you can make maximum use of the depth of field at a given aperture.

Incident light reading

A method involving the use of a hand meter to measure the light falling upon a subject instead of that which is reflected from it.

ISO rating

The standard by which film speeds are measured. Most films fall within the range of ISO 25 to ISO 3200. A film with double the ISO rating needs one stop less exposure and a film with half the ISO rating needs one stop more exposure. The rating is subdivided into one-third of a stop settings i.e. 50, 64, 80, 100 and so on.

Lightbox

Frosted glass box containing fluorescent tubes, used to view transparencies. There are both table-top and portable versions.

Loupe

Magnifying device used to view transparencies on a lightbox.

Macro lens

A lens which is designed to focus at close distances to give up to a life-size image of a subject.

Matrix metering

See evaluative metering

Mirror lock

A device which allows the mirror of an SLR camera to be flipped up before the exposure is made to reduce vibration and avoid loss of sharpness when shooting close-ups or using a long-focus lens.

Neutral Density Filter

A filter that reduces the intensity of the light reaching the image without affecting colours in any way. Allows the use of larger apertures in very bright lighting conditions.

Open Flash

Technique of firing a flashgun manually without synchronisation to the camera. It can be used to 'paint' with light, when the photographer fires several bursts of flash to illuminate different parts of the subject while the shutter remains open.

Photoflood

A film light sometimes used for studio photography. Gives a predominantly blue cast to lighting.

Polarising filter

A neutral grey filter which can reduce the brightness of reflections on non-metallic surfaces such as water, foliage and blue sky.

Programmed exposure

An auto-exposure setting in which the camera's metering system sets both aperture and shutter speed according the subject matter and lighting conditions. It usually offers choices like landscape, close-up, portrait, action etc.

Pulling

A means of lowering the stated speed of a film by reducing the development times.

Pushing

A means of increasing the stated speed of a film by increasing the development times.

Reciprocity failure

The effect when very long exposures are given. Some films become effectively slower when exposures of more than one second are given and doubling the length of the exposure does not have as much effect as opening up the aperture by one stop.

Reflector

Used to throw light back on to a subject to fill in shadows and even out lighting. Can be used with flash or in sunlight. There are many commercially available types but reflective materials such as polystyrene, silver foil and white card are also commonly used.

Shutter priority

A setting on auto-exposure cameras which allows the photographer to set the shutter speed while the camera's metering system selects the appropriate aperture.

Slow-Sync Flash

Flash setting in which the shutter remains open longer than normal to retain detail in the background of the scene.

SLR

Single lens reflex, the most common type of 35mm camera. Allows the image to be viewed through the lens via a mirror angled at 45 degrees. When the shutter is fired, the mirror flips up out of the way to allow light through to the film behind.

Snoot
A conical device which fits over the front of a studio lighting unit to concentrate its output and reduce light spill.

Softbox
A large light reflector, shaped something like an umbrella, with a translucent screen which softens and diffuses studio flash lighting.

Spot Light
A light source fitted with a lens which enables a precisely focused beam of light to be projected.

Spot metering
A means of measuring the exposure from a small and precise area of the image which is often an option on SLR cameras. It is useful when calculating the exposure from high-contrast subjects or those with an abnormal tonal range.

Substitute reading
An exposure reading taken from an object of average tone which is illuminated in the same way as the subject. This is a useful way of calculating the exposure for a subject which is much lighter or darker than average.

TLR
Twin lens reflex, a type of medium format camera which has two lenses, one for focusing and one for exposing the image. Now largely superseded by SLRs.

TTL Metering
Through the lens metering, which allows the correct exposure to be worked out in-camera without the need for a separate hand-held light meter.